The Essential Max Ernst

403 illustrations, 15 in colour

Thames and Hudson · London

Translated from the German
Max Ernst
by R. W. Last

Printed and bound in Great Britain by Jarrold and Sons Ltd, Norwich

ISBN *0 500 18136 5 cloth*
ISBN *0 500 20130 7 paper*

There is little to be gained from looking for a style common to all Surrealism; and the same holds good for Max Ernst's work. For in both cases it is the method which is crucial, not the style or the form. Max Ernst employs highly specific and identifiable techniques of manipulation and combination. Because his work is the result of conscious thought, and yet allows room for chance to operate, it possesses a whole variety of meanings. It addresses itself directly to the observer's powers of association.

Max Ernst is often thought to be a painter of dreams, and of the depths of the unconscious, but this is not so. Against the background of his knowledge of the mechanisms of dreams, wit and the subconscious, he pursues his creative game with historical associations, artistic allusions, psychological relationships, visions, materials and artistic techniques: he juxtaposes unrelated areas of civilization; or breathes fresh life into objects and structures by making them become alien to us, or negate their own function. And in these ways he creates works of art which, in spite of all his doubts about the viability of art, do have a more than purely personal relevance.

Max Ernst went to a university instead of an academy of art, and he is an intellectual artist. He makes use of the past, and hence his relationship with Mannerism and Romanticism is much closer than is the case with other modern artists; and he reacts strongly to the present, never trying to conceal his hatred of authoritarianism, war and the Church. Max Ernst has substituted complex technical operations for the painter's creative process; he has substituted combination for 'inspiration'; he has expanded his repertoire of images to include trivial areas not considered worthy of art; he has revolted against normative artistic pretensions. But he has also turned his critical awareness in on itself, on to the artist and his art-making.

For sixty years he has fashioned art out of the apparent negation of traditional concepts of art. Picasso has said that he does not seek but finds. Max Ernst would say the opposite. Ernst has no solutions to offer, only contradictions and tensions.

This book sets out to cover each stage in the development of Max Ernst's work. It would be inappropriate in a study of this nature to engage in detailed analyses of individual works. But whenever his work seems to render it desirable, Max Ernst will be set briefly against the political and artistic background of which he himself has been so conscious an observer and so critical a judge.

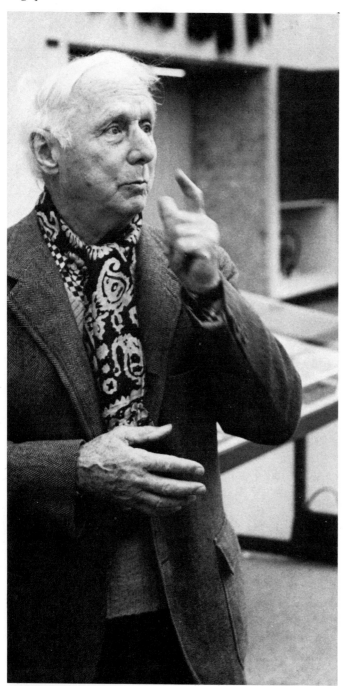

Max Ernst was born in the year 1891, as a Prussian subject, in the Rhineland. Difficulties began in his parental home, and at school, as the belief took root in the boy's mind that he was born to paint. The grown-ups sought to suppress this idea by force. The educational folly of the grown-ups was no match for the mind of the boy. To resist it was associated in his mind with a secret feeling of joy. This feeling was to have decisive importance for his later life: it opened up to him almost limitless possibilities of finding, wherever his destiny and the events of the world might bring him, wonderful friends among like-minded people, among devils and angels all free as air. This explains the so-called 'many-sidedness' of his work.

A painter may know what he does not want. But woe betide him if he wants to know what he does want! A painter is lost if he finds himself. The fact that he has succeeded in not finding himself is regarded by Max Ernst as his only 'achievement'. [M.E.]

1 Max Ernst 1970
2 Max Ernst, biographical data 1967

Lebensdaten

Max Ernst wurde anno 1891 als preußischer Untertan im Rheinland geboren.

Schwierigkeiten begannen im Vaterhaus, Schule und Gymnasium, als sich im Hirn des Knaben der Glaube einwurzelte, er sei in die Welt gekommen um zu malen. Die Erwachsenen versuchten diese Idee mit Gewalt zu unterdrücken. Der Erziehungsunfug der Erwachsenen war dem Hirn des Knaben nicht gewachsen. Sich dagegen zu sträuben war für ihn mit einem geheimen Wonnegefühl verbunden. Es hatte für sein späteres Leben eine entscheidende Bedeutung: es erschloß ihm fast unbegrenzte Möglichkeiten, unter gleichgearteten Menschen, unter vogelfreien Engeln und Teufeln, herrliche Freunde zu finden, wo immer auch sein Schicksal und die Weltereignisse ihn verschlugen. Daraus erklärt sich die sogenannte „Vielseitigkeit" in seinem Schaffen.

Ein Maler mag wissen was er nicht will. Doch wehe! wenn er wissen will, was er will! Ein Maler ist verloren, wenn er sich findet. Daß es ihm geglückt ist, sich nicht zu finden betrachtet Max Ernst als sein einziges „Verdienst".

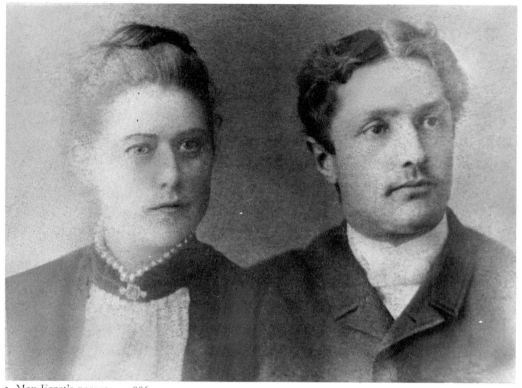

3 Max Ernst's parents *c.* 1886

In 1891 – the year in which Cézanne was working on his *Card-players*, Adolf von Hildebrand on the Wittelsbach fountain, and Rodin on his *Balzac* – Seurat died, and Otto Dix, John Heartfield and Max Ernst were born. Shortly before came Hans Arp (1886), Marcel Duchamp and Kurt Schwitters (1887), Giorgio de Chirico (1888), and Naum Gabo and El Lissitzky (1890); and shortly after, George Grosz and Joan Miró. None of them was to be an innovator in the field of form; their achievement was to find ways of coming to terms with reality, to experiment with the correspondences between life and art. When they began their active careers, French Cubism had already burst the chains of traditional art, but seemed to have got into an impasse of its own with its new artistic vocabulary. The collage, developed by the Cubists, proved none the less to be the most viable artistic form for those who came after them.

Max Ernst was born on 2 April 1891 at Brühl, near Cologne, second child of a teacher of the deaf, Philipp Ernst, who was also a painter.

When his father was painting in his garden, and a tree in the picture irked him, he painted it out, and then wondered if he ought not to remove the real tree as well. 'At the time it occurred to [Max] that there was something amiss in the relationship between painter and subject' (bib. 64).

The relationship with his parents, particularly with his father, is crucial. 'My father harassed me and always shouted at me when I did not paint things as he wanted them' (bib. 42). Max Ernst tried many times to escape his father's Prussian discipline by running away.

In 1896, he ran away from home, turning up in his nightshirt at Kevelaer, where some pilgrims to the local shrine gave him the title of Christ Child. Brought back home, his father painted him as the boy Jesus; what he depicted was the wish-fulfilment of a father in the Wilhelminian empire who refused to face up to his son's rebelliousness.

In 1897, Max Ernst's sister Maria died. 'From that time a sense of the void and the forces of destruction were dominant in his spirit, his conduct and later his work' (bib. 59). Between 1898 and 1909 Max Ernst attended the primary and civic high schools at Brühl.

4 Philipp Ernst: *Portrait of his Son Max as the Christ Child* 1896
5 *Self-portrait* 1909

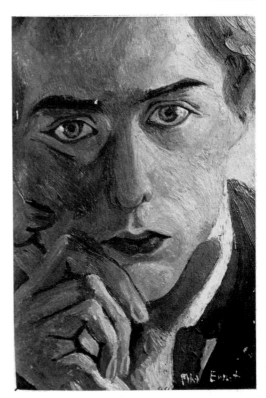

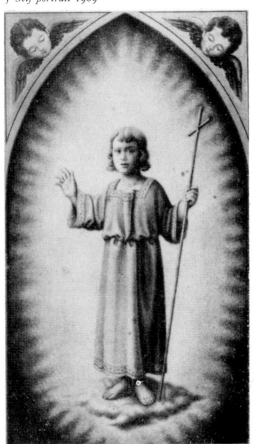

When, in 1906, on the same night during which his sister Loni was born, 'a friend by the name of Hornebom, a clever, multi-coloured, loyal bird, died' (bib. 64), Max was convinced that, in her lust for life, his sister had 'appropriated for herself the vital juices of the dear bird. . . . That crisis soon passed. But a spontaneous and irrational mental confusion between people and birds and other creatures persisted in the young man's imagination; and this is reflected in the symbols of his art' (bib. 64).

'The geographical, political and climatic conditions of Cologne as a city are perhaps propitious to the creation of fertile conflicts in a sensitive child's mind . . . early Mediterranean influences, Western rationalism, Eastern occult leanings, Nordic mythology, the Prussian categorical imperative, the ideals of the French Revolution, and so forth' (bib. 44).

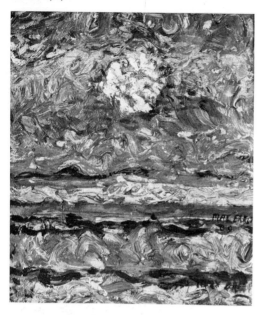

6 *Landscape with Sun* 1909
7 *Landscape with Sun* 1909

While studying philosophy and psychology (with brief excursions into the history of art) at the University of Bonn from 1909 to 1914, Max Ernst studiously avoided 'all forms of study which might degenerate into gainful employment. Painted. Indiscriminately devoured everything . . . he got his hands on. . . . Result: a head filled with confusion. In painting, too, his eyes drank in all that came into his ken, but not so indiscriminately: he loved Van Gogh, Gauguin, Goya, Seurat, Matisse, Kandinsky, etc.' (bib. 64).

He read Max Stirner and Friedrich Nietzsche. He found the pictorial creations of mental patients disturbing; a book about their art planned long before Hans Prinzhorn (1922) remained uncompleted. In the Wallraf-Richartz-Museum, Cologne, he was moved by the work of Lochner, Altdorfer and Friedrich.

Of his near-contemporaries, Vincent van Gogh seems to have inspired him most deeply. Two small landscapes of 1909 do display tendencies in this direction, but on the other hand reveal a schematic approach to landscape (sun over plain or sea) which is rare in Van Gogh and seems to anticipate Max Ernst's forest and sun motifs of the 1920s.

Around 1910 the artistic scene in the German empire burst into life: in 1905 'Die Brücke' had been founded by Erich Heckel, Ludwig Kirchner and Karl Schmidt-Rottluff in Dresden; in 1909 Alexej Jawlensky, Wassily Kandinsky and Gabriele Münter, among others, formed the Neue Künstlervereinigung in Munich. In 1910 Herwarth Walden founded the periodical *Der Sturm* in Berlin, and Max Pechstein founded the Neue Sezession. In the same year the great Sonderbund exhibition took place in Düsseldorf, the Blauer Reiter was formed in Munich, and Heinrich Campendonk, August Macke and Heinrich Nauen combined with others to form the Rhenish Expressionists. Max Ernst, as a friend of Macke, was close to this group, and exhibited together with them in the Cohen bookshop in Bonn, and in the Feldmann gallery in Cologne two years later. He also took part in the 'Erster Deutscher Herbstsalon' in Berlin, alongside Chagall, Delaunay, Klee, Kandinsky and Macke.

The Cologne Sonderbund exhibition of 1912, which offered a conspectus of contemporary art right up to the immediate present, was perhaps the most important international exhibition in the Rhineland before the First World War, and coincided with Max Ernst's final decision to become a painter.

For a while he was strongly influenced by Macke, until the latter introduced him in 1913 to Delaunay and Apollinaire, who were on a visit to the Rhineland. He produced a whole series of drawings which, according to the evidence of a fellow-student, all originated as sketches from nature. Parkland and landscape, painted in juxtaposed parallel brush lines, form the principal subjects.

Highly individual experiments began to accrue. In the drawing of dogs and a human figure (ill. 10) the soft outlines of Art Nouveau are blended with the simple, 'musical' agility of the forms on Matisse's great murals painted for Count Shchukin in Moscow. But at the same time a characteristic peculiar to Max Ernst is foreshadowed in the negative way in which the outlines are arrived at: it is the background which is filled in, not the figures. They are left unpainted, and remain like negatives on the surface of the picture, with no internal form or precise outline; like many forms in Max Ernst's later work, they have shape without substance.

In his subsequent work, Max Ernst continues to explore this tension between the visual end product and the technical means.

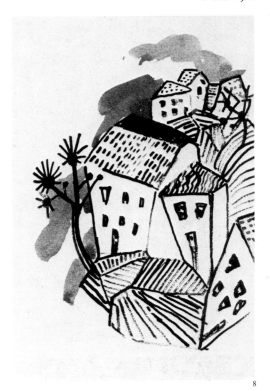

8

8 *Group of Houses* 1911–12
9 *Street in Paris* 1912
10 *Youth Running* 1913

9

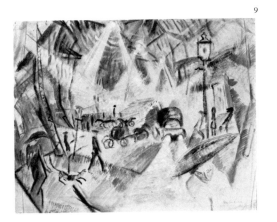

10

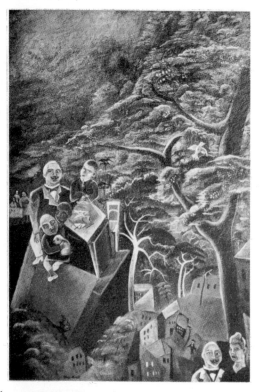

The 1912 Cologne Sonderbund exhibition and the meeting a year later with Delaunay turned Max Ernst towards Orphism, and towards Futurism (which the Galerie Feldmann exhibited separately at about the same time). The way in which visual experience or physical movement was transformed into rhythm and colour tone excited Max Ernst, without, however, inducing him to join in the trend towards abstract form which was already becoming apparent in the Sonderbund exhibition, and for which Wilhelm Worringer had paved the way in his essay *Abstraktion und Einfühlung (Abstraction and Empathy)* as far back as 1908. Max Ernst moved closer to the formal principles of contemporary art movements, but in no case did he identify himself with any one group. The trend towards the technique of assemblage is characteristic of these pictures from the period between 1913 and 1918. In them he experiments with juxtapositions of the most disparate styles. These works are attempts to use his knowledge of art past and present to map out a path for himself.

11 *Immortality* 1913–14

12 *A Sunday Morning c.* 1913–14

13 *Crucifixion* 1913

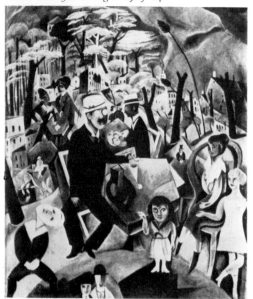

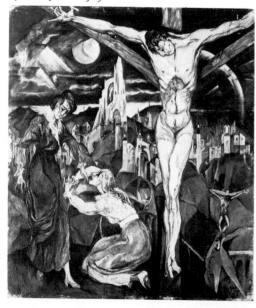

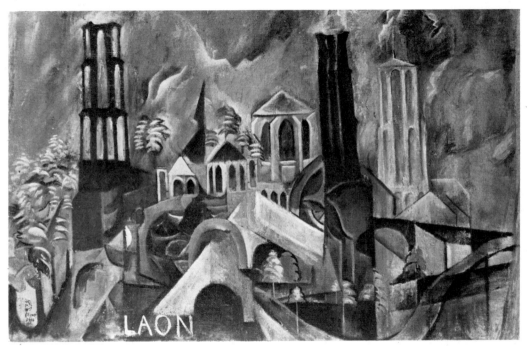

14 *Laon* 1916

15 *Untitled* 1919

'Art has nothing to do with taste, art is not there to be tasted.' Max Ernst wrote these words in 1912 in one of his art reviews for the Bonn newspaper *Der Volksmund*. In 1914 he met Hans Arp.

Then came the outbreak of war. 'None of my friends is in any hurry to sacrifice his life for God, king and country. . . . Max must enlist. Field artillery. Four months in Niehl barracks, Cologne, then out into the shit. Four years' (bib. 64). In the first year of the war Macke was killed.

During a spell of leave in Berlin for an exhibition at Herwarth Walden's *Der Sturm* gallery in 1916, Max Ernst met two virulently left-wing anti-war artists, George Grosz and Wieland Herzfelde. A protest movement in the arts, founded by émigrés in Zurich, was also making its presence felt in Berlin: its name was Dada. 'For myself', Grosz wrote later, 'my "art" at that time was a safety-valve, which allowed the pent-up hot steam to escape.'

16

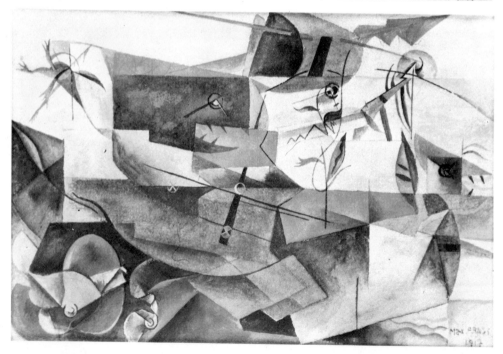

Max Ernst stayed in the army until 1918. 'Shouting, swearing, spewing,' he wrote later, gets you nowhere. There's no point either in trying to wrap yourself up in contemplation. You do get a couple of watercolours out of it' (bib. 64).

Although Max Ernst, like Otto Dix and George Grosz, hated the war, he did not react as they did. They turned drawing and painting into vehicles for their hatred; they employed art as a weapon in the battle against the bourgeoisie and the warmongers. Max Ernst sought to liberate himself from the impact of the horrors of war through creative activity directed, not at society at large, but at his own world of emotion.

The three watercolours of 1917 are attempts at spiritual self-preservation by means of aesthetic formal discovery; in the same year Max Ernst confirmed this aspiration in his essay 'Vom Werden der Farbe' in the periodical *Der Sturm*. But these watercolours are inadequate to the task of coming to grips with reality, which Max Ernst was to attempt time and again.

In 1919, just after the end of the war, there appeared in Cologne his illustrations for Johannes T. Kühlemann's book of poems *Consolamini* and for the periodical *Der Strom*.

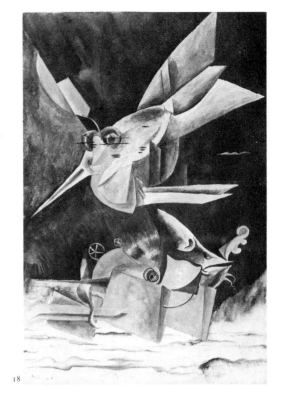

18

16 *Battle of the Fish* 1917
17 *Landscape* 1917
18 *Victory of the Spindles* 1917
19, 20 Illustrations from Johannes Th. Kühlemann's *Consolamini* 1919

19

20

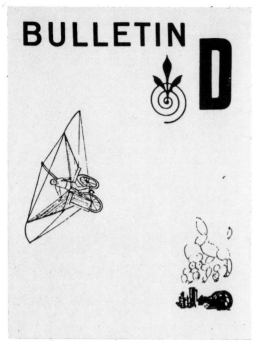

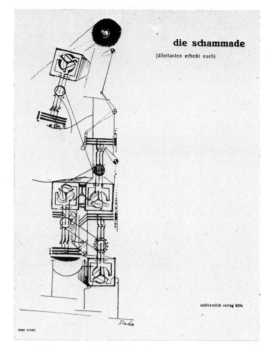

21 Title-page of *Bulletin D*. 1919

22 Title-page of *Die Schammade* 1920

'Max Ernst died on 1 August 1914. He re-
turned to life on 11 November 1918, a young
man who wanted to become a magician and
find the myths of his time' (bib. 59).

This quest, which would have been unthink-
able without the wartime despair and subse-
quent political polarization that affected
Germany, begins with Dadaism.

'For us, at that time in Cologne in 1919,
Dada was first and foremost an attitude of
mind,' he said later in a film by Peter Scha-
moni. 'Contrary to general belief, Dada did
not want to shock the bourgeois. They were
already shocked enough. No, Dada was a
rebellious upsurge of vital energy and rage;
it resulted from the absurdity, the whole
immense *Schweinerei* of that imbecilic war. We
young people came back from the war in a
state of stupefaction, and our rage had to find
expression somehow or other. This it did
quite naturally through attacks on the founda-
tions of the civilization responsible for the
war. . . . Our enthusiasm encompassed total
revolution' (bib. 36).

In 1919 Hans Arp came to Cologne from
Zurich, where he was already well known as a
co-founder of Dada. Together with Max
Ernst and Johannes Theodor Baargeld, an
extreme left-wing activist, Arp founded a
Dada group in Cologne under the name of
'Zentrale W/3'. Their activities had little to
do with art, but a great deal to do with life.
They broke up the production of a patriotic
drama. They produced a series of periodicals;
most of which were shortlived: *Bulletin D*,
Der Ventilator and *Die Schammade*. *Der
Ventilator* struck out against the upsurge of
proto-Fascism. It was distributed at factory
gates – ultimately in a printing of 40,000
copies – and was finally banned by the British
army of occupation, as was *Bulletin D*. *Die
Schammade*, of which only one number
appeared, contained contributions by Baar-
geld, Ernst, Arp, Louis Aragon, André
Breton, Paul Eluard, Richard Huelsenbeck,
Francis Picabia, Philippe Soupault and Tristan
Tzara; it thus represents an early step towards
contact with the Parisian avant-garde.

In 1916 the first Dada Soirée took place in Zurich. Arp, Ball, Huelsenbeck, Janco and Tzara combined cabaret, theatre, music, readings and the visual arts in riotous, non-sensical performances. The Cabaret Voltaire in Zurich became the focal point of the new movement. As early as 1917, Max Ernst contributed to an exhibition at the Dada gallery in Zurich.

In 1917 Duchamp submitted a urinal as a 'readymade' to a New York exhibition. With Man Ray and Francis Picabia he was a member of the group around the periodical *291*.

In Berlin in 1918, Grosz, Huelsenbeck, Raoul Hausmann, Johannes Baader, Franz Jung and John Heartfield founded a Dada club which by its peak in 1920 – on the occasion of the 'First International Dada Fair' in Dr Otto Burchard's gallery – had taken up a radical position which set it apart from all the other groups.

In Hanover, Kurt Schwitters practised his own brand of Dadaism from 1919 onwards.

'Dada has to be experienced. Dada is direct and self-evident. . . . Dada advances a kind of anti-cultural propaganda, born of honesty, of disgust, of the profoundest revulsion at the artistic sublimity affected by the intellectually acceptable bourgeois' (bib. 13).

The collage was the most important new medium both for visual artists and the creative writers who made their own substantial contribution to the development of concrete poetry (Aragon, Arp, Ball, Hausmann, Schwitters). In Zurich 'simultaneous poems' appeared, and in Berlin Hausmann published poem-posters (1918).

Word-play and conscious suppression of logic in language also characterize Max Ernst's Dadaist texts. The poem 'Worringer, profetor DaDaistikus' (published in *Die Schammade*, 1920) ends: '11.10 to 5.23 pm unio expressiva erotica et logetica or the coital spasms of brother pablo mysticus and Sister scholastica Feininger or the picasso ethic. kille killi! 6.0 pm picastrate Eum!'

A page of advertisements from *Die Schammade* reflects the Dadaists' fascination with the manipulation and distortion of words, with nonsensicality and typographical chaos. It also points to their delight in Dada pseudonyms, as does the self-advertisement in *Der Querschnitt* (for translation see the entry in the list of illustrations).

Werner Spies has established that in his plays on words Max Ernst has frequently made use of the portmanteau words which in his reading of Freud in 1913 he found analysed as components of the joke in its relationship with the subconscious mind.

Advertisement panel (23):

Kryskall-Palast Köln — Severinstraße 226

Das führende Theater West-deutschlands!

391

demonstration=analytische exhibristik wumba wumba
tzimda tzimda
nur korrekte Beziehungen zum zarten Geschmeck
kein Bußpalmin kein Friedenspalmona
zzzzumba bumbah fffffh...?
Zahnradsensaktionär (korrekter Salto-Delta)

PICABIA

kaskādou R bemon'-Dessalgnes Vorderkaufschukakteur A. Breton Delicatešdada Baargeld 391 Eluard Aragon 391 Doublemondādada mäs Dada Arp Gabrielle Buffet As l'antiphilosophe Arensberg Stieglitz – Paris Zürich Newyork Köln
Dépositaire E. Eguière 3 place de l'Odéon 3 PARIS

Soeben erschienen!

FIAT MODES

(pereat a.s) 8 signierte Originallitografien
(FJHJ MÖDES)
mondāndada MAX ERNST
Verlag der ABK, Köln, Kunstgewerbemuseum. Preis M. 80.— Museumsausgabe 1—10 M. 150.—
. . . die Blätter wurden im Auftrag der Stadt Köln gezeichnet. Es ist dies der erste uns bekannte Fall, in dem eine Stadtverwaltung ein Auftraggeberin eines dadaistischen Kunstwerks dasteht. Köln marschiert demnach.
. . . Max Ernst ist der Kaulbach des Dadaismus . . . (W. Worringer).
. . . der Gebärvater methodischen Irrsinns . . .

Mouvement Dada
Direzione: Tr. Tzara, Zürich Seehof Schiffstraße 28

Dada 1 vergriffen
 Luxusausgabe frs. 8.—
Dada 2 2.—
 Luxusausgabe 8.—
Dada 3 1.50
 Luxusausgabe 20.—
Dada 4—5 4.—
 Luxusausgabe 20.—
„391" No. 12 2.—
Tr. Tzara: La première aventure céleste de M. Antipyrine 2.—
Tr. Tzara: 25 Poèmes, 10 Holzschnitte von Arp 3.—
 Luxusausgabe 15.—
 Luxusausgabe auf Bütten . . 60.—
Fr. Picabia: L'Athlète des Pompes funèbres . . . 2.50
Fr. Picabia: Rateliers platoniques 4.—
Fr. Picabia: Poésie Ronron 5.—

Demnächst erscheint:
Tr. Tzara: **"maisons"** (Holzschnitte von Arp)
PARIS Anti-littérature.

Dilatorische Kunstdruckanstalt
Spezialität:
Akzidenzdilettantismus
Max Hertz, Köln
Mühlenbach 38.

23

Self-advertisement (24):

Dada est mort, vive Dada!
Ein großes Dada-Dämmern scheint heraufzuziehen. Wie im Muspilli gehen die Helden gegeneinander los. Der Huelsenbecker gegen den Hauptgott Tzara; der Präsident des Weltalls wurde desgleichen von Huelsenbeck schwer beschädigt und last not least wendet sich der Dadaistenführer Serner gegen Weltmeister Huelsenbeck und Tzara (Großgroßhaupt) ***. Ebengenannter versucht weiter und auch einen Todesstoß dem Weltmeister beizubringen. Großdada Arp (Qualitätsarp), Serner und der Dadafex Maximus (Dadamax Ernst) sollen einen noch nicht bestätigten Gerücht zufolge in einer Nacht zusammengetreten sein, um den neuen Dada-Rütli zu verschwören. Mit äußerster Vorsicht und strengster Geheimhaltung ihrer Pläne treffen diese unvergleichlichen Männer ihre Vorbereitungen. Sie holen, so sagt man, zu dem letzten, entscheidenden Schlage aus.

24

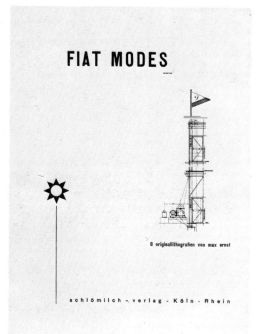

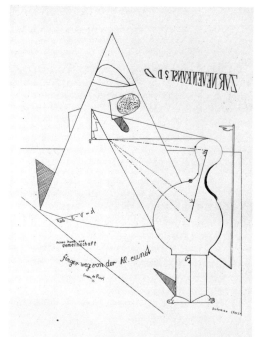

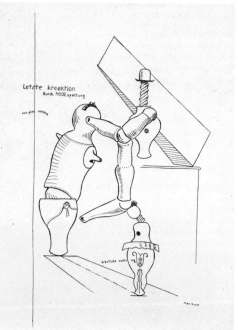

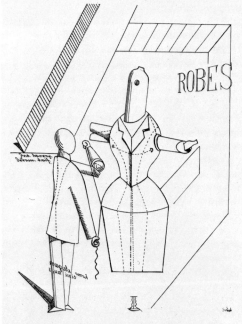

When Max Ernst visited Paul Klee in Munich in 1919, he found in the Goltz bookshop an issue of the periodical *Valori Plastici*, and so came to know the works of Giorgio de Chirico. The first result of Max Ernst's inspiration was the collection of eight lithographs, plus title-page, called *Fiat Modes*. The advertisement from *Die Schammade* (ill. 23) retails the background story: astonishingly, *Fiat Modes* was subsidized by the municipality of Cologne.

De Chirico had studied Nietzsche, Arnold Böcklin and Max Klinger. His 'metaphysical landscapes' (Apollinaire), dating from the period between 1912 and 1918, take as their starting-point Nietzsche's description of the great empty squares of Turin in *Ecce homo*. Max Ernst and the later Surrealists were fascinated more than anything else by De Chirico's arbitrary and paradoxical handling of centralized perspective (which the Cubists had just given up) and his formalized human figures based on tailor's dummies (the *manichini* or manikins).

Both these features are to be found in the collection *Fiat Modes*, which Max Ernst himself described as a homage to De Chirico. A given system of perspective is disrupted by a different system or a plane surface. The figures are sometimes tailor's dummies, sometimes human beings who look like tailor's dummies. The sense of confusion is heightened by the presence of writing, some of it arranged perspectively, i.e. in space, in which Dadaist word-play reappears. There in neat script can be read 'finger weg von der hl. cunst' (hands off hly art) or 'non plus umbra'.

Whereas De Chirico, for all his discontinuities, creates a unified canvas (such as is also to be found in Max Ernst's *The Virgin Chastises the Infant Jesus*, 1926, ill. 155), the dominant principle in *Fiat Modes* is that of juxtaposing apparently irreconcilable forces, a principle fundamental to the collages which were to appear a little later on.

The tendencies towards stylization in a related etching, *Aquis Submersus*, point to Schlemmer, and to Hoerle and Seiwert who were both members of the Rhineland avant-garde.

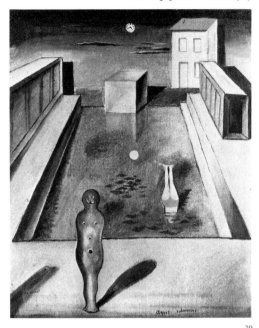

29

25–28 Four lithographs from *Fiat Modes* 1919
29 *Aquis Submersus* 1919
30 *Untitled* 1919

30

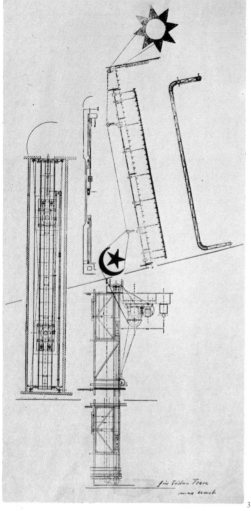

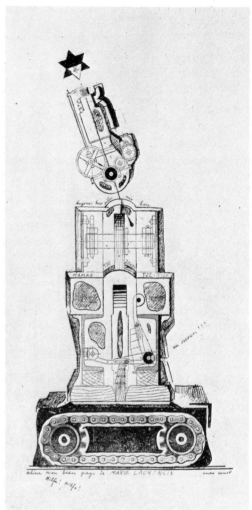

31

32

When Marcel Duchamp went to New York in 1915 he described plumbing and bridges as the best art America had produced. This was the period when Picabia did his *Mechanical Drawings*, when the Futurists enthused over speed, machinery and metropolitan life, and when German literary Expressionism tended towards a highly emotional machine cult. Duchamp had blazed the trail with his plans for pseudo-mechanical structures which culminated in the *Large Glass* (1915–23). Around 1920, Lászlo Moholy-Nagy was also engaged in drawing fantasy machines.

31 *Hypertrophic Trophy* 1919
32 *Farewell my Fair Land of MARIE LAUREN-CIN* 1919

Max Ernst's *Mechanical Drawings* could be regarded as a riposte to Picabia, whose work he had certainly seen in Alfred Stieglitz's New York periodical *291* (1903–15) or in Picabia's own *391* (1917–24). Max Ernst's drawings differ from Picabia's principally in that they are not in any way symbolic in character.

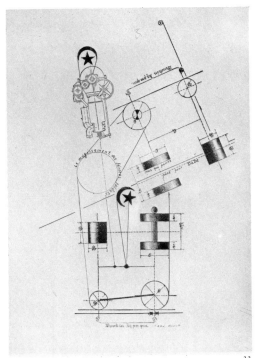

33

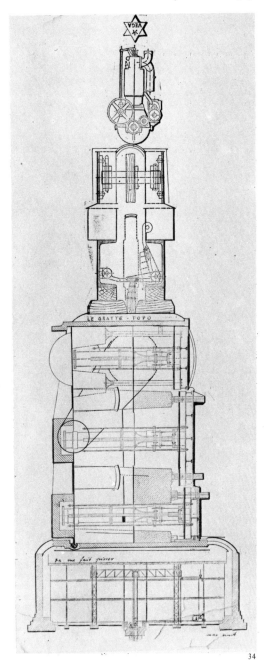

These works are the first fruits of a technique which Max Ernst developed himself. As he was waiting at the printer's for proofs of a Dada publication to be completed, he collected up line blocks which were lying around, and used them to make prints which he then filled out with ink and brush and also lettered. Each group of blocks furnished several prints which vary in arrangement and in the nature of the artist's freehand additions.

Hypertrophic Trophy was rejected in 1920 by the Parisian 'Section d'Or' group on the grounds that it was 'not made by hand'. Predictably, the element of the mechanical in its production, which Max Ernst was to use over the years in the most varied ways, met with stiff resistance. A printed note accompanying the work indicates that the line blocks were representations of stage machinery. *Farewell my Fair Land of MARIE LAUREN-CIN* is probably a reference to that artist's efforts to obtain a French visa for Max Ernst.

34

33 *The Bellowing of Savage Soldiers 1919*
34 *That Makes Me Piss 1919*

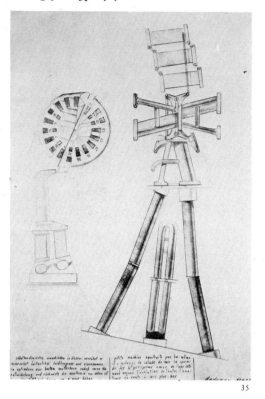

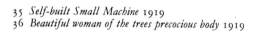

35

35 *Self-built Small Machine* 1919
36 *Beautiful woman of the trees precocious body* 1919

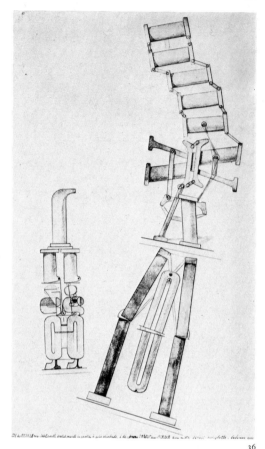

36

This series of pictures also dates from 1919: Ernst made graphite rubbings from large wooden printing type he found in a printing shop. As a foretaste of the frottages, unstable frameworks are constructed which are neither mechanical nor architectural. What matters is the procedure: a pictorial form is created with the assistance of found objects deployed in an unorthodox manner.

These pictures have none of the semantic content of Breton's *Poem-Objects*; nor can they be related to Apollinaire's visual poem arrangements (*Calligrammes*, 1918); nor again can they be regarded as quotations from reality, as in synthetic Cubism. They are ingenious games, played with a found material, and they have no weighty artistic pretensions.

Max Ernst produced about fifty such rubbings. He sent a series of them to a Dada exhibition in Berlin, and that was the last he saw of them. The exhibition in question was probably the First International Dada Fair in 1920, which lists in its catalogue several works by Max Ernst alongside others by Baader, Grosz, Hausmann, Heartfield, Picabia, Hannah Höch, Rudolf Schlichter and Schmalhausen. The greater part of the exhibition was to be shown subsequently in the USA; but it is said that the ship with its cargo of Dada productions sank. The first Cologne Dada exhibition would also have made its way to the States (at the request of Katherine Dreier) if the British occupation authorities had not withheld permission.

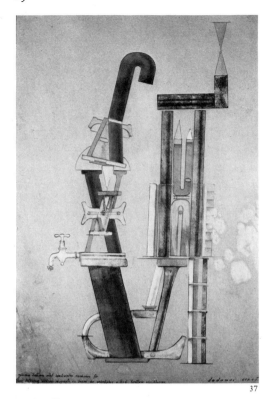

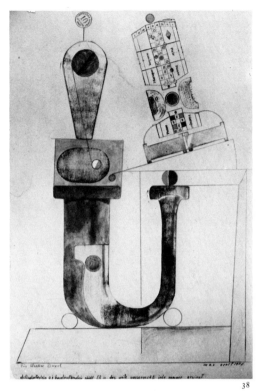

37 *Small machine constructed by Minimax Dadamax
himself* . . . 1920
38 *Chilisalpeterlein* 1920

The frottage technique, which was further
developed in 1925 for the illustrations of the
Histoire naturelle, is clearly anticipated here.
However, in these works the original is
hardly altered; by 1925 it was being changed
beyond recognition. The procedure in this
case is clearly mechanical; later it was to
become a mixture of mechanical techniques
and the creative inspiration which they set in
motion (that is, a semi-automatic method).
This applies equally to the collage element in
these pictures. Materials taken out of their
context are deliberately transmogrified to
produce a new pictorial unit. Max Ernst
draws on the alienation principle developed
by the Cubists, but has not yet attained the
plurality of meaning typical of his best work.

The Dadaists, and especially the Zurich
group, tried to steer well clear of what they
called 'art-making'. By rejecting all artistic
ideals they sought the overthrow of the
bourgeois aesthetic. Bakunin's thesis that joy
in destruction is at the same time a creative
joy is in line with the anarchy of the Dadaists,
who took the view that it was possible to
open up new horizons by standing the world
on its head. The Cologne Dadaists shared this
rejection of traditional picture-production;
and Max Ernst took as his starting-point a
mental block about artistic creativity. He
worked from negation. The new methods he
developed, which fail to meet the criteria of
conventional art, and so form part of the
protest against bourgeois ethics, take him in
search of new concepts of pictorial art; and
although these too end up as art, they express
a rejection of contemporary society, and are
therefore aesthetically and socially revolu-
tionary.

DADA

ausstellung

DADA-VORFRÜHLING

Gemälde
Skulpturen
Zeichnungen
Fluidoskeptrik
Vulgärdilettantismus

die urne des dadaisten max ernst
erfreut sich außerordent-
licher beliebt- heit wiewohl
ich mir selber die größte
mühe gebe

—— baargeld ——

(ich habe kein kissen für meine urne)

ich bin nicht mehr in der Lage meinen sattel zu sättigen baargeld

für dreigliede-
rung des dada-
istischen orga-
nismus

was die zeitungen mir vor-
werfen, ist unwahr. ich habe
noch niemals bauchdecken-
reflexe zur erhöhung der licht-
wirkung meiner bilder ver-
wendet. ich beschränke mich
lediglich auf rinozerisierte
rülpspinzetten. max ernst

— besuchen Sie DADA?
— Ich habe kein BEDÜRFNIS
— dada ist keine BEDÜRFNIS-
ANSTALT.

jeder besucher dieser ausstellung ist prädestinierter dadaist entweder
lächelt er freimütig man kann ihn sodann als edeldadaist ansprechen
oder er fällt dem irrwahn des antidadaismus anheim zu spät bemerkt
er die personalunion von metzger und opferlamm in sich er ist
dadaist schlechthin

כשר
חברה גמילות חסים
חברה אהבת רעים
חבירה הכנסת כלה
חברה גמילות חסים
כשר על פסח

ich grüße nur noch simulanten

der wecker mit schluß für
erstgebärende
von Dr. Val. SERNER läuft
mit der geburt ab
 baargeld

die liebe auf dem zweirad ist
die wahre nächstenliebe
 baargeld

dadamax ernst

Katalog

roll nicht von deiner spaule
sonst bricht dein dadasienzopf
sonst picken dir die winde
die flammen aus dem kropf

sonst fließt aus deinen röhren
der schwarze sternenfisch
und rollst mit seinen krallen
die ersigeburt vom tisch

arp "die schreibmaler"

arp

1. relief der arp ist da
2. zeichnung
3. zeichnung
 baargeld gen. zentrodada
4. antropofiler Bandwurm (relief)
5. die familie ist der ursprung der
 familie (relief)
6. der sportsmann max ernst beim training am 100 m-Ständer
7. ausgießung des urohämatins auf aufgeregte expressionisten
8. vergebliche verleumdung und inthronisierung des dada baargeld
9. dadaisten, leere gefäße und bärte spielen miteinander.
10. der bruder präses der a b k bei verrichtung der brüderlichkeit
11. inauguralgaumen und fruchtverknotungen am primärportemonnaie.
12. fluidoskeptrik der Rotzwitha von gandersheim
 max ernst (gen. dadafex maximus)
13. ein lustgreis vor gewehr schützt die museale frühlingstoilette vor
 dadaistischen eingriffen (l'état c'est MOI!) (monumentalplastik)
14. falustratra (plastik)
15. große dadaisten werfen ihren schatten voraus (plastik)
16. unerhörte drohung aus den lüften (plastik)
17. knochenmühle der gewaltlosen friseure (relief)
18. sämtliche quer- und längsschnitte (relief)
19. originallaufrelief aus der lunge eines 47jährigen rauchers
20. bitterkeit der matraze (relief)
21. noli me derigere (relief)
22. erectio sine qua non
23. 3 minuten vor dem sündenfall

24. start der expressionisten
25. der falsche archipenkolo
26. hypertrofie-trofäe
27. zwischen suppe und fisch
28—32. zeichnungen
33. lächeln sie nicht
 baargeld und max ernst
34. simultantripijchon; die dadaisten und dadaistinnen

Dr. Alsen, Louis Aragon, W. C. Arensberg, Maria
d'Arezzo, Céline Arnauld, Arp, Cansino d'Assens,
Baader, Baargeld, Alice Bailll, Pierre-Albert Birot,
André Breton, George Buchet, Gabrielle Buffet,
Marguerite Buffet, Gino Cantarelli, Carefoot, Maja
Chrusecz, Artur Cravan, Crotti, Dalman, Paul
Dermée, Mabel Dodge, Marcel Duchamp, Suzanne
Duchamp, Jaqnes Edwards, Carl Einstein, Paul
Eluard, Max Ernst, Lulllu Ernst, Germaine Everling,
J. Evola, O. Flake, Theodor Fraenkel, Augusto
Giacometti, Georges Grosz, Augusto Guallart,
Hapgood, Raoul Hausmann, F. Hardekopf, W. Heart-
field, Hilsum, R. Huelsenbeck, Vincente Huidobro,
F. Jung, J. M. Junoy, Mina Lloyd, Lloyd, Marin,
Walter Mehring, Francesco Meriano, Miss Norton
Edith Olivié, Walter Pack, Clement Pansaers,
Pharamousse, Francis Picabia, Katherine N. Rhoades
Georges Ribemont Dessaignes, Sardar, Dr. V. Serner
Philippe Soupault, Alfred Stieglitz, Igor Stravinski,
Sophie Taeuber, Tristan Tzara, Guillermo de Torre,
Edgar Varèse, Lassa de la Vega, Georg Verly,
A. Wolkowitz, Mary Wigman

verwandeln sich in blumen

picabia

35. cell rond

vulgärdilettant

36. ein tiroler (relief)
37. eine tirolerin (reliève)

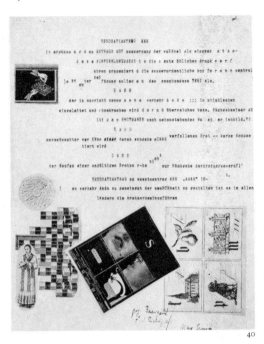

40

This typescript was read out in 1920 at the Cologne Dada exhibition. It includes a coin rubbing – the simplest form of the art of frottage, familiar as a children's game.

39 Leaflet for 'Dada-Vorfrühling' exhibition, Cologne 1920
40 Max Ernst and Johannes T. Baargeld: *Resolution* 1919–20
41 Announcement of re-opening of 'Dada-Vorfrühling' exhibition; illustrations by Max Ernst 1920

41

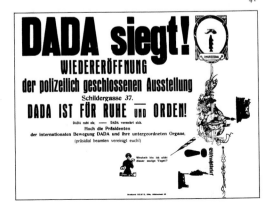

In 1919 the first sensational Cologne Dada exhibition took place. The second followed a year later under the title 'Dada-Vorfrühling' (Dada Early Spring) in the courtyard of the Brauhaus Winter, a beer hall. Max Ernst himself has described what took place: 'Entry effected through a room reserved for "Gentlemen". But a great throng none the less. Poster: "There is the beloved Dada Baargeld, there the dreaded Dadamax Ernst." Climax of the exhibition: Baargeld's *Anthropophiliac Tapeworm* and Dadamax's *Fluidosceptric of Rotzwitha von Gandersheim, Unheard-of Threats from the Skies* and *Original Running Frieze from the Lung of a Seventeen-year-old Smoker*. Those works destroyed by members of the public in fits of rage were regularly replaced by new ones. Charges of fraud, obscenity, creating a public scandal, etc., were withdrawn after police interrogation of the accused. The exhibition was closed by the police' (bib. 64).

The *Fluidosceptric* consisted of an aquarium with coloured water, out of which jutted a wooden female hand. On the bottom of the aquarium lay an alarm clock; in the water floated a lady's wig. The allegation of indecency turned out to refer to Dürer's etching *Adam and Eve*, which formed part of a composite work entitled *A Young Man of Cologne*.

While his father was writing from Brühl: 'My curse upon you. You have dishonoured our name', Breton was writing approvingly from Paris suggesting an exhibition there. The Cologne Dada demonstrations, in which the visitors were deliberately encouraged to destroy some of the works, were rather like Happenings.

It seemed impossible that conventional middle-class art should survive. In the year of the exhibition, Noske's troops marched against the revolutionary supporters of the German soviet republic; there were many dead. The Kapp-Putsch sought the establishment of a military régime. In Munich Hitler announced the programme of the National Socialist German Workers' Party.

Later, Max Ernst said, 'My works at that time did not aim to please but to raise a scream' (bib. 60).

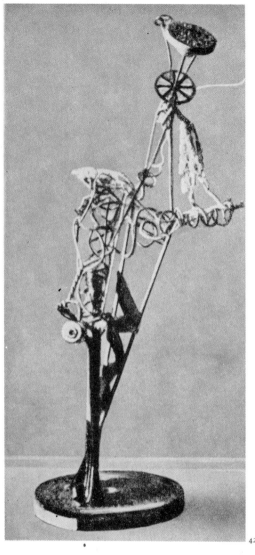

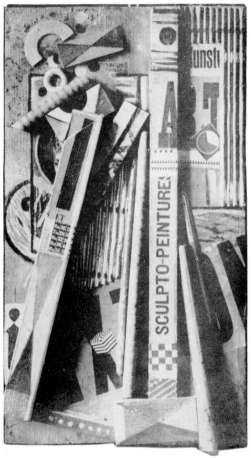

43

Like the objects in the 1920 Cologne exhibition, the *Objet dad'art* is an assemblage of found material arranged in a random fashion, far removed from all 'artistic content' or 'design'. It stands half-way between Schwitters, who consciously aims at 'art' with his collages of various materials, and Duchamp, who protests against the conventional artistic product by transferring everyday objects into a sphere which has all the associations of art.

42

As an art form, the relief of found pieces of wood and metal, arranged in a more or less random fashion, has its own brief tradition, derived from the work done by Picasso (and, independently, by Tatlin) between 1912 and 1914. The Merz reliefs of Schwitters, which are in line of succession to Arp's wood reliefs, are roughly contemporaneous with these pieces by Max Ernst. The legend *sculpto-peinture* is most likely an ironic reference to Alexander Archipenko's use of the term to describe his *Médrano* series of *c.* 1914. One of Max Ernst's pieces in the 1920 Cologne Dada exhibition bore the title *the false archipenkolo*; he was of course utterly uninterested in what Archipenko was actually trying to do.

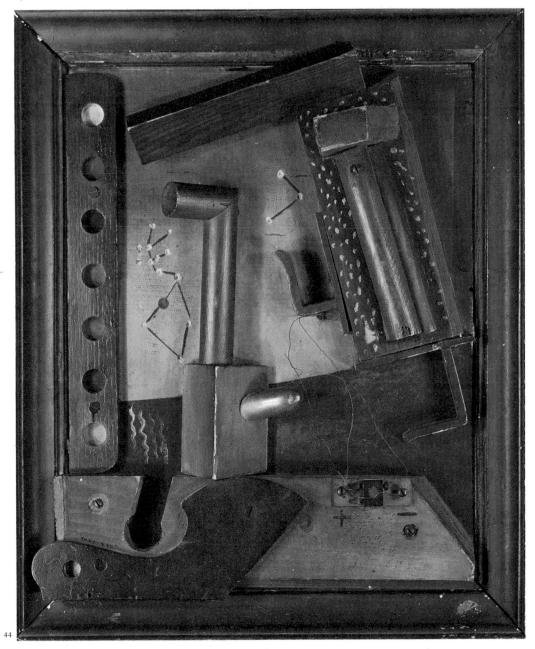

42 *Objet dad'art* 1919

43 *The Fruit of Long Experience* 1919

44 *The Fruit of Long Experience* 1919

The frame and the use of paint endow the assemblage with an ironical quality which serves as a protest against conventional painting on canvas.

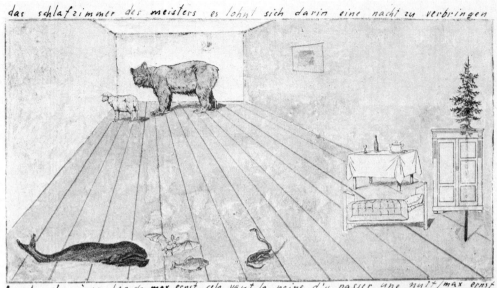

das schlafzimmer des meisters es lohnt sich darin eine nacht zu verbringen

la chambre à coucher de max ernst cela vaut la peine d'y passer une nuit/max ernst

45

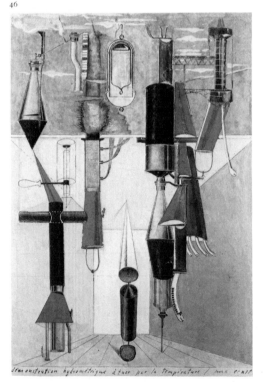

46

45 *The master's bedroom . . .* 1919
46 *Hydrometric demonstration . . .* 1920
47 *Dada in usum delphini* 1920
48 *Winter landscape: gassing of the vulcanized iron maiden to produce the necessary warmth for the bed* 1921

47

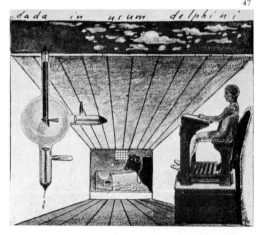

dada in usum delphini

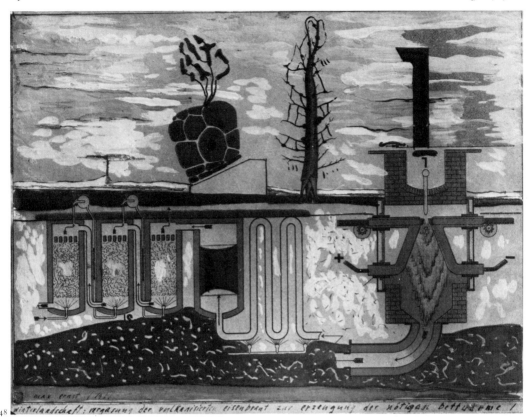

48

'What is collage? Max Ernst has defined it in the following manner: Collage technique is the systematic exploitation of the fortuitous or engineered encounter of two or more intrinsically incompatible realities on a surface which is manifestly inappropriate for the purpose – and the spark of poetry which leaps across the gap as these two realities are brought together' (bib. 64). The collage is a pictorial entity composed of disparate constituents, pasted together and possibly also worked over with brush or pen. The *papier collé*, developed by the French Cubists, was a preliminary step towards collage; it contained found pieces of wallpaper and other paper which took over the function of painting, thus serving a formal compositional objective, and which thus, despite their reference to reality, remained neutral in content. Dada expanded and modified this principle.

Around 1919–20, collages were produced in Berlin by Grosz, Hausmann, Heartfield and Höch, in Hanover by Schwitters, and in Cologne by Arp, Baargeld and Max Ernst; all were determined far more by content than form.

Whereas the early works of the Berlin Dadaists hold up a mirror to the age through a whole variety of materials presented in chaotic disarray, Max Ernst creates an artistic reflection of visual material of a technical or trivial nature (advertisements, prospectuses, diagrams, educational aids) by pasting and overpainting. Ernst is not creating a formal structure as he puts these fragments together; he is transforming an original, and so is half way between the collage proper and the 'readymade aided', for which Duchamp's *Apolinère Enameled* (1916–17), based on an advertisement for Sapolin Enamel, is the model.

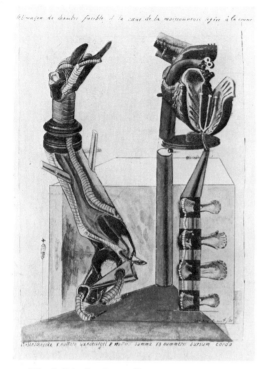

49 *The fusible chamber snail . . .* 1920

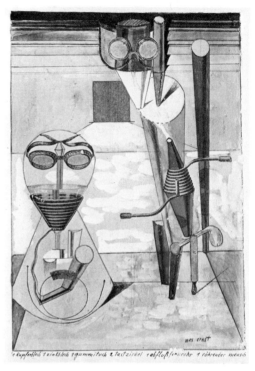

50 *1 copper plate 1 zinc plate 1 rubber cloth 2 calipers*
 1 drainpipetelescope 1 piping man 1919–20

52 *Katharina ondulata* 1920

51 *Stratified rock gift of nature composed of gneiss . . .*
 1920

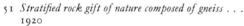

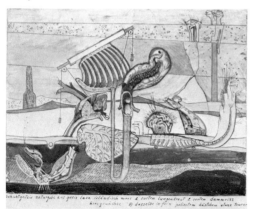

'I see advertisements of all kinds of models, mathematical, geometrical, anthropological, zoological, botanical, anatomical, mineralogical, palaeontological and so forth, elements so diverse in nature that the absurdity of bringing them together has a disorientating effect on the eye and the mind and generates hallucinations which give new and rapidly changing meanings to the objects represented. I felt my "sense of sight" suddenly so intensified that I saw the newly emerged objects appearing against a changed background. In order to hold them fast, all that was needed was a little colour or a few lines, a horizon, a desert, a sky, wooden floorboards and suchlike. And so my hallucination had been fixed' (bib. 64).

The starting-point in *The fusible chamber snail
. . .* is a technical drawing, in *Katharina
Ondulata* a piece of wallpaper. These surfaces
have been so worked over with gouache and
ink and collage elements that they are hardly
recognizable. The pictorial form which they
inspire gains a new significance through this
process of metamorphosis.

The technique of the Dada collage is sufficient evidence in itself that the Dada conception of the artist differed from that even of the Cubists. For the aim is not to reproduce on paper a *Glacial Landscape* or *Sandworm*. There is no goal at all, only a starting-point: renunciation of conventional paint on canvas, and a provocative interest in the whole sphere of reproductions, with their specific material content, associations and function. The so-called artistic process consists in the choice of an original which invites modification and thus incorporation into art. The creative procedure is therefore identical with the changes undergone by the initial material, once adopted. The process of individual artistic creation through formal invention is replaced by the principle of modification of objects taken from reality, in this case pre-existing pictorial material. In contrast to the conscious creation of an autonomous whole, the interaction between found object and artist allows chance to take a leading role. Max Ernst is at one with the Dadaists in this respect: chance, not composition, is given pride of place.

By its very nature, the collage – here as elsewhere – keeps its various levels of reality intact, without blurring or blending them through the reality of colour pervading the picture. Naturally there are as a consequence important differences of degree between the 'readymade aided', at one extreme, and the collage of wood engravings assembled according to content, at the other.

Hugo Ball, the Zurich Dadaist, defined this ambivalence, which holds good for Ernst's collages as well; these collages, despite their heterogeneity and fortuitousness, retain a pictorial character. They are art, without seeking to be art in the old-fashioned sense. 'The new art is appealing', writes Ball, 'because in a world of total disruption and chaos it has maintained the will to pictorial form; because it is directed towards forcing the image into being, however great the conflict between the different technical resources and between the component parts' (*Fragmente eines Dada-Tagebuches*, 1916–17).

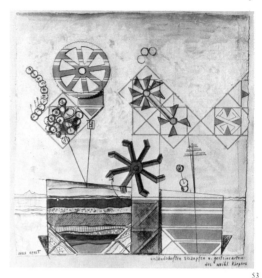

53

The titles of these collages do not in any way assist in the deciphering of their content. By means of language they achieve a distortion of meaning parallel to the pictorial distortion. Frequently appearing in two languages, they are poem-like formulations which are part of the collage itself, not – as in the case of Paul Klee – poetic variations on the pictorial theme. Like Ernst's poems, they play with words, names, concepts and associations.

53 *Glacial landscapes icicles & minerals of the f. body* 1920
54 *2 holohedra sulphate silicate picastrate . . .* 1919
55 *The Hat makes the Man* 1920
56 *The Sandworm* 1920

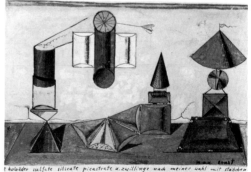

54

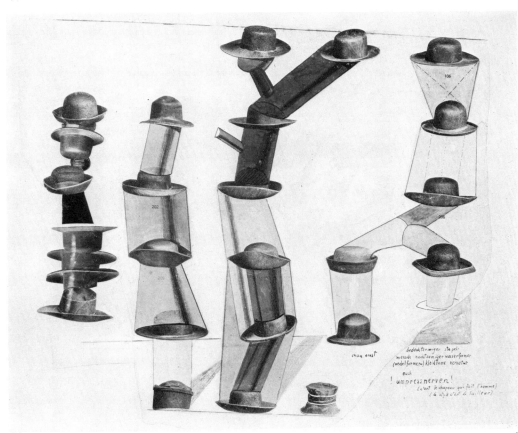

55

The *Glacial Landscapes* are based on a piece of wallpaper, the *Holohedra* on an old woodcut. *The Hat Makes the Man* is a composition from cut-out hat ads, the *Sandworm* an inverted,

heavily overpainted brochure for children's hats. At the time when he did these, Max Ernst had to take charge of his father-in-law's hat-blocking shop for a few weeks.

56

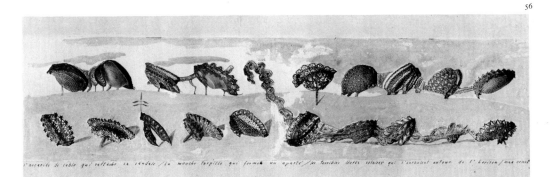

57 *Max Ernst c.* 1920

58 *Mine Hostess on the Lahn . . .* 1920

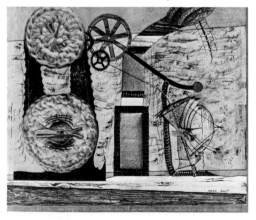

The elaborate collage painting *Design for a Manifesto*, which was clearly conceived on the occasion of an exhibition, offers a survey of the methods and motifs Max Ernst employed in his collages between 1919 and 1920. Well before his *Loplop* series of 1930–31, Max Ernst here reflects his own methods by depicting them.

The upper part is a biological drawing on which are stuck a photograph of a lady cyclist, already used in *Die Schammade*, and a photograph of his own sculpture *Objet dad'art* (ill. 42). Underneath appears a *Knitted Relief*, which was illustrated in 1921 in the Paris periodical *Littérature*, then *The Preparation of Glue from Bones*, a modified readymade (zinc printing-plate) which is reproduced in the Tyrolean Dada manifesto *Dada augrandair* (ill. 80), and whose original has been preserved. In the lower part there is a photograph of Max Ernst. On the right woollen tassels are transformed into the vast clawed feet of a sportsman. The horsemen on the left are silhouettes, of whom the foremost has characteristics similar to an early drawing (ill. 10). The figures are unpainted; their shape emerges from the surrounding forms.

Collage, modified readymade, photographs, drawings, printed and written letters: all are brought together here to make a résumé of what Max Ernst – whose portrait forms the tip of the inverted pyramid – produced in the years 1919 and 1920. For all its symmetry this collage too lacks visual harmony; heterogeneity is its chief characteristic. The observer is thrown back on to his own ability to blend the elements of the work.

What is striking is the evident fascination which all manner of reproduced material exercised on Max Ernst. In the case of this collage, the source material is not other people's illustrative material but his own works. His own modified or pasted-up reproductions of reproductions inspire him here to renewed metamorphoses. Without this reflection of a reality which is devalued to a cliché when it is reproduced, the Pop art of the 1960s would be unthinkable.

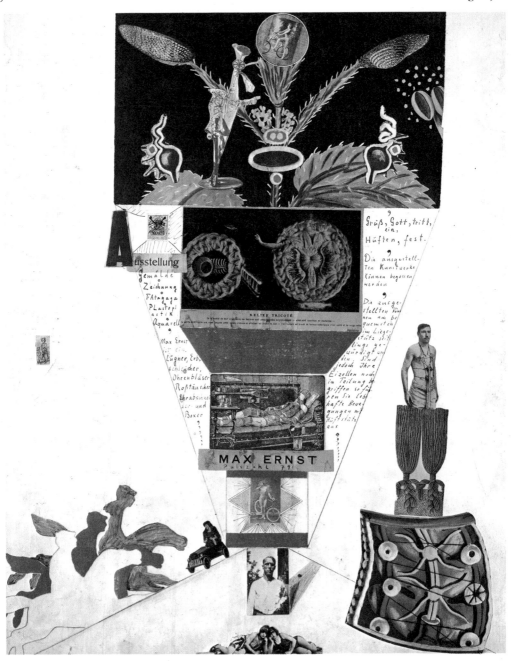

60

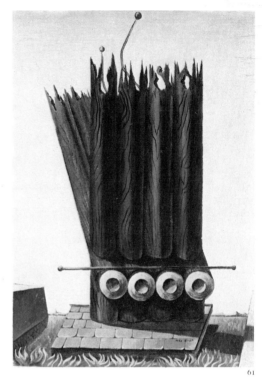

61

62

60 *The Little Tear Gland that Says Tick-Tock* 1920
61 *The Forest* 1923
62 *Forest and Sun* 1920

In his autobiography Max Ernst writes of his childhood: 'Mixed feelings, when he first went into a forest: delight and oppression. And what the Romantics called "emotion in the face of Nature". The wonderful joy of breathing freely in an open space, yet at the same time distress at being hemmed in on all sides by hostile trees. Inside and outside, free and captive, at one and the same time' (bib. 64).

This dichotomy took root in Max Ernst's mind, and was ultimately to find expression in the forest pictures of the later 1920s. It first took shape in the collages *The Little Tear Gland that Says Tick-Tock* and *Forest and Sun*, of 1920, but in these there is little trace of the oppressive psychological significance of the forest. Inspired play with materials takes precedence over specific expressive aims.

LA MISE SOUS WHISKY MARIN se fait en crème kaki et en **5 anatomies**

les dames sont priées d'apporter tous leurs bijoux

VIVE LE SPORT
AU SANS PAREIL 37 AVENUE KLÉBER PARIS 16e
du 3 mai au 3 juin 1920

VOUS N'ÊTES QUE DES ENFANTS

ENTRÉE LIBRE EXPOSITION DADA **SORTIE FACILE**
mains dans les poches MAX ERNST tableau sous le bras

dessins mécanoplastiques plasto-plastiques peintopeintures anaplastiques anatomiques antizymiques aérographiques antiphonaires arrosables et républicains.

comme un seul homme AU-DELA DE LA PEINTURE *blague dans le coin*

63

les dames sont priées d'apporter tous leurs bijoux

AU SANS PAREIL
37, AVENUE KLÉBER
PARIS 16

VOUS N'ÊTES QUE DES ENFANTS

du 3 mai au 3 juin

EXPOSITION DADA
MAX ERNST

dessins mécanoplastiques plasto-plastiques peinto-peintures anaplastiques anatomiques antizymiques aérographiques antiphonaires arrosables et républicains.

ENTRÉE LIBRE *SORTIE FACILE*
mains dans les poches tableau sous le bras

AU-DELA DE LA PEINTURE

64

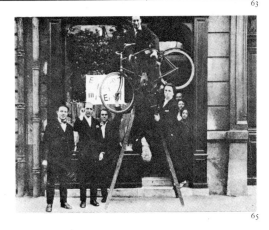

65

63 Invitation, Au Sans Pareil gallery, Paris 1920
64 Invitation, Au Sans Pareil gallery, Paris 1920
65 Opening of Max Ernst exhibition, Au Sans Pareil gallery, Paris 1920. From left to right: Hilsum, Péret, Charchoune, Soupault, Rigaut, Breton

On the occasion of the 'Dada-Vorfrühling' exhibition in Cologne in 1920, André Breton suggested that Max Ernst should exhibit in Paris. There too Dada had found its supporters, and around 1918–19 these included Breton himself, Aragon, Eluard and Soupault, i.e. the circle around the periodical *Littérature*. In 1919 Picabia arrived in Paris, where he proceeded to publicize his own periodical *391*. In 1920 Tristan Tzara, Hans Arp and Benjamin Péret joined them; and Marcel Duchamp, too, spent a little while in Paris. The first provocative Dada demonstrations took place, and in them Breton and Tzara were particularly prominent. Tzara presented works by Picabia in the Au Sans Pareil gallery. In 1921 there followed spectacular 'Dada excursions' and the Dada mock trial of the conservative writer Maurice Barrès.

Max Ernst accepted the invitation. Under the slogan 'Beyond Painting' (Au-delà de la peinture), he exhibited from May to June at Au Sans Pareil. 'Beyond Painting' does not just mean the abandonment of painting, or a movement towards sculpture or the object. The phrase also means 'Beyond Art', art in the conventional sense. The opening of the exhibition turned into a Dada demonstration. Aragon, Breton, Tzara and others shocked visitors and passers-by with an outrageous display of clowning.

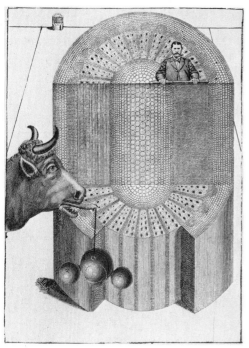

66 *The Orator* 1920

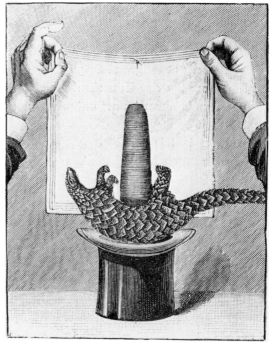

67 *Magician* 1920

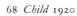

68 *Child* 1920

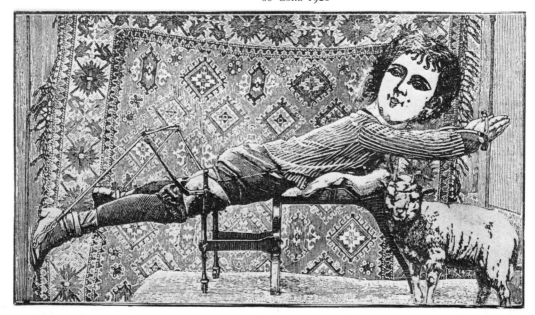

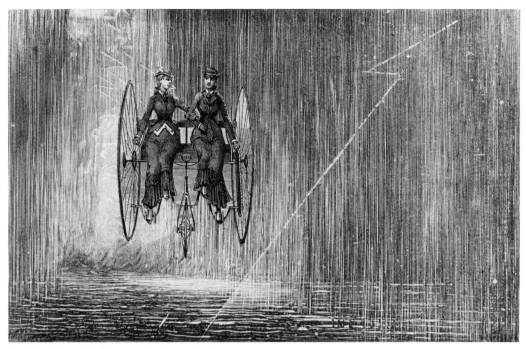

69 *Two Young Girls Promenade Across the Sky* 1920

Also around 1919–20, Ernst produced a series of collages which draw exclusively on book illustrations dating from the end of the nineteenth century. By combining elements which differ in scale, and by forcing incompatibles to coexist, Ernst takes elements which were originally designed to illustrate a whole, sound world, and uses them to demonstrate just how lacking in wholeness he considers that world to be.

In the schoolbook collages, Ernst was reacting against a bourgeois concept of art; but he was doing so in order to create art. In these collages, on the other hand, he is reacting against the whole pictorial world of his parents' generation, which he sees as documentation of that generation's mental attitudes. He demonstrates their illusory nature, destroys them, and forms new visual images which employ the same materials as evidence of the resolve of the Dada generation to break with all that is old. The creative act consists in using this fund of bizarre and trivial images to reveal the psychological ramifications of the world-view which underlies it.

The artist is thus not coming to terms with the immediate present but reaching back to the imaginative world of his parents' generation, which of course still persists in that it has left its mark on his own upbringing. The theme is the conflict of generations: Ernst demonstrates that it is not enough to mark oneself off from the old by creating something new; the artist must also reflect the old itself and unmask its hypocrisy.

About the year 1915, the Italian Futurists as well as the Russian Constructivists introduced pieces of photographs into their collages. By virtue of these mechanically reproduced fragments of reality, the photocollage with its fragmented illusionism creates an optical reflection on the content of the environment.

70

71

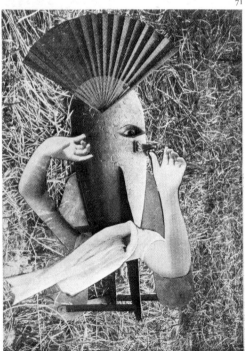

In the course of the Dadaists' anti-artistic endeavours, photography and film at times received more attention than painting. In Germany, in addition to Max Ernst, the Berlin Dadaists were leading practitioners of the photocollage around 1920. Around 1924–25, Heartfield, Moholy-Nagy and El Lissitzky independently developed the photomontage. In contrast to the photocollage this has a clear objective as a vehicle for political propaganda, information and advertisement.

For Max Ernst the photocollage was one discipline among many. Through it, he developed mysterious shapes which already anticipate Surrealism, and whose claim to reality is hinted at through the use of photography. The seemingly objective fiction of the photocollage appears to have taken the place of the subjective fiction of painting. Since the collage elements as such are difficult to distinguish from the photograph, the whole gives the impression of having turned into a photograph itself, of being something real, despite the implausibility of what is portrayed. This aspect of photocollage may well have attracted Max Ernst, as may the element of apparent anonymity, and the implicit assault on the cult of uniqueness and originality (these works were printed and published as limited editions).

In *Anatomy of a Young Bride* and *The Chinese Nightingale* the photocollage demonstrates its ability to establish a form: the first illustration anticipates *The Fair Gardener* (ill. 100), the second the Maloja stones (ill. 251). An untitled collage (ill. 75) takes up the theme of the aeroplane. *The Massacre of the Innocents* (ill. 76) can be regarded, with its upturned house façades (symbolizing destruction), fleeing figures, and aeroplane, as a reminiscence of the aerial battles of the First World War.

70 *Anatomy of a Young Bride* 1921
71 *The Chinese Nightingale* 1920
72 *Self-portrait* 1920

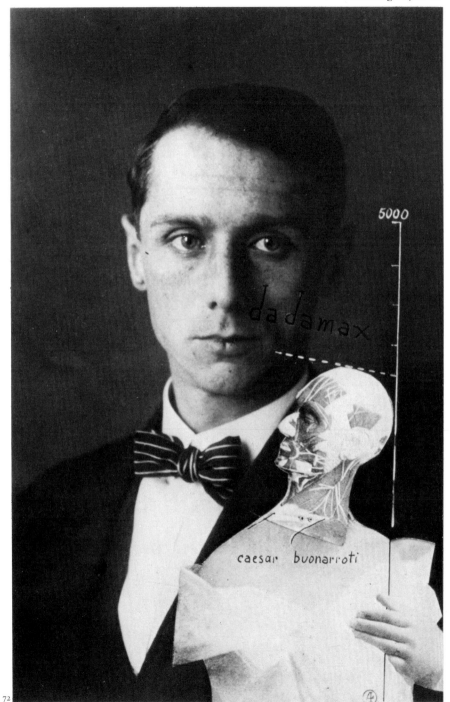

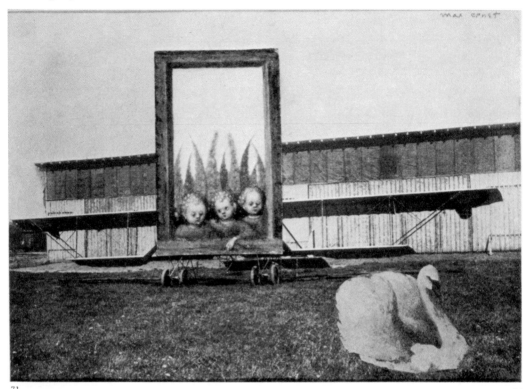

73 74

le chien qui chie le chien bien coiffé malgré les difficultés du terrain causées...

...ne neige abondante la femme à belle gorge la chanson de la chair / max ernst

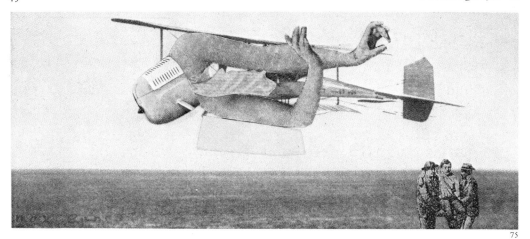

75

73 *The Swan is Very Peaceful* 1920

74 *The dog who shits . . .* 1920

75 *Untitled* 1920

76 *The Massacre of the Innocents* 1920–21

76

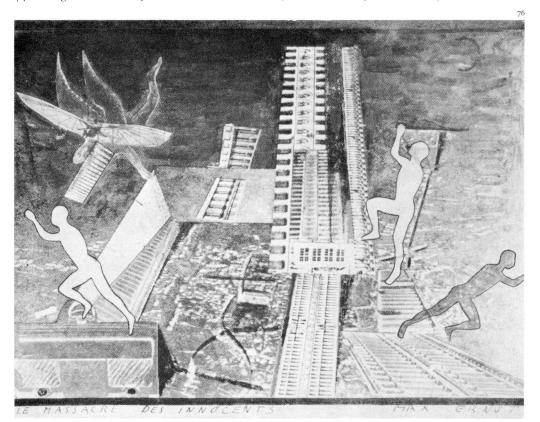

LE MASSACRE DES INNOCENTS MAX ERNST

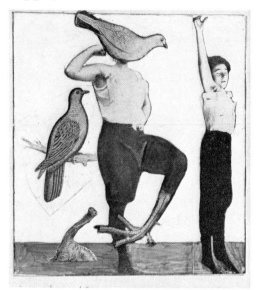

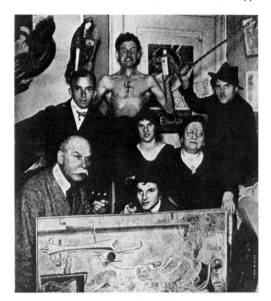

The collages which he did in collaboration with Arp under the title *Fatagaga* (acronym for 'Fabrication of pictures [*tableaux*] guaranteed gazometric') should be regarded in the context of the de-subjectivization of the artistic product; two examples are reproduced here. Arp and Ernst have pooled their abilities, but not only in order to produce the best possible result; they superimpose their personal concepts in order to obliterate the individual imprint. The collage shown above is one of the stages leading to *The Fair Gardener* (ill. 100).

77 Max Ernst and Hans Arp: *Fatagaga* 1920
78 Mutter Ey in 1919 with the painters Adalbert Trillhase, Karl Schwesig and Gert Wollheim. Foreground: large version of ill. 80

In Düsseldorf in 1919 the group of artists 'Das Junge Rheinland' was founded. The key members of the movement were Gert Wollheim, Otto Pankok and Otto Dix. Their focal point was the gallery-cum-coffee-shop of Johanna Ey, better known, archetypally, as Mutter Ey ('Mother Egg'). In the end Max Ernst became part of the movement. Mutter Ey was the first dealer to recognize the significance of Ernst; his first German exhibition took place in her gallery in 1922. On her sixty-fifth birthday in 1929, Max Ernst sent her this telegram from Paris: 'Great egg, we praise thee,/Egg, we laud thy might;/ Before thee Rhineland bends the knee,/ And buys thy inexpensive works on sight.'

When, in 1924, Ernst went to Indo-China in the wake of Paul Eluard, he sold a large number of his pictures from the Cologne and Paris periods to Mutter Ey before making off.

79 Max Ernst and Hans Arp: *Everything Here is Still in Suspense* 1920
80 'Dada Augrandair', Tarrenz 1921. Manifesto with Ernst's collage *The Preparation of Glue from Bones* 1920

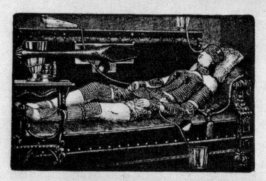

DADA
INTIROL
AUGRANDAIR
DERSÄNGERKRIEG

TARRENZ B. IMST 16 SEPTEMBRE 1886—1921 1 FR. 2 MK.
EN DEPOT AU SANS PAREIL 37 AVENUE KLÉBER PARIS

MAX ERNST: Die Leimbereitung aus Knochen
La préparation de la colle d' os

NET

Un ami de New-York nous dit qu'il connait un pickpocket littéraire; son nom est Funiguy, célèbre moraliste, dit bouillabaisse musicale avec impressions de voyage.

Tzara envoie à Breton: une boîte de souvenirs conservés dans du lait d'autruche et une larme batavique munie d'indications pour sa transformation en poudre d'abeilles. Il est attendu à Tarrenz b. Imst par le rire morganatique des plaines et des cascades.

Le titre de ce journal appartient à Maya Chrusecz.

Wir kochen geneigte Herrschaften in Parafin und hobeln sie auf.

Arp visse S. G. H. Taeuber sur le tronc d'une fleur.

Dans le catalogue du salon Dada il se trouve une erreur que nous tenons à corriger. Le tableau mécanique de **Marcel Duchamp** „Mariée" n'est pas daté de 1914, comme on voulait nous faire croire, mais de **1912.** Ce **premier tableau mécanique** a été peint à Munich.

La baronne Armada de Duldgedalzen, connue dans l'histoire sous le nom La Cruelle, a organisé devant des invités, sur ses domaines à Tarrenz, un massacre parmi les paysans des environs.

Maintenant que nous sommes mariés, mon cher Cocteau, vous me trouverez moins sympathique. En Espagne on ne couche pas avec les membres de sa famille, dirait Marie Laurenein.

Tzara envoie à Soupault: 4 baleines en éponge molle, 2 aguilles pour l'empoisonnement des arbres, un peigne perfectionné à 12 dents, un lama vivant et agité et une pomme cuite au jambon de cadavre. A Mic les salutations de son cœurouvert.

Arp envoie à Eluard: un turban d'entrailles et d'amour à 4 chambres. A Benjamin Péret: des minéraux bouillis des drapeaux de fourmilières et des postiches sur l'impériale couronnée par les putains des souris.

Funiguy a inventé le dadaïsme en 1899, le cubisme en 1870, le futurisme en 1867 et l'impressionisme en 1856. En 1867 il a rencontré Nietzsche, en 1902 il remarqua qu'il n'était que le pseudonyme de Confucius. En 1910 on lui érigea un monument sur la place de la Concorde tchéco-slovaque, car il croyait fermement dans l'existence des génies et dans les bienfaits du bonheur.

Tzara envoie à Marcel Duchamp: des bonbons d'amour trempés dans du whisky nègre et un nouveau divan turc muni de cuisses vivantes de pucelle.
A Man Ray: Une carte postale transparente avec les montagnes et le reste, et un frigorifère qui parle français à l'approche d'un magnéto.
A Marguerite Buffet: un paquet de chocolat à la boutonnière ainsi que 3 notes musicales d'une qualité tout-à-fait exceptionnelle.

Paris (16), 12 rue de Boulainvilliers.

TRISTAN TZARA

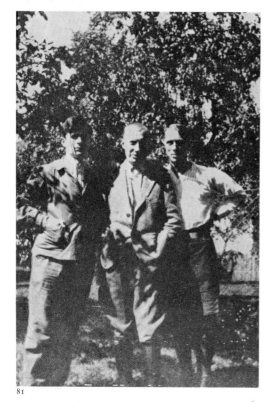

81

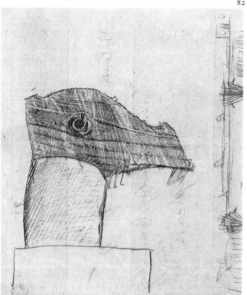

82

After Arp and Tzara had left Zurich, and Duchamp, Man Ray and Picabia had left New York – and the trend towards political activity had become dominant in Berlin – Dada lost its provocative impetus in most of its centres. Permanent negation could not be institutionalized; a new springboard was required. Of course, the famous Paris Dada excursions, and the Salon Dada at the Galerie Montaigne – where Max Ernst was one of those represented – were still going on in 1921; but Dada was becoming, on the one hand, a general outlet for the French avant-garde, and, on the other, a base for new political activities which ran counter to Dada because they worked with preconceived aims. Breton, who remained aloof from the Salon Dada, and from whose group Picabia and Tzara in turn broke off, sought to involve himself actively in politics: not Anarchism but Communism.

In 1921, Max Ernst was still living in Cologne because he could not get a visa for travel to Paris. He and his wife Luise met Hans Arp, Sophie Taeuber, Tristan Tzara and his girl-friend Maya Cruszec in the Tyrolean village of Tarrenz. There the manifesto *Dada Augrandair* (ill. 80) was conceived. Max Ernst contributed *The Preparation of Glue from Bones*, a collage consisting of an advertisement for a curative spa altered only by the addition of a countersink bit. Hindsight has given it associations with the horrors of Nazism.

It was in the Tyrol that Max Ernst produced *Animal Head on Plinth*, the first frottage to have no direct reference to the rubbed-through object; it was done on the back of a telegram.

When Breton turned up in the Tyrol, the tensions between himself and Tzara persisted. Max Ernst, having little interest in conflicts of principle, left with Arp. This was before Paul and Gala Eluard arrived. The Eluards accompanied Breton on a visit to Sigmund Freud in Vienna, and then went to see Max Ernst in Cologne. The photographs of this meeting show some of the works from the 1920 Cologne 'Dada-Vorfrühling' exhibition which have since been destroyed. The following year, 1922, found Max Ernst, Arp, Eluard and Tzara in the Tyrol again.

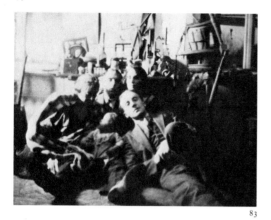

83

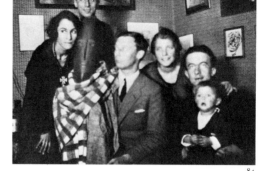

84

81 Tristan Tzara, Hans Arp and Max Ernst, Tyrol 1921
82 *Animal Head on Plinth* 1921 or 1922
83 Left to right: Luise and Max Ernst, Gala and Paul Eluard, Cologne 1921

84 Left to right: Gala Eluard, Max Ernst, J.T. Baargeld, Luise Ernst, Paul Eluard and Jimmy Ernst, Cologne 1921
85 Max Ernst and Gala and Paul Eluard, Tyrol 1922

85

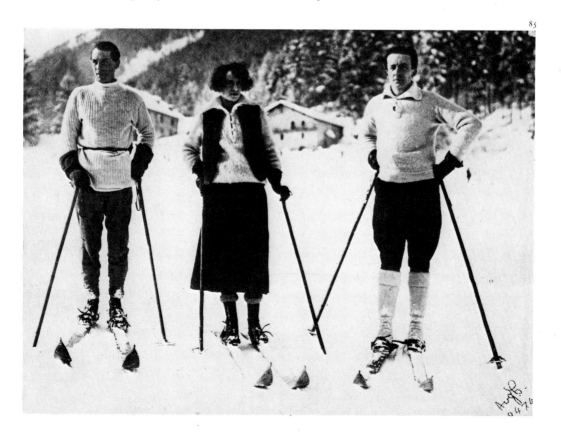

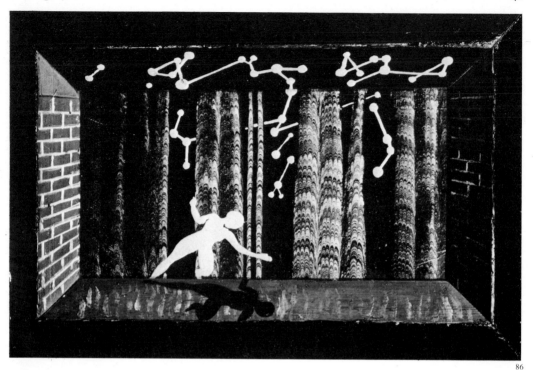

86

max ernst 87

In 1922 Max Ernst finally got his wish. He went to France, where he was to remain until the Second World War. 'Thirty years of Germany', he said later, 'were enough.'

In that year he produced, among other things, a few sketches and the strange little picture *Dancer Beneath the Sky*. The inside of the frame is painted with brickwork in perspective. A structure which looks like the marbling on old-fashioned book endpapers fills the actual picture area; against it a figure is silhouetted in white. Its shadow falls on to the lower part of the frame The two parts of the painting (picture area and frame) can be seen in terms of a stage curtain and proscenium on which a figure is moving. It might be said that Max Ernst was here defending himself against the conventional easel painting, which had suddenly begun to play a part in his work again, by altering its terms of reference.

Disparate elements are here brought together in a less complex and more acute form. The man-beast hybrid makes its appearance and transforms an idyllic interior into a demonic stage-set.

'All these works . . . experiment with those paradoxical and irrational qualities which are generally ascribed to dreams. . . . Everything is astonishing, stirring, and possible' (bib. 65).

In the same year, Fritz Lang was directing his film *Dr Mabuse*, and Murnau his *Nosferatur*, much admired by the Surrealists.

The twin starting-points of Max Ernst's expressive impulse are a search for appropriate avenues for working out in visual terms the private obsessions of his childhood, and also his understanding of the Freudian analysis of such obsessions. His relationship with an authoritarian father, the pressures of middle-class family life, are psychoanalytically interpreted, in works like that shown below.

88

86 *Dancer Beneath the Sky* (*The Sleepwalker*) 1922
87 *The Shadow* 1922
88, 89 Collages from *Les Malheurs des Immortels* Paris 1922

89

In Cologne in 1921, Eluard worked with Max Ernst on *Répétitions*. This appeared in Paris in 1922. The poems are by Eluard; Max Ernst contributed eleven collages and a frontispiece. In 1922 the two collaborated on the text of *Les Malheurs des Immortels*, accompanied by twenty-one collages by Max Ernst.

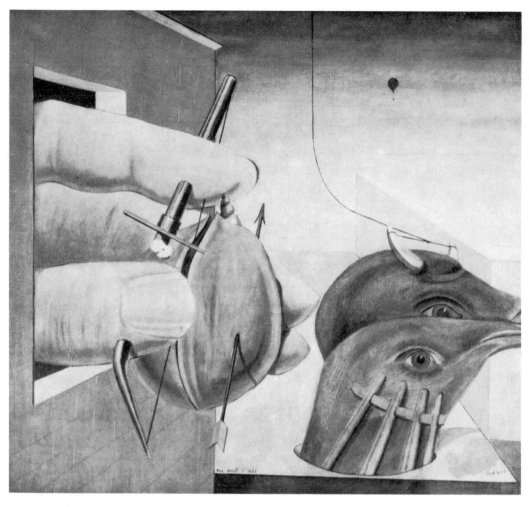

90 *Oedipus Rex* 1922

In 1921–22, when Max Ernst was still living in Cologne, he reverted to painting large-scale canvases. The layout of *Oedipus Rex* is determined by architectonic elements which are, however, arranged in such a way as to run counter to the visual expectations derived from the system of central perspective developed in the Renaissance. This verism of the improbable, later taken up by Tanguy, Dalí and Magritte, anticipates Surrealism.

The steam-age *Elephant of the Celebes*, with its bull's head, is at one and the same time powerful and impotent; the liveliness of the birds in *Oedipus Rex* is held in check by a halter – there are bull's horns here too – and by palings. Living creatures exist here in a rigid state of suspended animation. The saw leaves no trace of cut marks behind; it splits the nut, which looks like an eye, and thus anticipates the opening sequence of Buñuel's film *Un chien andalou* (1928).

When Eluard visited Max Ernst in Cologne in 1921, he bought *The Elephant of the Celebes*. It demonstrates the extent to which Ernst

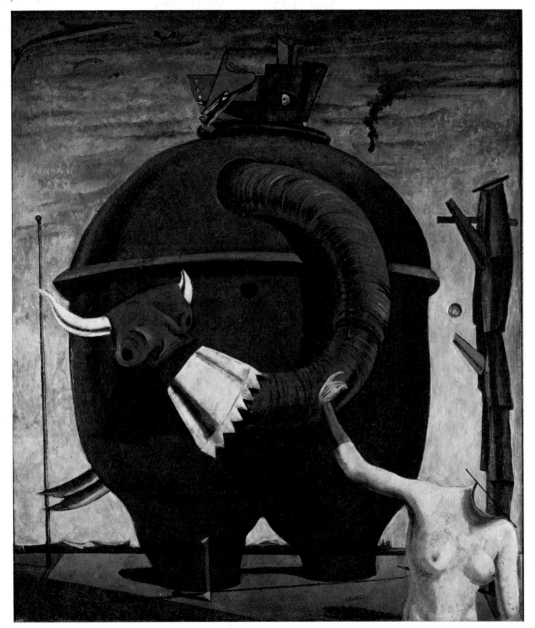

91 *The Elephant of the Celebes* 1921

too had freed himself from Dadaism. Now he was once more concerned with the creation of a total effect, although a disrupted one. As in De Chirico's metaphysical landscapes, different systems of perspective and scale are superimposed.

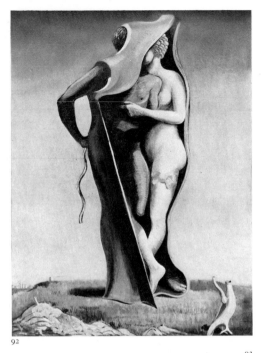

92

93

In the motif of the walled-in female figure Max Ernst is taking as his theme the Surrealist quest for the visual manifestation of the unconscious and the visionary. The figure is prevented from natural contact with the environment. The seeing eye is contrasted with the (physically blind) eye of the imagination. The fact that the masonry has eyes has a relevance to physical blindness: even he who is unable to see has his visions; and when an individual possesses the eyes of the imagination, objects have eyes to see *him*. The name of St Cecilia has overtones of *caecitas, cécité*, blindness. Max Ernst was later to say of frottage that it was a 'means of ridding oneself of one's blindness' (bib. 64). Dissatisfaction with merely optical perception leads to a search for complex possibilities of experience, in which the visible and the unconscious mingle. This interpenetration becomes a theme in its own right, which finds symbolic expression in the motif of the walled-in figure.

From 1922 to 1924 the controversy in Paris intensified. At a performance of Tzara's *Le Cœur à gaz* the Dadaists and Surrealists came to blows.

In 1922 Breton published a first definition of Surrealism, a term first used by Apollinaire in 1917: 'This word, which is not of our invention, and which we could discard as the vaguest critical jargon, is in fact used by us in a precise sense. We mean by it the definition of a psychic automatism which is closely allied to the dream state, a state whose limits are nowadays exceedingly difficult to fix' (bib. 45).

The pictures shown here date from the period between this utterance and the first Surrealist Manifesto (1924). In them the logic of the dream – probably consciously applied – takes over from the logic of waking life. Max Ernst modifies in pictorial terms what Breton, approaching from literature, elevates to a theoretical dogma.

92 *Long Live Love* 1923
93 *Niceland (Pays sage)* 1923

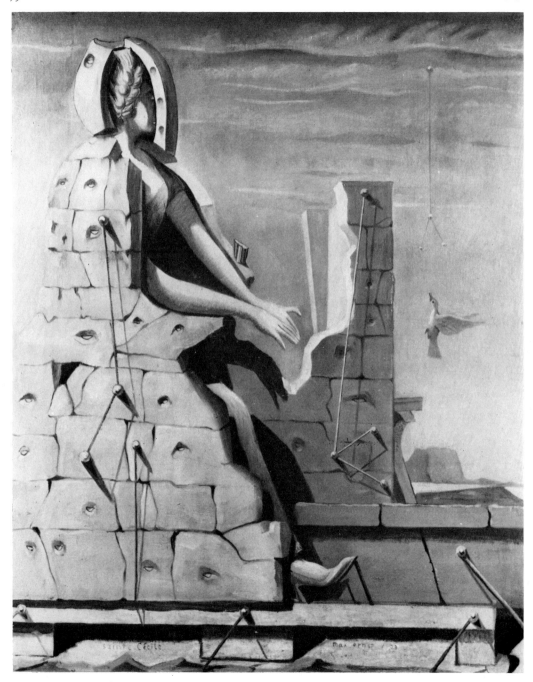

94 *St Cecilia (The Invisible Piano)* 1923

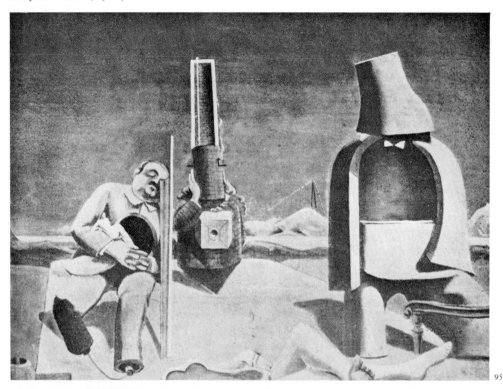

95

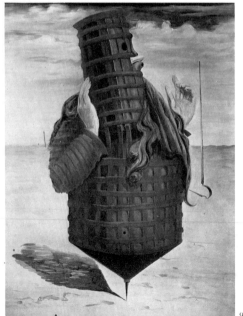

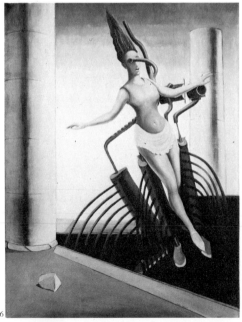

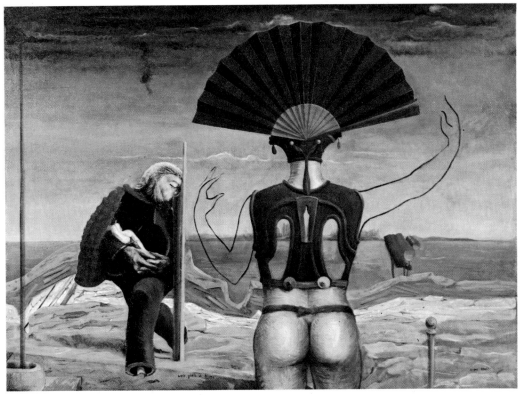

98

In 1923 Max Ernst painted the first version of *Woman, Old Man & Flower*, which depicted three variations on a human figure in a state of trance, one of them clearly derived from De Chirico (see also ill. 99). In the overpainted second version only the old man remains; a partly transparent figure in rear view has been added to the foreground.

The old man is a broken pot with a weird head, large hands and no feet; his eyes are shut, and this shut-off state (blindness) recurs in *St Cecilia* (ill. 94). The introversion of the old man is set in contrast to the openness of the youthful figure.

The figure in *Ubu Imperator* (the title refers to the protagonist of Jarry's dramas) is a spinning top with arms; all it can do is turn on its own axis. *An Equivocal Woman* wobbles, more doll than woman, on a system of pipes in a bare architectonic landscape.

These rigid figures have no will, no life spirit; they are exposed, defenceless. Eyeless, they inhabit an unreal half-world; they seem to belong to bad dreams, and yet Max Ernst is by no means a painter of dreams. Working along intellectual lines, he develops artificial worlds of images which are as instinct with knowledge of the human condition, and as abstract in formulation, as the texts of James Joyce and Samuel Beckett.

95 *Woman, Old Man & Flower I* 1923
96 *Ubu Imperator* 1924
97 *Teetering Woman* (*An Equivocal Woman*) 1923
98 *Woman, Old Man & Flower II* 1923

'The Surreal', wrote Breton in 1929 in his foreword to Max Ernst's 'collage novel' *La Femme 100 têtes*, 'is that function of our will which enables us to alienate everything from itself.' Theodor W. Adorno wrote later: 'The Surrealist gathers up those things denied to man by material reality' (bib. 1). As a successor to Dada, Surrealism reacts against the scientifically measurable world, a world without mystery, hallmarked by the intellect – and thus, from this point of view constitutes a withdrawal into the self. Sigmund Freud, not Albert Einstein, is the idol.

Max Ernst's pictures from this period should not, however, be interpreted as reflections of subjective secrets of the inturned psyche. In the fusion of diverse stylistic and thematic levels, in the 'alienation' of perceptible objects, the unconscious is raised by means of exemplary instances to the level of consciousness. Psychic tensions form the principal themes of these pictures.

In the *Pietà* Max Ernst takes up the iconographic theme of the Virgin Mary cradling the dead Christ in her lap. Here a paternal figure, derived from De Chirico's *Brain of a Child* (1914, at that time in Breton's possession; see also ill. 95) cradles a youth. The latter's greyness shows him to be a statue – in this he parallels the father figure in De Chirico's *The Return* (1918). The subtitle *Revolution by Night* is probably an allusion to Max Ernst's obsession with his own siring. The father in the picture has given life to the youth, just as Mary has to Jesus. Mary seeks to temper the sufferings of her son through love, although she does not understand them; but this father takes over from her only the gesture of protection. He is holding a dummy; there is no inner bond between father and son. In his father's arms the son is as cold as a statue.

Here Max Ernst is giving expression to one of his basic emotional concerns – and clearly doing so quite consciously. Not only the figure of the father, but also the spatial displacements, the outlined figure with the bandaged head, and the veristic mode of painting, call De Chirico to mind; but the psychological implications are characteristic of Max Ernst.

Scepticism, irony, doubt: the states of mind which characterize Max Ernst's work are intellectual ones. It was inevitable that his attitude to the doctrinaire Surrealism of the Breton sect should reflect critical awareness, detachment, and sometimes total disagreement.

The formula to which Breton had made his comrades-in-arms swear appears in the first Surrealist Manifesto (1924) as a definition: 'SURREALISM, n. Pure psychic automatism, by which an attempt is made to express, either verbally or in writing, or in any other manner, the true functioning of thought. Dictation by thought, totally outside the control of reason, beyond all aesthetic or ethical considerations. . . . Surrealism rests on a belief in the higher reality of certain neglected forms of association, in the omnipotence of dream, in the disinterested play of thought. It tends to destroy the other psychic mechanisms and to substitute itself for them in the solution of life's principal problems.'

Max Ernst was unable to associate himself with these normative claims, and it is not to be wondered at that in 1969 this man who for decades was held to be one of the 'genuine' Surrealists expressed this view: 'I admit . . . that I have kept a certain distance between myself and the experiments and doctrines of the Surrealists.' There could be no other way: in the last analysis, a 'certain distance' is characteristic of both his life and his work.

Max Ernst sets his own dialectic of semi-automatic technique and rational control – inspiration and intellect – against the pure psychic automatism demanded by Breton. For Max Ernst the picture is a 'found object' from the subconscious, from which he distances himself in the course of the creative process. He deliberately pours scorn on the 'fairytale of the creativity of the artist'. He is a controller, not a creator.

Max Ernst stands aloof from indoctrination, establishing instead his own brand of extended Surrealism which is both sensitive and intellectual, not in manifestos, demonstrations or through the written word, but through his work, expressed in a series of constant reformulations.

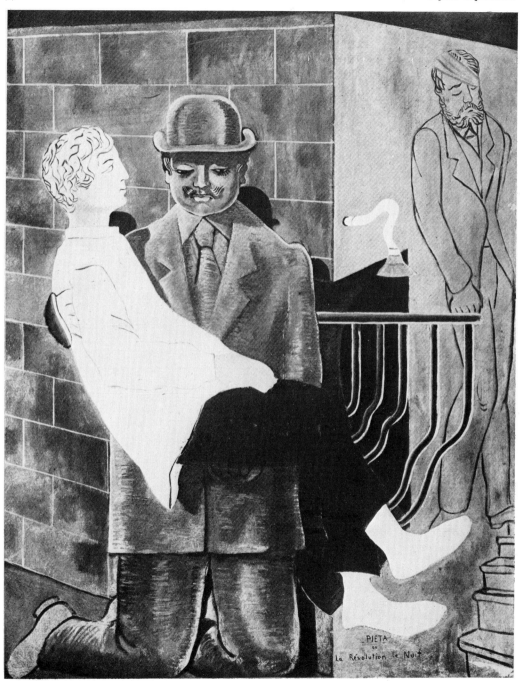

99 *Pietà, or Revolution by Night* 1923

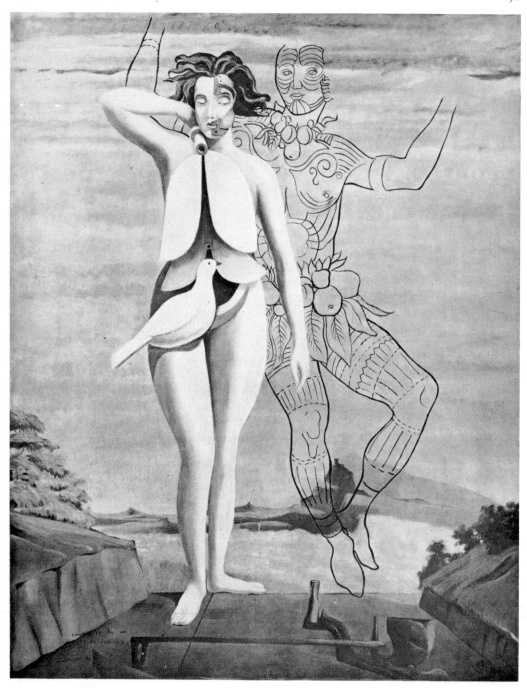

The figure of *The Fair Gardener* (*La Belle Jardinière*), whose name alludes on the one hand to the Parisian store of the same name and on the other to the Madonna (1507) by Raphael in the Louvre, has an early prototype in *Anatomy of a Young Bride* (ill. 70). In 1922 he had sent a collage with the same subject to the Weimar Bauhaus at their request for inclusion in a Bauhaus portfolio; his suggestion that photographic reproductions of the collage should be sold was turned down by the Bauhaus on the grounds that they would not be 'original works of graphic art'.

The picture bears the handwritten title *The Creation of Eve or The Fair Gardener*; with the dove (Annunciation) and the open womb, it probably constitutes an erotically interpreted variation on the Biblical theme of creation. It was exhibited in the 1924 Salon des Indépendants in Paris, remained with Mutter Ey in Düsseldorf when Max Ernst travelled to Saigon, and in 1929 was taken in exchange by the Düsseldorf Kunstmuseum for the picture *Long Live Love* (ill. 92) which had been deposited there. It was seized in 1937 by the Nazis, and displayed under a sign reading 'Insult to German Womanhood' in the touring exhibition of 'Degenerate Art' ('Entartete Kunst') which opened in Munich. Thereafter the picture disappeared. It is possible that it was stored, along with all those works of art adjudged to be 'still saleable', at Schloss Niederschönhausen, and later handed over to one of the depots for 'degenerate art'.

Max Ernst could never reconcile himself to the loss of this picture. 'That the Nazis destroyed *The Fair Gardener* continued to infuriate me to such a pitch that I could finally no longer resist the temptation to make a new version' (bib. 42). This he did in 1967, under the title *The Return of The Fair Gardener* (ill. 102). The surreal landscape of the first version, like a compilation of quotes from many sources, has given way to a neutral suggestion of a landscape. The juxtaposition of a three-dimensional painted figure and a drawn one remains.

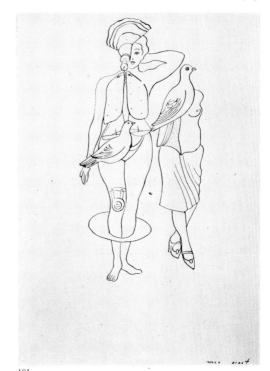

101

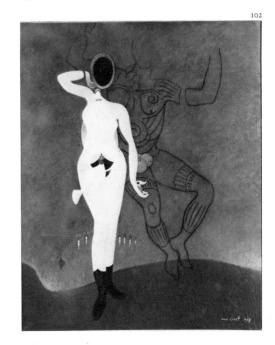

102

101 *The Fair Gardener 1923*
102 *Return of the Fair Gardener 1967*

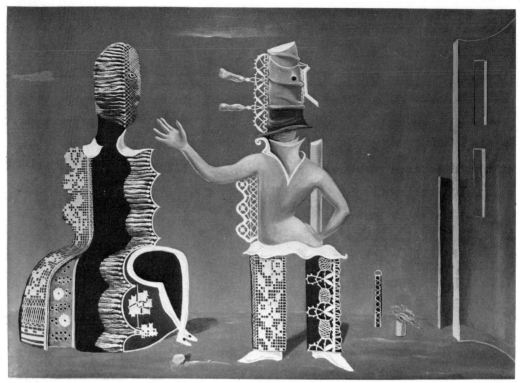

103 *The Couple* 1923

Shortly before the Surrealist movement defined itself in 1924 with Breton's first Surrealist Manifesto, Max Ernst, for ever in search of new means of expression, gave up the veristic painting of personality analysis based on De Chirico. A series of experiments form the transition to the frottages of 1925.

In *The Couple* the collage technique is applied to painting; the application of lace and crochet patterns, scarcely appropriate to the subject, gives the picture its element of surprise. *Of this Men Shall Know Nothing*, dedicated to Breton, contains an irrational element unusual in Max Ernst. The poem-like inscription on the back of the picture interprets the starscape: the soaring nude and the moon symbolize the female sex, the giblets on the ground and the heavenly bodies directed towards them symbolize the male sex.

The inscription on the other side of *Of this Men Shall Know Nothing* runs:

'The sickle moon (yellow and parachute-like) prevents the little pipe from falling to the ground. Because it is being treated with respect, the pipe thinks that it is rising up to the sun.

'The sun is split into two, the better to revolve.

'The model is stretched out in a dreamy pose. The right leg is bent forward (a precise and pleasing movement).

'The hand shields the Earth. This movement endows the Earth with the significance of a sexual organ.

'The moon goes at great speed through its phases and eclipses.

'The picture is unusual in its symmetry. The two sexes maintain each other in a state of balance.'

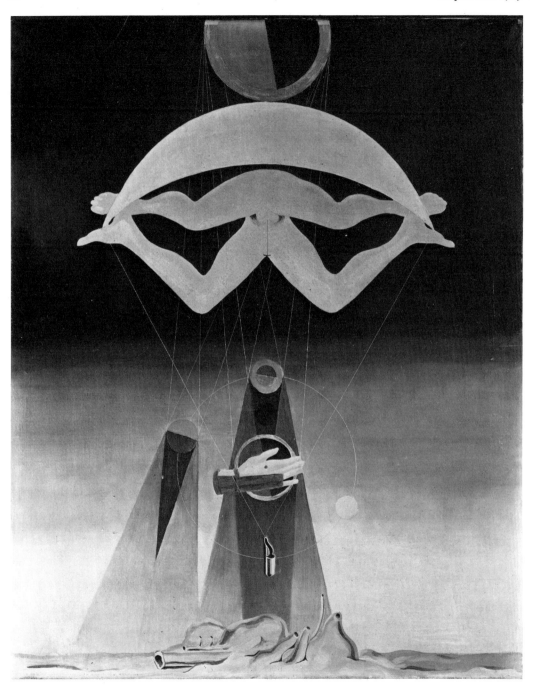

104 *Of this Men Shall Know Nothing* 1923

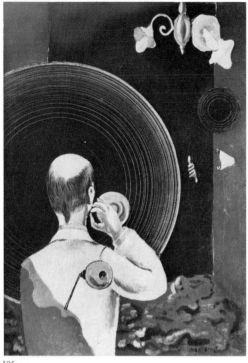

105

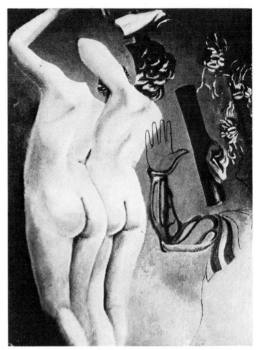

106

107

The details of the works of this period may be realistic; but seen as a whole each of them contains many unexplained discontinuities. As late as 1922, in *The Blue Monkey*, there had at least been some suggestion of a continuity running through the whole picture; there is in many of the works of 1923–24 (ill. 105–06) the addition of fragments of bodies and objects, obscure in their appearance, which cannot be brought together into a decipherable unity. The collage-like use of juxtaposition is replaced in *The Couple* by an impulsive application of colour, a kind of painting which in its anatomical deformations ventures close to Expressionism. But the emotional identification between will and execution, the unreflective outpouring of art, does not interest Max Ernst.

105 *Untitled* 1923
106 *Two Young Girls in Beautiful Poses* 1924
107 *The Blue Monkey* 1922
108 *The Couple* 1924

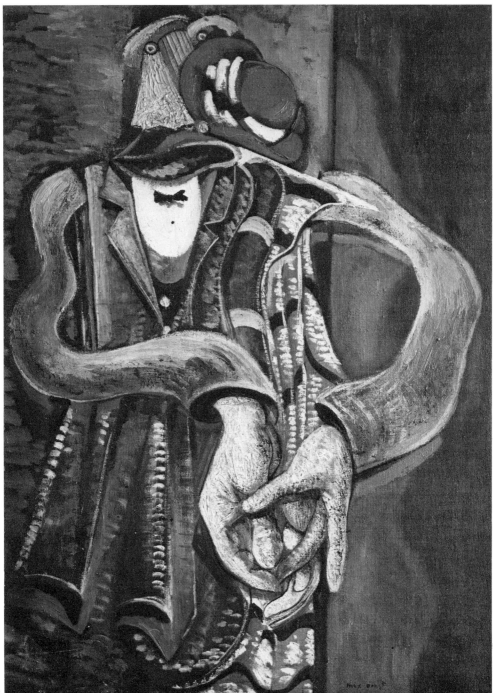

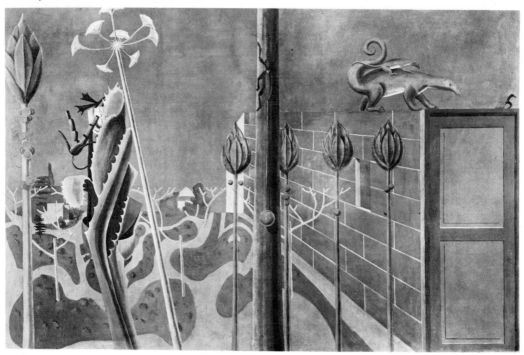

In 1923–24 Max Ernst was living with Paul and Gala Eluard at Saint-Brice and Eaubonne. A photograph from this period shows him together with Gala and her daughter Cécile in the house at Eaubonne. A painting by De Chirico (*Troubadour*, 1917), is hanging on the wall, and the door is covered from top to bottom with painting. This decoration is part of a cycle of paintings which ran through the whole house, done by Max Ernst in 1923. Partly papered over, partly painted out when the building changed hands, the paintings were forgotten for years. Not until 1967 did Cécile Eluard take charge of their uncovering. The colours are extremely well preserved. In a continuation of Renaissance and Baroque tradition, walls and doors are covered with fantastic figures, plants and animals. An unreal world, in which natural size-relationships have no part, is revealed in monumental paintings filled with gaiety and poetry.

In contrast to the decorative paintings in Baroque palaces, there is, according to Max Ernst's own statements, no consistent overall plan. He painted his way round this house for sheer pleasure – just as he was later to decorate all the houses he lived in. The representation of two butterfly wings on a double door has been lost, because they had been covered with oil paint and were therefore not able to be saved. The opening and closing of the doors gave the illusion of the movements of a butterfly.

Both the large-scale landscapes and the small friezes for Cécile Eluard (ill. 112–14) call to mind the imaginative world of the murals at Pompeii. Fear and oppression exist only on the outer limits of this realm of fantasy. The figures make up the liberated population of Arcadian landscapes. The erotic implications should not be overlooked; emblematically concise, they can be seen with particular clarity in *At the First Clear Word* (ill. 115), whose motifs, according to Werner Spies (bib. 57), have been taken from Freud's analysis of W. Jensen's story *Gravida*.

109 *Histoire naturelle* 1923

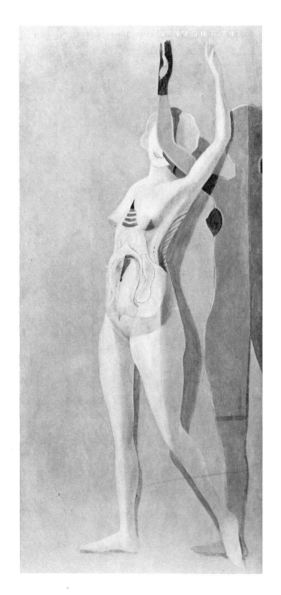

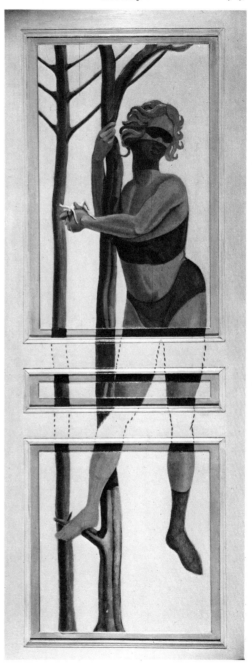

110 *Reality Must Not Be Seen as I Am* 1923

111 *Enter, Leave* 1923

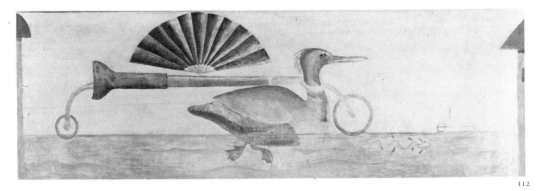

112

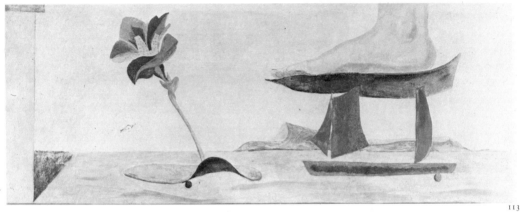

113

112 *There Are No More True Hydrocycles* 1923
113 *Friendly Advice* 1923

114 *The Birds Cannot Vanish* 1923
115 *At the First Clear Word* 1923

114

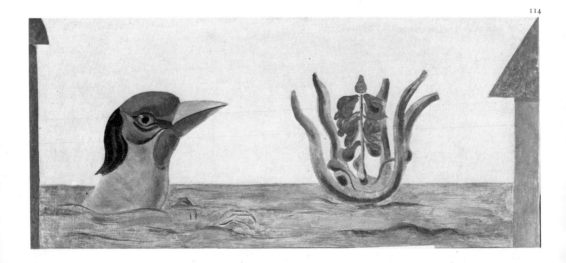

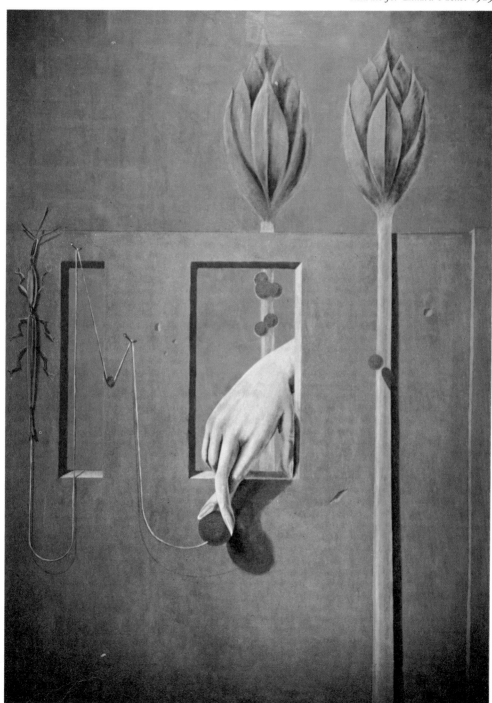

2 enfants sont menaces par un rossignol /M.ernst

This is a specimen of the proto-Surrealist phase in Max Ernst's work. Like *Dancer Beneath the Sky* (ill. 86) and *Dadaville*, it makes use of real objects, including the frame itself, in order to mock the illusionism of conventional painting.

The incorporation of language and script in a picture was something that attracted Max Ernst, not in the way that it did the French Cubists, but rather in the context of Filippo Tommaso Marinetti's Futurist *parole in libertà* (1912–13) and Apollinaire's *calligrammes* (1918), in which letters and words form part of the picture itself; this is the origin of concrete poetry. The superimposition of text and picture is also to be found in Paul Klee at this period; and André Breton's *Poem-Objects* have a special position among the numerous later variations. In the picture poems by Max Ernst the spatial and perspectival arrangement of the lettering confuses the perception of the positioning of the objects.

The cork relief *Dadaville* relates to the Dada period and its experiments with materials; at the same time it takes up the forest motif once more, by transforming a microstructure (cork) into a macrostructure (forest).

116 *Two Children are Threatened by a Nightingale* 1924
118 *Dadaville* 1923–24

117 *Who is this . . .* 1924

119 *Picture Poem* 1923

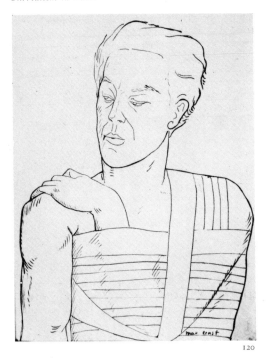

120

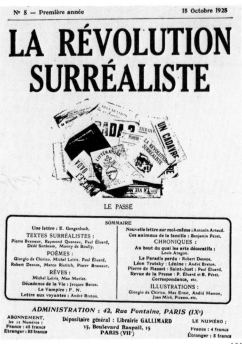

121

From the outset Surrealism – like Dada – was a literary movement, numbering Aragon, Breton, Eluard, Soupault, René Crevel, Robert Desnos and Benjamin Péret among its adherents. Although André Masson and Joan Miró were close to the Surrealists from 1923–24 onwards, and Max Ernst had been one of them from the beginning, painting found no place in their theoretical programmes. Furthermore, none of the painters fulfilled Breton's demands for the psychic and automatic representation of dream states; although Ernst, Masson and later Tanguy did produce automatic drawings.

In 1924 the growing political commitment of some groups of artists became more evident. The former Dadaists Grosz and Heartfield joined Schlichter and Piscator in Berlin to found the Rote Gruppe (Red Group), a league of Communist artists. Marinetti, leader of the Italian Futurists, published a tract, *Futurismo e Fascismo*, which documented his perversion of Futurism to political ends. Until 1929, Pierre Naville and Benjamin Péret edited a periodical called *La Révolution surréaliste*; and from Breton's 1924 Manifesto onwards, Communist leanings were evident among the doctrinaire Paris Surrealists.

122

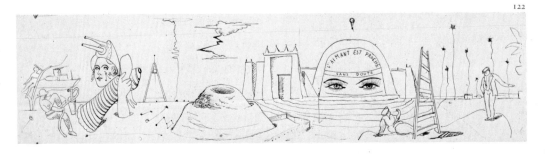

As early as 1922 Max Ernst had depicted his Surrealist friends, with their idols and pseudo-idols, in a composition freely adapted from Raphael's *Disputà* (*c.* 1509), and under the influence of the deaf-and-dumb language that he had been taught by his father.

This painting, which lies 'midway between visionary landscape and fairground cut-out photograph' (John Russell), belongs to the tradition of group portraits of like-minded friends which had persisted since the Renaissance. Although Arp and Baargeld still make an appearance, the Paris Dadaists Picabia and Tzara are already missing. By 1924 the situation had crystallized: Dada is dead, long live Breton's Surrealism, to whose members this pictorial monument is erected.

120 André Breton 1923
121 Title-page for *La Révolution surréaliste* 1925
122 *Automatic Writing Lesson* 1924

As on the old Dutch group portraits, a key explains who is who. Breton (13), as head of the movement, is given the biggest head. De Chirico (15) appears in the form of a statue (cf. ill. 99); Max Ernst (4) sits on Dostoyevsky's lap. According to John Russell, Crevel is playing an invisible piano; the pose is certainly that of St Cecilia (ill. 94), but he is really operating a slot machine with figures of footballers. Also among those represented are Raphael (7), Eluard (9) and Aragon (12).

In spite of having documented Surrealism with this programmatic picture, Max Ernst held aloof from all its demonstrations. He was out of town when, in 1924, there appeared the periodical *La Révolution surréaliste* and the first Surrealist Manifesto. In the Manifesto Breton lists those who have identified themselves with his views; and Max Ernst's name is missing. Nonetheless, he still took part in the first Surrealist exhibition in 1925 at the Galerie Pierre in Paris.

123 *All Friends Together* 1922

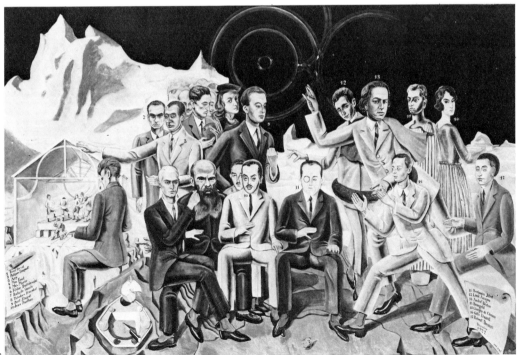

123

124 *Skimming Along the Walls* 1925

125 *Caesar's Palette* 1925

After 1924, only a few of Max Ernst's pictures were painted in the traditional sense with the brush. As early as 1925, a year after the establishment of Surrealism, he cultivated the frottage, which he had employed sporadically since 1919. He decided that from now on his possibilities of giving visible shape to his visions would lie 'beyond painting'; the visions in themselves are stimulated by material and technique; that is, they are not simply to be understood as the subjective productions of a meditative seer. He opposes the psychic automatism demanded by Breton with his own dialectic of semi-automatic technique (frottage) and 'control through reason'. For him the picture is a 'found object' from the subconscious, from which he distances himself in the course of the creative process by means of a process of conscious manipulation.

Max Ernst has depicted the 'mechanism of poetic inspiration' in his tongue-in-cheek account of the invention of frottage. In August 1925, staying at a seaside inn at Pornic, on the Atlantic coast of France, he found himself compulsively staring at the floorboards. 'In order to encourage my meditative and hallucinatory powers, I made a series of drawings from these floorboards, by placing sheets of paper on them at random, then rubbing them with a black pencil. When I looked closely at the drawings thus obtained . . . I was overcome by a sudden intensification of my visionary faculties' (bib. 35).

126 *The Origin of the Clock* 1925

127 *Leaf Customs* 1925

When Max Ernst was at Pornic in August 1925, he was afraid of trouble with the authorities, because he had made a rare exception and been one of the signatories of a Surrealist manifesto against a French imperialist war in Morocco.

Thirty-four of the frottages made at Pornic appeared a year later in an edition of 306 copies in Paris under the title *Histoire naturelle*. A series of further works was put together by Paul Eluard to form a private collection. A substantially expanded version of *Histoire naturelle* appeared in Cologne in 1965.

'Frottage is nothing other than a technical means of intensifying the hallucinatory faculties of the spirit in such a way that "visions" automatically appear, a means of ridding oneself of one's blindness' (bib. 64).

The frottage, whose development according to Max Ernst's own words was substantially furthered by Breton's ideas, although it does not fulfil his demands, owes its existence to the interaction between the structure of the rubbed object and the creative imagination stimulated by this structure.

The structure, sometimes identifiable, sometimes rendered unrecognizable, establishes new images, plants, animals, which in their origins have nothing to do with the rubbed object. Only at the beginning of the series is the structure identical with a representation (that of wood, ill. 124).

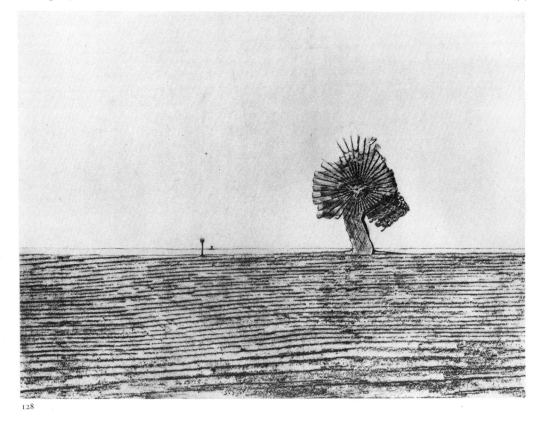

128

129

What distinguishes these 1925 frottages from earlier experiments with rubbing is that as a rule there is no representation or imitation; in the creative process new visual forms, relationships and associations emerge which, for all their unreality, become tangible and credible. The motifs emerge of their own accord.

It is the technique that brings about the magical qualities of the eye frottages, in which the frottage principle is itself the theme; it makes the artist a seer.

128 *The Pampas* 1925
129 *The Sea and the Rain* 1925
130 *The Escaper* 1925
131 *The Wheel of Light* 1925

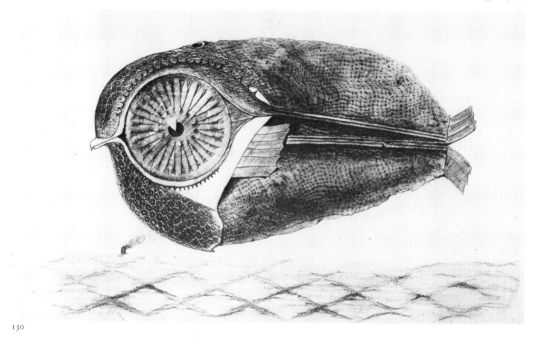

130

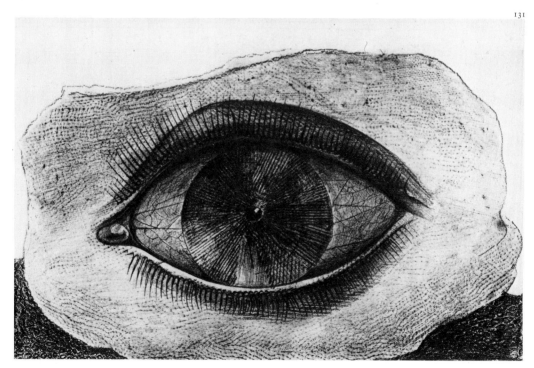

Max Ernst's 1925 frottages form a unique cycle of works. Broken off shortly after, essentially without influence on their successors, they document a blend characteristic of Max Ernst: artistic technique; the form-creating imagination which is stimulated by technique; and the 'alienation' or estrangement of the original material from itself, the neutralization of our habitual reactions to it.

The synthesis of semi-automatic production and rational control results in that 'stimulated, supervised automatism' (Werner Spies), whose clear-cut production process and artistic results are so suggestive in their effect.

132 *Head* 1925
133 *Between Walls Flowers Grow* 1925
134 *Teenage Lightning* 1925

134

132

133

135 *Fish* 1925

136 *Fields of Honour. Floods, Seismic Plants* 1925

The principle, inherent in frottage, of causing a microstructure to appear as a macrostructure, appears very frequently in Max Ernst's work (not least among the decalcomanias of the period around 1940; see p. 164). A rubbing, initially a direct impression, is taken out of its context and gains a different role inside a new pictorial framework formed by

137 *The Stable of the Sphinx* 1925

bringing different kinds of structure together. What was originally wood grain now looks like a slatted surface; that is, the direct (1:1) imprint now has the appearance of a reduced version of much larger objects.

Around 1924–25 appeared a series of still-life pictures closely linked in technique with the pencil frottages. In these still-lifes Max Ernst confronts the positive image of a fruit with its negative image or the negative image of another fruit. What is painted appears as plastic and positive; the rubbing appears as an impression, a shadow, a flat negative. Thus he highlights the dialectic of presence and absence.

Since 1912 an inclination towards unpainted and negative forms has been evident in Max Ernst's work (ill. 10). Absence can also be relevant in the content of a picture. *St Cecilia* (ill. 94) plays on the organ, her iconographic trade-mark; but the keyboard is not there, as the subtitle points out.

138 *Still-life* 1925

139 *Visible Apple* 1924

140 *Two Grapes* 1924

141 *More Lovelorn than Living* 1925
143 *Caged Bird* 1925

142 *Caged Bird* 1925
144 *The Dove was Right* 1926

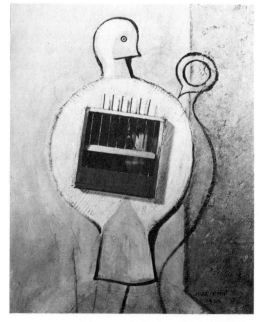

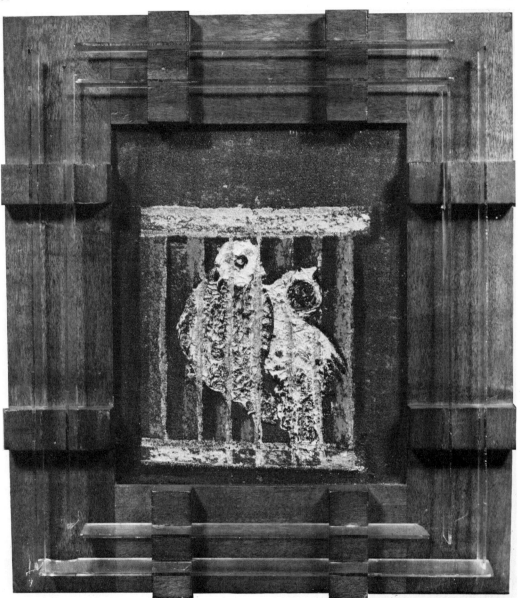

145 *Labyrinth* 1924

The old fondness for the bird motif once more breaks through here. Basically regarded as a symbol of love and death, it stands here for unrequited love.

The cage prevents the free spreading of wings. From now on Max Ernst was to be occupied in pictorial terms with the obsessions deriving from his childhood.

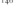
146

148

147

The pictures of women, dating from 1925–26, are characterized by a very delicate gradation of pastel tones. These figures form a pleasant contrast to the *Angst* and perturbation of the many other motifs used in the period 1925–30. Standing out from the ground, which is either a frottage or left indeterminate, the figures appear richly clad and yet lacking in any physical presence. There is, as usual with Max Ernst, no working-out of facial details.

It was in 1926 that Max Ernst had his first major one-man exhibition, at the Galerie Van Leer in Paris.

146 *Desert Flower* 1925
147 *Figure* 1926
148 *Two Naked Girls* 1926
149 *Two Sisters* 1926

150 *100,000 Doves* 1925

151 *Red Birds* 1925

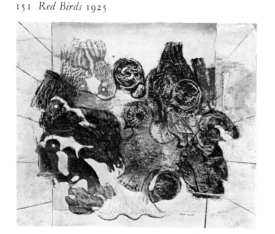

Max Ernst modified the frottage technique in various ways in works on canvas. Among the first of these were a number of pictures with bird motifs, including *100,000 Doves*, whose title echoes that of the French clothing concern '100,000 Chemises'. The technique used here is called grattage. After several coats of ground have been applied, objects are placed under the canvas. The raised portions are then scraped off, so that in these places underlying layers of colour are revealed. The forms which appear are interpreted or reinterpreted with the brush: frequently a spool turns into an eye or the head of a bird. As in the case of pencil frottage, the picture is the result of interaction between stimulation through technique and control through intellect.

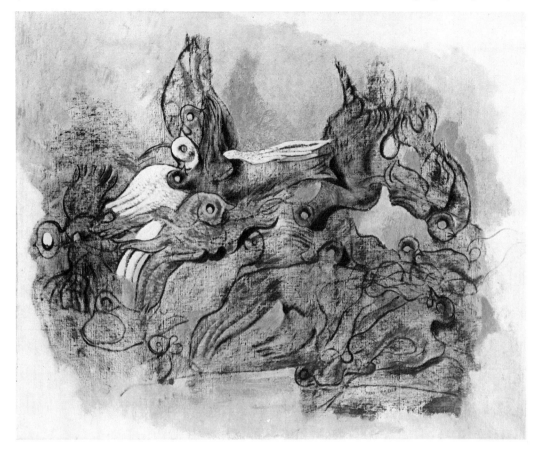

152 *Blue and Pink Doves* 1926

The technique used in these pictures involves the sacrifice of modelling, and illusionism in general, in favour of surface structure. Spatial indications are rare. The background is not an indication of pictorial space but a surface which serves to delimit the objects in the picture, and which has been added at a late stage in the creative process. The final accents are added in the form of corrections and additions made with the brush. The self-contained, emblematic pictorial form of the proto-Surrealist phase has given way to an open, planar form which offers no more than allusions to a pictorial content.

'The final superstition, the last sad residue of the myth of creation, to remain in Western culture was the fairytale of the creativity of the artist. It was one of the first revolutionary acts of Surrealism to attack this myth in the sharpest manner and with objective weapons' (bib. 26).

Later Max Ernst underlines his point of view: 'The expression "artistic creation", applied in a religious sense, as if it were a question of a mission which the artist has to fulfil, and as if he were ordained for this mission by some God, this God being God or else the artist himself, and to maintain that this mission raises him above the ordinary mortal – no, I will have no truck with this' (bib. 46).

153

154

Those who took part in the first collective exhibition of the Surrealists in the Galerie Pierre in Paris were: Arp, De Chirico, Ernst, Klee, Masson, Miró, Picasso, Man Ray, Pierre Roy. Pierre Naville attacked the individualism of his Surrealist comrades-in-arms, and sought to make it clear to them that they were only shadow-boxing and not helping the proletariat towards revolution. Breton defended himself against these accusations, but, with Aragon, he did join the Communist party in 1927. His subsequent pseudo-revolutionary posturing, which the party itself did not always sanction, led to resignations and expulsions from the Surrealist group. By way of compensation, in 1927 and 1929 Buñuel, Dalí, Giacometti and Magritte joined it.

A programmatic picture, probably painted from an idea by Breton, which clearly alludes to Parmigianino's *Madonna dal collo lungo* (*c.* 1535–40), serves the anticlerical endeavours of the group more than their pro-Communist efforts. 'And indeed the blasphemy did not lie in the Christ Child being beaten; all that was shocking was the fact that the halo rolls down' (bib. 42). The three witnesses in the background are Breton, Eluard and Ernst.

In the latter half of the 1920s the Surrealists made films which in many ways were pioneer undertakings. After *Entr'acte* (1924) by Picabia and René Clair came *Anémic Cinéma* (1925) by Duchamp, *Emak Bakia* (1926) and *L'Etoile de mer* (1928) by Man Ray, *La Coquille et le clergyman* (1928) by Antonin Artaud, and finally *Un chien andalou* (1928) by Dalí and Buñuel, followed in 1930 by Buñuel's masterpiece *L'Age d'or*. In this violently anticlerical film Max Ernst plays the leader of a gang of thieves. At the première in Paris in 1930 an accompanying exhibition with works by Dalí, Ernst, Miró and Tanguy was destroyed by right-wing extremists. The police prohibited further performances of the film.

153 Max Ernst in *L'Age d'Or*, film by Luis Buñuel, 1930
154 Max Ernst, 1934, photograph by Man Ray
155 *The Blessed Virgin Chastises the Infant Jesus Before Three Witnesses: A.B., P.E. and the Artist* 1926

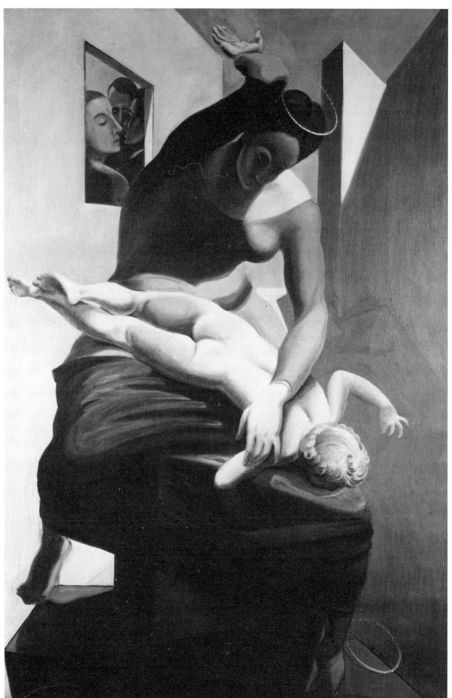

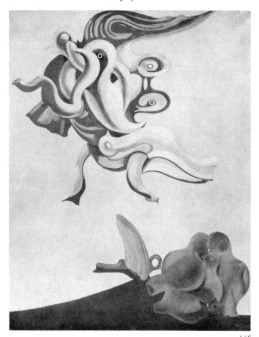

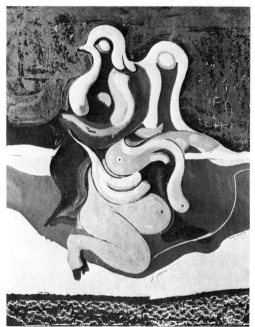

156

157

156 *Monument to the Birds* 1927
157 *Monument to the Birds* 1927
158 *Monument to the Birds* 1927

In the period between the appearance of the two Surrealist Manifestos by Breton (1924 and 1930), Surrealism branched in two directions, growing on the basis of the two main preoccupations of the movement. Automatism led to an abstract variant represented by early Tanguy, Masson and Miró; and the concern with the fixing of dream images produced the veristic illusionism of Dalí, Magritte and the later Tanguy (which had been anticipated by De Chirico and Max Ernst). Max Ernst stands between the two currents. In the golden age of Surrealism, he experimented with ever new materials and motifs which cannot readily be brought under a common heading. His work as a whole is not built up on pictorial possibilities which, once opened up, continue to be explored. He changes his technique, his motifs, before he is anywhere near perfecting them. Max Ernst is not a finder but a seeker.

No one picture or series of pictures can be taken in isolation as fully representative of Max Ernst. His artistic personality can be defined only by studying the multiplicity of avenues he has explored. Nothing of his is definitive in character; each individual work reflects one of the artist's varied traits. Motifs overlap or succeed each other in time without any value distinctions being drawn between them. After 1925 there comes a phase in which he devotes most of his time to birds and forests. The *Monuments to the Birds* and the *Birds' Weddings*, which demonstrated, in the view of the Nazi spokesman W. Willrich, 'a preoccupation with idols of occult cretinization' (quoted in bib. 63), are, in contrast to the oppressive *Forests* and *Hordes*, glorifications of an ideal weightlessness and of a lust for life which includes the erotic – although they are not without more mysterious and demonic strains. Seldom are Max Ernst's utterances unambiguous; frequently they contain their own dialectical opposite. Iconographical references to Baroque representations of the Ascension and Assumption are not to be excluded.

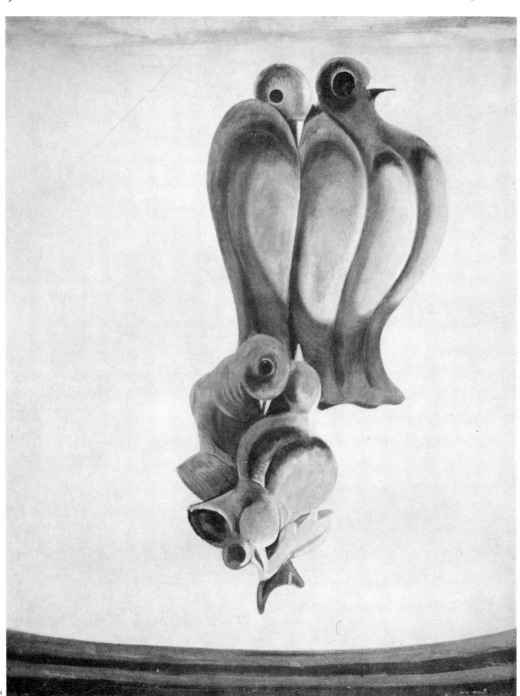

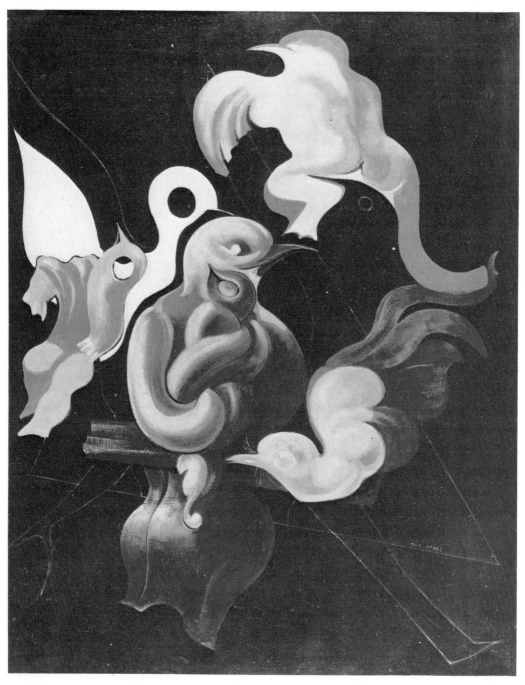

159 *After Us – Motherhood* 1927

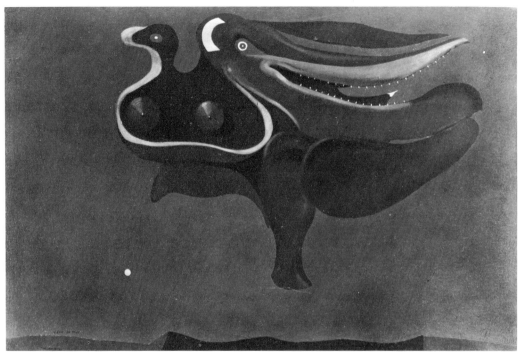

160

160 *The Elect of Evil* 1928
161 *Bonjour Satanas* 1928

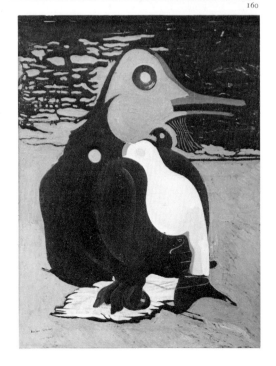

More sombre variations on the bird theme are
The Elect of Evil and *Bonjour Satanas*. Glorifica-
tion has given place to the manifestation of
evil desires. Iconographical references to
Christian mythology are often present, accord-
ing to Werner Hofmann: thus, in the emble-
matic system of the Baroque period, the
pelican stands for Christ.

'Alongside the emblematic quality of many
of his bird groups and bird monuments, it is
striking that the linear engulfing impulses
often intensify to a savage, wounding voracity
such as can be seen among the young of the
pelican. . . . Besides: the picture *After Us –
Motherhood* . . . relates to the transcending of
matriarchal security in which the soaring
"Holy Ghost bird" points to the highest level
of spiritual transformation of the Great
Mother' (bib. 63).

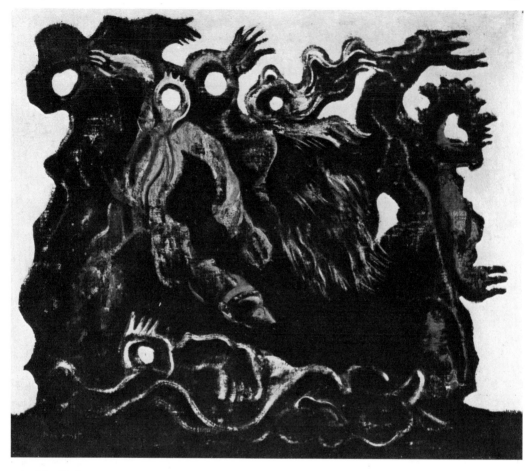

162 *The Horde* 1927

163 *The Horde* 1927
164 *Vision Induced by a String Found on my Table* 1927
165 *They Have Slept Too Long in the Forest* 1926

These pictures too are only partly painted with the brush. The technique used is grattage, the scraping off of successive layers of paint (see p. 84). Objects arbitrarily arranged under or behind the canvas operate to create form. Use is also made of threads soaked in paint, which are placed or dropped on the canvas, where their traces are used in the development of forms and structures. Only when the painting is nearing completion are the figures given shape by outlines which then take on the significance of 'background'.

Immediately after 1925 exhibitions of the Surrealists took place on a larger scale. Man Ray, Dalí, Tanguy, Magritte and Miró all had their first big one-man exhibitions. Max Ernst showed his works in Paris, Brussels, Berlin and Düsseldorf. In 1928 he was represented, along with Arp, De Chirico, Masson, Miró, Picabia, Roy, Tanguy and Georges Malkine, in a Surrealist exhibition at Le Sacre du Printemps in Paris.

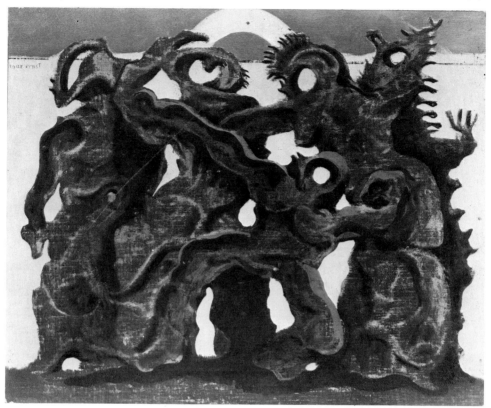

163

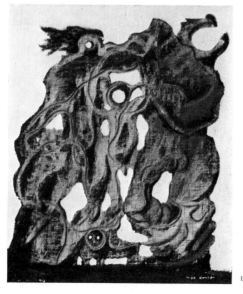

164

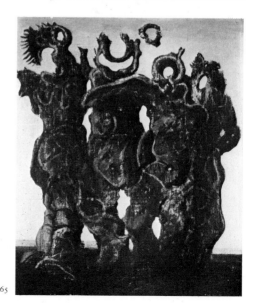

165

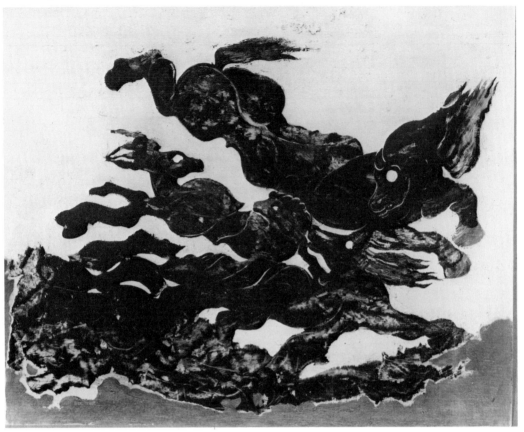

166 *The Bride of the Wind* 1926 169 *The Bride of the Wind* 1926–27

167 *Scene of Severe Eroticism* 1927

168 *Stallion and Bride of the Wind* 1925

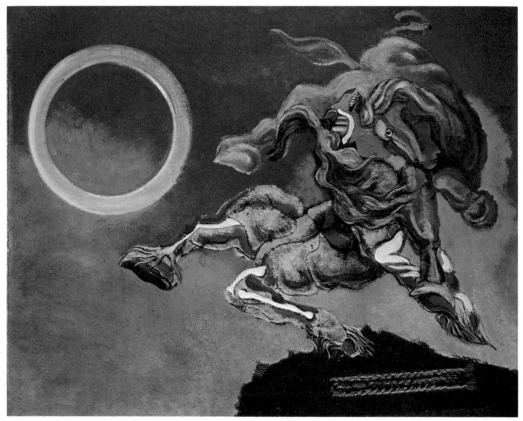

169

The motif of the storm wind (which in German has the poetic name of *Windsbraut*, literally 'bride of the wind') had first become current as a result of Kokoschka's 1914 picture; it has been taken up by Max Ernst in one of the *Histoire naturelle* series. In the series of pictures which followed, a tendency towards taking up and changing the meaning of well-known themes becomes apparent. The *Brides of the Wind* share the same technique as the *Hordes* (p. 97); and, with their intertwined horses rushing through the air, they symbolize sexual union. The key for their interpretation is offered by the *Scene of Severe Eroticism*, whose amorphous bodies bear female heads and in one case a (masculine) bird's head. The couplings of these monsters represent struggle rather than gratification or contentment.

The nature of these pictures calls to mind a childhood dream about his father. 'Measles, fever. Before me a wardrobe in mahogany (imitation), crudely painted, black on red. The coarse brushstrokes generate in the fevered brain illusions of an organic nature – menacing eyes, fat noses, a bird's head with oily black hair, etc. Everything is in movement. A little man with a Kaiser Wilhelm moustache emerges from the surface of the wood with comic gestures, doing splits, knees-bends, trunk movements, all manner of gymnastic exercises. He takes a greasy soft brush from his pocket. With it he emphasizes in black the lines on the mahogany surface, which are black enough already. New and ever more repulsive forms of slimy beasts and worms creep out of the wood' (bib. 64).

170

171 172

In 1925 Hitler's *Mein Kampf* appeared; at the same time the Nazi party was reconstituted and the SS formed. The German Nationalists entered the government for the first time (in a coalition with the Centre). In 1926 the Hitler Youth came into being. In 1930 the party received 6·5 million votes at the Reichstag elections and became the second largest party, with 107 seats. In 1933 the Nazis came to power.

170 *Vision Induced by the Words 'The Immovable Father'* 1927
171 *Young Men Trampling on their Mother* 1927
172 *They have Slept Too Long in the Forest* 1927
173 *The Horde* 1927

These pictures are not symbols, nor are they admonitions. What they depict is agitation, aggression, the ruthless advance of the monsters. Where the forest pictures ward off the menace and maintain a defensive posture, the *Hordes* go over to the offensive. That nothing stands in their way renders them especially menacing in their effect.

Again the painter's personal preoccupations intrude: *Vision Induced by the Words 'The Immovable Father'* is the title of one such picture, in which dark figures that cannot be made out in detail conceal the outline of a sun. The alogicality of dream has given way to insight into the terrifying mechanics of the aggressive drives within mankind, whether personal or political in nature.

173

174

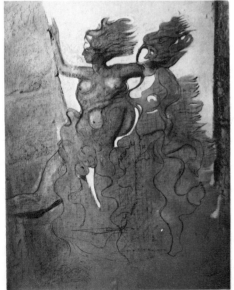

175

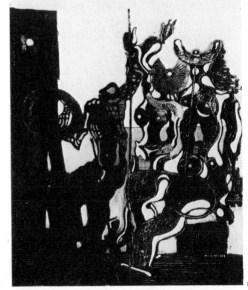

176

Do these pictures still bear any relationship
to Surrealism? Surrealism is more an attitude
of mind than a stylistic tendency. Surrealism
is the sum of Breton's doctrine, Dalí's
paranoiac-critical method, Magritte's intel-
lectual semantics, Miró's automatism and Max
Ernst's combination of guided chance and
imaginative power. Each of the Surrealist
painters goes his own way. In the last analysis
there is remarkably little to hold them
together.

174 *Man, Woman's Best Friend* 1928
175 *Two Young Naked Chimeras* 1927
176 *Two Girls and Monkey Armed with Rods* 1927

177 *Figures, One Headless* 1928
178 *The Kiss* 1927

177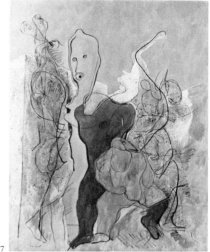

178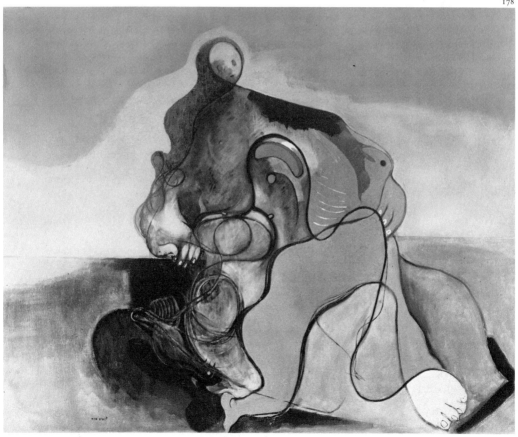

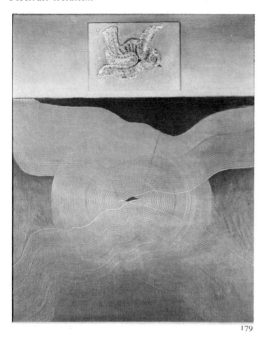

179

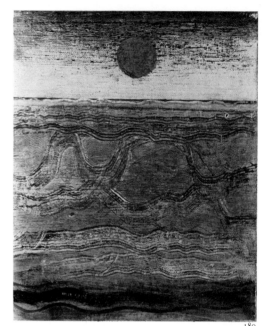

180

179 *The Gulf Stream* 1927
181 *The Gulf Stream* 1925–26

180 *Earthquake* 1926
182 *Wave-shaped Earthquake* 1927

181

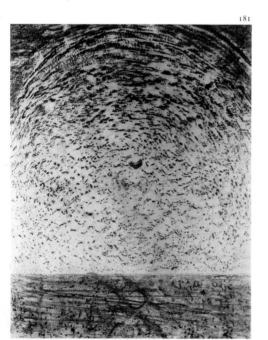

182

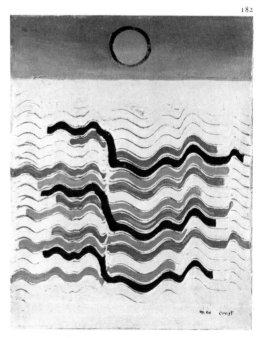

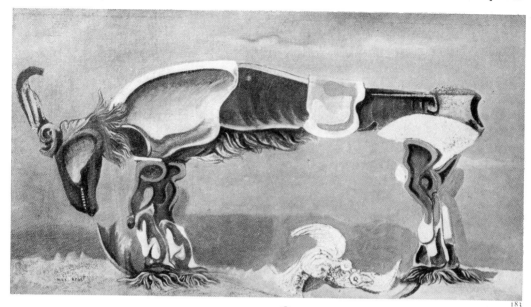

184 183

183 *The Beautiful Season* 1925
184 *The Beautiful Season* 1925
185 *The horse . . . he's sick . . .* 1920

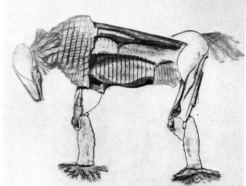

185

*The Gulf Stream, Earthquake, The Beautiful
Season* and *The horse . . . he's sick . . .* present
two recurrent series of motifs at this time.
The *Earthquake* and *Gulf Stream* pictures,
anticipated in a 1925 frottage, draw on yet
another technique. The canvas is prepared
with several thick layers of colour; structures
are scratched into the still wet mass of
colours, for example, with a comb. Thus the
wave-shaped earth tremors or water move-
ments are evoked in formulaic, abstract
patterns. *The horse . . . he's sick . . .* first
makes an appearance as an early collage (1920),
returns as a frottage, and also exists in the
form of a painting which still retains the
character of the collage, that is, it lacks overall
harmony. The *Gulf Streams* and *Earthquakes*
encapsulate a natural event; the *Sick Horses* are
specific depictions.

186

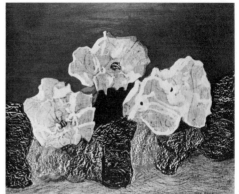

187

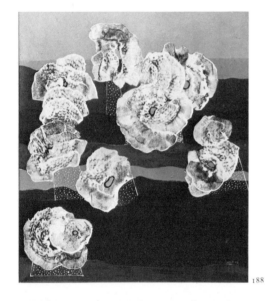

188

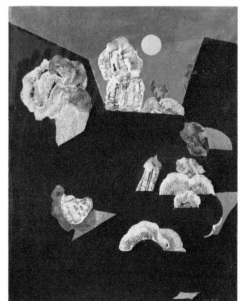

189

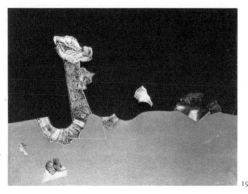

190

191

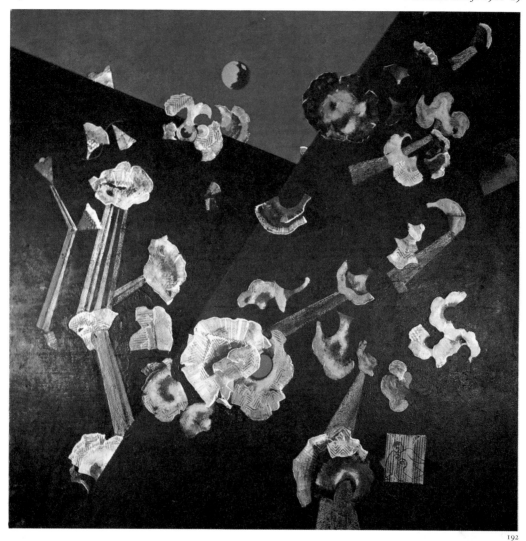

192

Alongside the predominant forest and bird motifs Max Ernst turned his attention for a while to flowers. The title *Shell Flowers* points to the ambiguity which characterizes the content of these works. The flower or shell forms, which mostly stand out, glowing with colour, against a dark background, are not painted in but applied with the knife in such a way that various colours and layers of colour interpenetrate without blending. They summon up equally strong associations of both biological phenomena and geological formations. They are graceful and beautiful images, of great decorative charm.

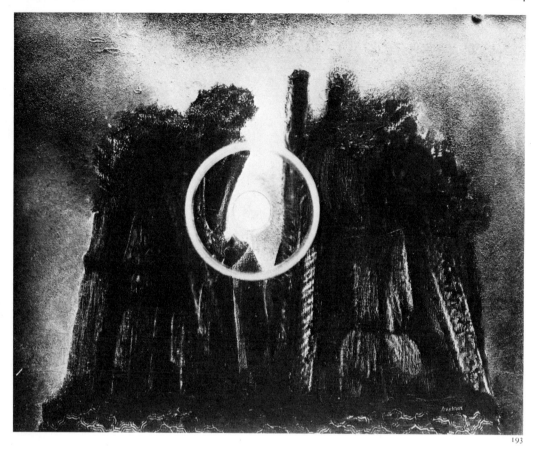

193

193 *Sun and Forest* 1926
194 *Forest* 1927
195 *Forest and Sun* 1932

195

194

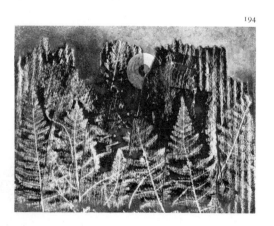

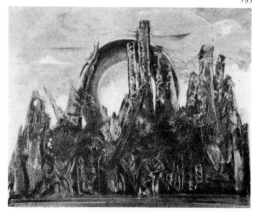

At a very early point in time Max Ernst had become an admirer of both Albrecht Altdorfer and Caspar David Friedrich. Without the tradition of German forest paintings his own would have been unthinkable. Around 1830, Caspar David Friedrich (in his 'Statement on the Observation of a Collection of Paintings by Artists still Mostly Living or Recently Dead') had expressed it in these words: 'Close your physical eye, so that you see your painting first of all with the eye of the spirit. Then bring out into the light what you saw in the darkness, so that it may react inward upon others.' Max Ernst echoed this when he said that it was his aim 'to bring into the light of day the results of voyages of discovery in the unconscious', to record 'what is seen . . . and experienced . . . on the frontier between the inner and the outer world'.

In these forest pictures Max Ernst continues the tradition, which originates with Caspar David Friedrich, of imbuing a landscape with the content of subjective experiences. In a technique which brings together brushwork, application of paint with the palette-knife, scraping and scratching, he contrasts dark walls of foliage with the mainly bright rings which stand for suns. The basic formation had already been worked out as far back as the early collages (ills 60, 62). These forest pictures, reflections of a childhood experience which was both liberating and disturbing (see p. 36), are manifestations of the coexistence of dark and light, reality and dream, menace and hope. As in few of his other series of pictures, Max Ernst reveals here just how close his relationship with the German Romantics really was.

196 *The Great Forest* 1927

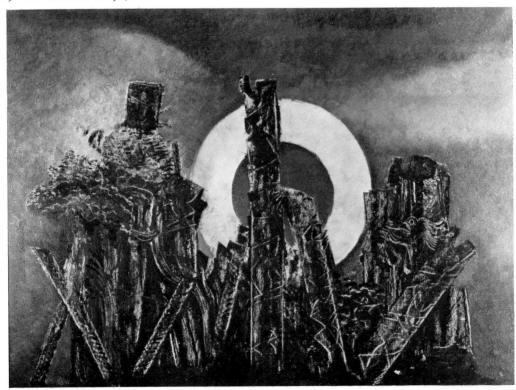

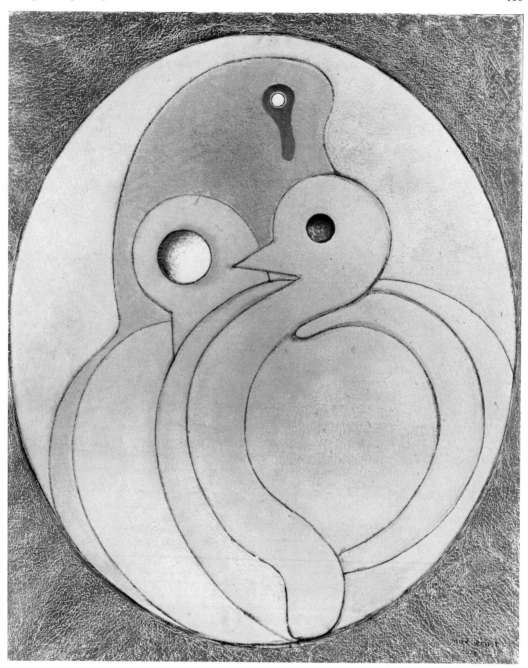

197 *The Interior of Sight (Egg)* 1929

Max Ernst's power of developing new pictorial forms was at a peak between 1925 and 1930. It was never a matter of chance abstract motifs: mythological and religious themes as well as personal obsessions underlie these metamorphoses of the world of concrete reality.

The title of the series illustrated here, *The Interior of Sight*, alludes to the significance which Max Ernst gives to the expression of the subconscious. The oval and the circle stand for the spellbinding or taming of horror (snake) or pleasure (bird). The round shape is at the same time the inward-turned eye. This eye holds the vision of the mutual devouring of the birds which stands at the same time for copulation. Here the plurality of meaning frequent in Max Ernst – menace alternating with pleasure – is expressed metaphorically, in terms of bird and snake. Werner Hofmann has drawn attention to the archetypal role of the egg shape, and has formulated the hypothesis that Max Ernst, 'for whose mental dialogues with other painters there is much

198 *Sun, Drinker and Snakes* 1929–30

evidence', had in mind as a prototype the *Virgin and Child with St Anne* of Leonardo (bib. 64).

199 *The Interior of Sight (Egg)* 1929

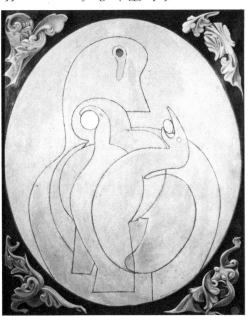

200 *The Interior of Sight (Egg)* 1929

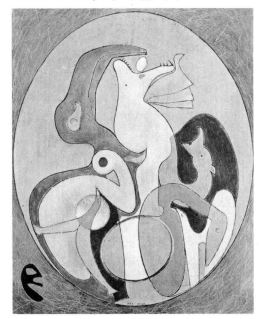

201

201 *Vision Induced by the Nocturnal Aspect of the Porte Saint-Denis* 1927

202 *Grey Forest* 1927
203 *Petrified Forest* 1927

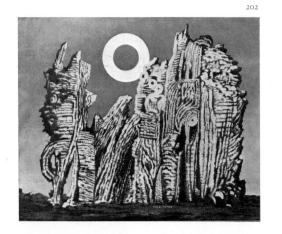

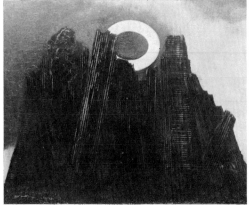

Both in *La Foresta Imbalsamata* and in *Forest and Dove*, Max Ernst offers variations on the polarity of menace and hope. The sun ring is missing, its place taken by a little bird, which enlivens the forest, but which is its prisoner. Max Ernst painted the large picture *La Foresta Imbalsamata* in 1933, in a single day during a holiday at Vigoleno in Italy, in order to cover, in his words, an 'exceedingly mediocre *St George*'. Werner Spies states that 'two days previously Max Ernst had seen Verdi's *Aida*. The villagers had also attended the performance and when they saw the picture they exclaimed "La Foresta Imbalsamata"' (bib. 63); they were referring to a duet in the third act.

In *Vision Provoked by the Nocturnal Aspect of the Porte Saint-Denis* the birds, now scarcely perceptible, are mere residues in a petrified world.

204 *Forest and Dove* 1927
205 *La Foresta Imbalsamata* 1933

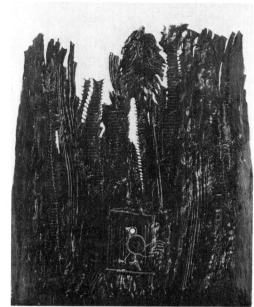

204

205

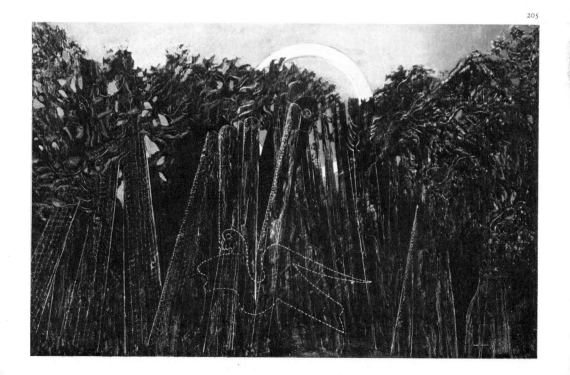

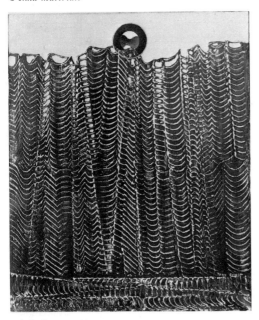

206 *Fishbone Forest c.* 1926

207 *The Imaginary Summer* 1927

In the *Fishbone Forests* Max Ernst presses stamped pieces of tin into the wet paint; the resulting ridges are then painted. As in the collages of 1920 which established this theme (ills 60, 62), Max Ernst here uses one material (tin) in order to evoke a quite different material (forest). So this series of pictures continues the characteristics of their predecessors, both in changing the significance of a found material and in the pictorial theme.

The *Fishbone Forests* have a rigid pattern. The severe tracery of the forest rises on a plinth; above it stands the sun. These forests are hard and uninviting; the rhythmic arrangement of the ridges breathes no life into them. The landscapes appear dead and withered.

Although Max Ernst has painted a number of large pictures, he prefers smaller ones, as in the *Fishbone Forests*; even the monumentality of the forest pictures (ills 193–96) is not matched by the use of a large canvas.

For Max Ernst the forest is both dreamland and trauma. He ironically champions his Romantic conception of the subjective significance of the forest, when, in 1934, in a prose piece called 'Les Mystères de la forêt', he conjures up the fancy of a civilized forest which has lost all inspiratory power:

'Who will be the death of the forest? The day will come on which a forest, hitherto a womanizer, resolves to frequent only teetotal places of refreshment, walk only on tarred roads and consort only with Sunday-afternoon strollers. He will live on pickled newspapers. Enfeebled by virtue, he will forget the bad habits of his youth. He will become geometrical, conscientious, dutiful, grammatical, judicial, pastoral, clerical, constructivistic and republican. . . . He will become a schoolmaster. Will it turn out fine? Of course it will! For we are going diplomat-hunting. . . . Will the forest be praised for its good behaviour? Not by me, anyway' (bib. 64).

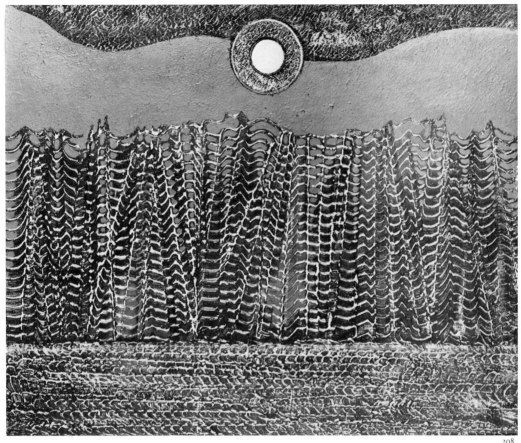

208

208 *Fishbone Forest* 1926
209 *The Forest* c. 1928
210 *Red Fishbone Forest* 1929

209

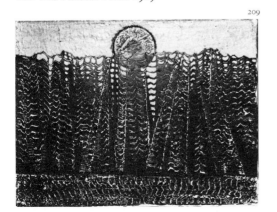

210

211 *Rome* 1929
212 *In the Paris Basin the head bird Hornebom brings night-time nourishment to the lanterns* 1929

In 1929 Max Ernst created his first pictorial novel, consisting of 147 printed collages and their titles. It was published in the same year under the title *La Femme 100 têtes*, with a foreword by André Breton (ills 211–21). Max Ernst had started mostly by arranging pieces cut out from printed illustrations (woodcuts, line blocks, steel engravings) on a neutral ground, thus developing his pictorial form in an additive fashion; in *La Femme 100 têtes* he finally goes over to a conception of the collage as an intervention in a picture taken over whole. This principle had already been practised in the overpainted illustrations of 1919–20 and in the collage for the Tyrolean Dada manifesto (ill. 80). Pictorial elements from other contexts are stuck on to an illustration, with the result that this illustration undergoes a complete upheaval in its original significance.

In contrast to the later *Une semaine de bonté* (ills 263–82), *La Femme 100 têtes* lacks thematic unity. Max Ernst likes to pounce on taboo subjects. Often the theme of a picture is the Immaculate Conception; on one occasion it is Extreme Unction; then St Nicholas walking on the waters like Christ (and steered by remote control), and finally God the Father involved in an underground railway accident. The anticlerical tendency, which is also characteristic of Buñuel's *L'Age d'or*, finds expression in the sarcastic distortion of religious rites. Another frequent feature is the exposure of repressed middle-class notions about sex, which can be seen in greater detail, although more obliquely, in *Une semaine de bonté*. Also in evidence is a sadistic streak which tips over into black humour.

'The intensity of these collages', Max Ernst said later, 'derives as much from the emotional commonplaces which serve as their point of departure as from the uses – no less sacrilegious, one could say, than purely absurd – to which they are put' (bib. 39).

213 *Accompanied by immaculate parasites the Great Nicholas is steered from afar by means of lateral appendages* 1929
214 *Let us all give thanks unto Satan and rejoice in the goodwill he has shown us* 1929

213

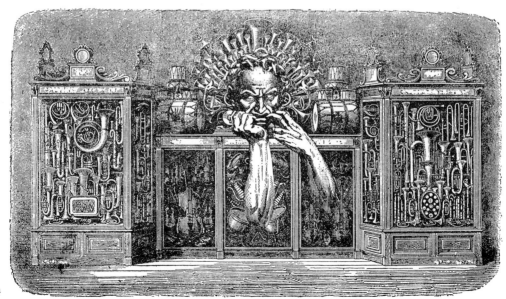

214

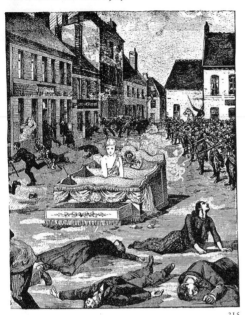

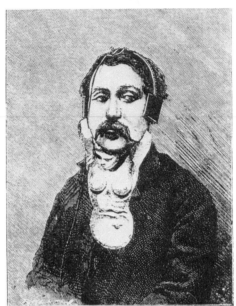

215

216

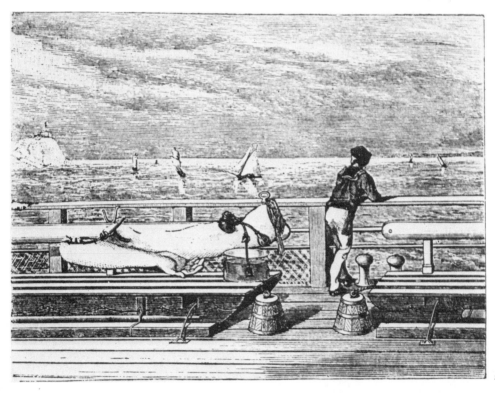

217

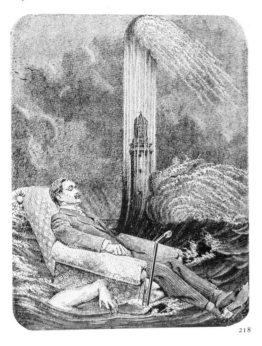

218

219

215 *At each bloody riot she blossoms forth filled with grace and truth* 1929
216 *And now I show you the uncle whose beard we loved to tickle on a Sunday afternoon* 1929
217 *Yachting* 1929

218 *Spiritual Repose* 1929
219 *Show me your suitcase, my dear* 1929
220 *. . . Cézanne and Rosa Bonheur . . .* 1929
221 *Hornebom and The Fair Gardener* 1929

220

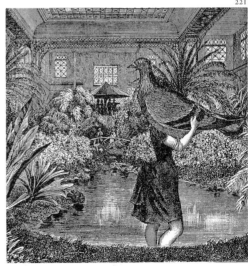

221

222

225 *Anthropomorphic Figure with Shell Flower (Loplop Introduces a Flower)* 1931

At the end of the 1920s Max Ernst evolved a new version of the human figure. This was the period at which Picasso came under the influence of the Surrealists and created his own deformed human figures. In Max Ernst's case, body and limbs are flat cut-outs with occasional organic forms reminiscent of the *Shell Flowers* (ills 186–92) intermingled. Turning the body into a formula led ultimately to a new pictorial motif, Loplop, a walking easel, on whom pictures are presented, and who is crowned with a bird's head.

According to Werner Spies (bib. 63), Max Ernst showed two easel assemblages at the second Dada exhibition in 1920. What is peculiar to the Loplop pictures is that in them Loplop mostly presents Max Ernst's own works, or details from them, as pictures within the picture.

222 *Chaste Joseph* 1928
223 *Man* 1929
224 *Anthropomorphic Figure* 1929

223

224

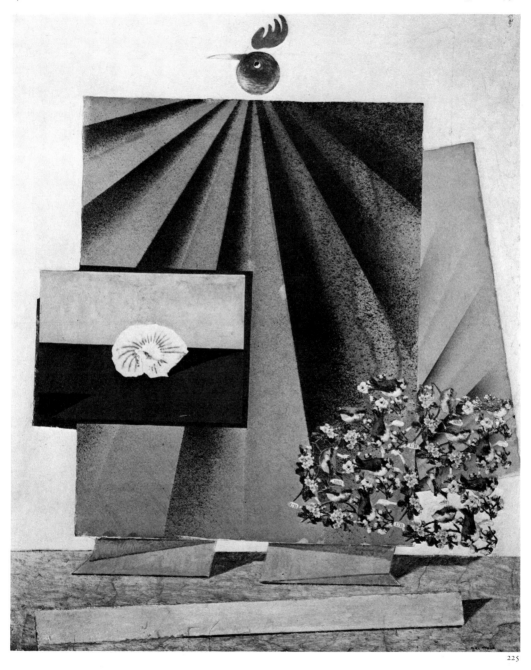

225

In this case Loplop presents a *Shell Flower* picture. Also incorporated is a sheet of cut-out flowers such as children used to stick into their scrapbooks.

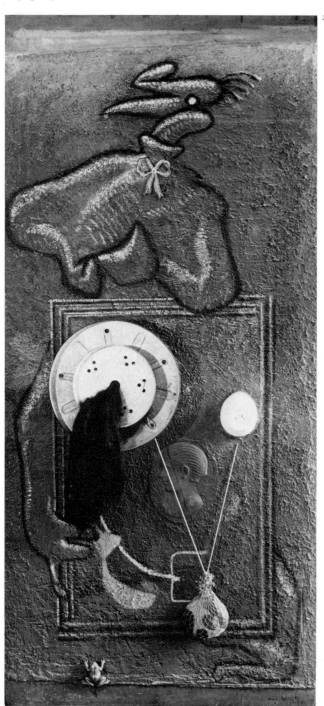

226

The mostly large works shown here act as variations on the Loplop series. At Buñuel's request Max Ernst played the part of the gang boss in the film *L'Age d'or*. The plaster-covered plywood walls used as background for his scene met with Max Ernst's approval: 'I stood once more before the famous wall of Leonardo da Vinci, who played so important a part in my "half-waking visions"' (bib. 38). Such plaster surfaces are the basis of these Loplop variations, as is also the case in *Europe after the Rain I* (ill. 285). Found objects are applied to the picture or the easel. In one of the relief-like paintings, Loplop is presenting himself (ill. 227).

It seems probable that the Loplop figure was inspired by Miró, who as early as 1925 had taken up a related theme; he and Max Ernst came into contact in 1927.

226 *Loplop Introduces a Young Girl* 1931
227 *Loplop Introduces Loplop* 1930
228 *Loplop Introduces* 1930
229 *Human Form* 1931

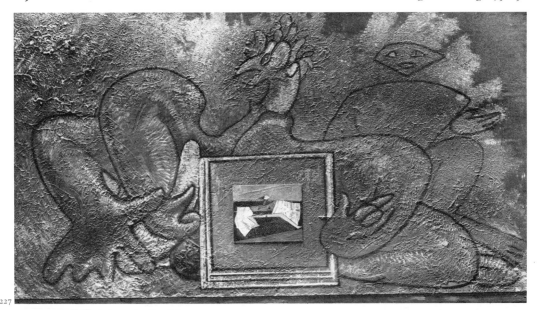

227

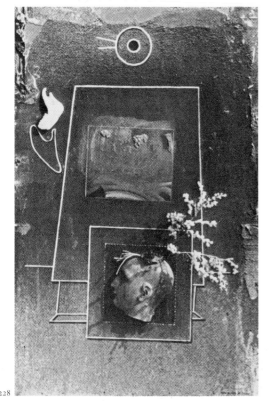

228

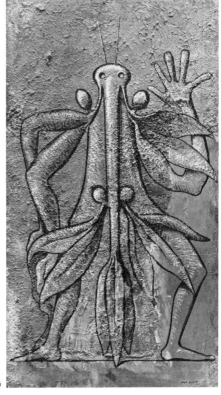

229

230

231

232

233

The Loplop series has a unique position in Max Ernst's work. The theme of the painting or collage is the presentation of a picture, which could stand independently of, or on an equal footing with, the rest of the work, whether as a frottage or a *Shell Flower*, a bird or a collage, or a still-life with the positive-negative effect, or again as part of the lush plant world which was to be important in the later 1930s. By exhibiting his motifs and techniques in this way, Max Ernst gives a reflection of them. The forty-year-old artist seems – not least by liberating himself through creative activity – to have shaken free from the oppression of his childhood experiences, and from the necessity for working them out in pictorial terms, to such an extent that he can turn his liberating creative activity, his externalization of personal problems through conscious creativity, into an artistic theme in itself. In his *Painter and Model* variations, Picasso observes the relationship between the reality of the model and the illusion of representation; in these works, Max Ernst displays his products and their availability.

230 *Loplop Introduces* 1931
231 *I Imagine You* 1931
232 *Loplop Introduces* 1931
233 *Loplop Introduces* 1929–30

234 *Loplop Introduces* 1931
235 *I am Like an Oak . . .* 1930–31
236 *Untitled c.* 1931–32

234

236

235

237

238

As a rule the Loplop pictures are collages; but they also include the last frottages that Max Ernst was to create (with few exceptions) until he reverted to the use of this medium in the late 1960s.

By 1930 the collage had gained recognition for the extremely significant role it was playing in the development of the pictorial arts and of the range of artistic expression. In the catalogue of a collage exhibition in 1930 at the Galerie Goemans in Paris, including works by the Cubists Braque, Gris and Picasso, the Dadaists Arp, Duchamp, Ernst, Picabia and Man Ray, and the Surrealists Dalí, Magritte, Miró and Tanguy, there is to be found a text by Aragon with the title 'La Peinture au défi' which is the first discussion of the historical development of collage, in which, according to Aragon, Max Ernst played a pioneer role. A year later in the *Cahiers d'Art* an article appeared by Tristan Tzara with the title 'Le Papier collé ou le proverbe en peinture', in which, again, weight is placed on the renewing function which collage had performed in the evolution of modern art.

A comprehensive definition of collage was finally given by Franz Mon in 1968: 'The formula "collage principle" indicates that collage does not mean simply one artistic technique among many, but reveals a basic attitude to artistic activity which pervades the whole of modern art. A collage unites in a composition elements which originate from the civilized environment, bear traces of modification, and are therefore socially mediated. . . . Collage transposes received reality, as seen through the filter of civilization, into an artistic world ripe for reconstitution. There is nothing real that might not become an element in collage. . . . The principles and techniques of composition in collage – such as the selection of seemingly incompatible materials, assembly and destruction, integration and disintegration, superimposition, juxtaposition and confrontation – also govern the experimental work which takes place in other artistic disciplines, in literature, in the theatre, in the film and in music' (bib. 31).

239

237 *The Marseillaise* 1931
238 *The Marseillaise* 1930
239 *Anthropomorphic Figure* 1931

The title *Postman Cheval* refers to the postman
Ferdinand Cheval, of Hauterives, near Lyon,
who, between 1879 and 1912, turned dream
into reality by building, with stones and shells
collected on his rounds, a 'Palais Idéal' full of
bizarre inscriptions and naïve sculptures. His
escape from his age fascinated the Surrealists,
who were preoccupied with the idea of
changing their own industrialized society.
Not surprisingly, their naïve hostility to
modern civilization, combined with a will to
revolution (a revolution brought about
through the spirit), rendered them suspect to
the Communists.

240 *Postman Cheval* 1929–30
241 *Loplop Introduces* 1932

241

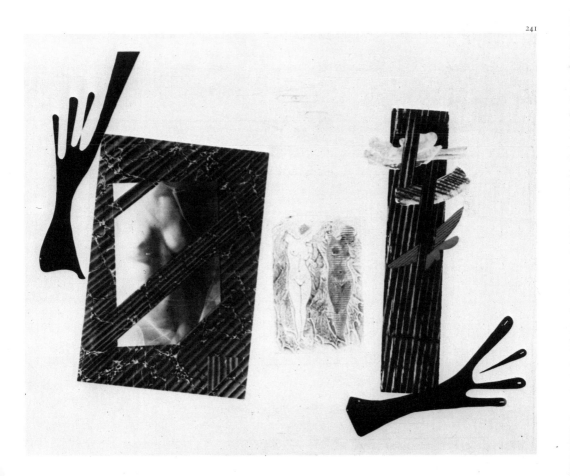

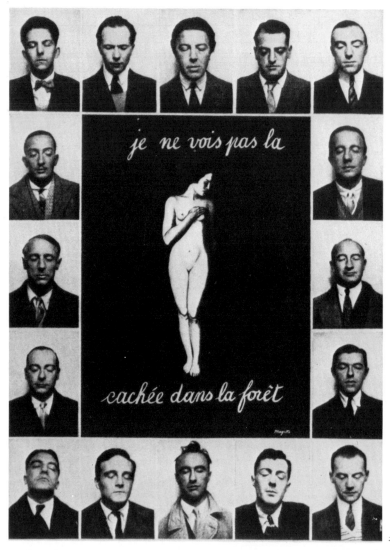

je ne vois pas la

cachée dans la forêt

242

242 *The Parisian Surrealists*, 1929

243 *Loplop Introduces Members of the Surrealist Group* 1930

A montage by an unknown hand portrays sixteen Surrealists round a picture by Magritte. Reading clockwise from top left: Maxime Alexandre, Aragon, Breton, Buñuel, Jean Caupenne, Eluard, Marcel Fourrier, Magritte, Albert Valentin, André Thirion, Tanguy, Georges Sadoul, Paul Nougé, Camille Goemans, Max Ernst and Dalí.

A Loplop collage by Max Ernst again presents the Surrealists: in the upper third Tanguy, Aragon (with cap), Giacometti, Crevel, Sadoul (standing in back view); in the centre part Péret, Tzara (with a monocle), Dalí, Max Ernst, Thirion; in the lower part Buñuel, Eluard (with a cigarette), René Char, Alexandre, Breton and Man Ray.

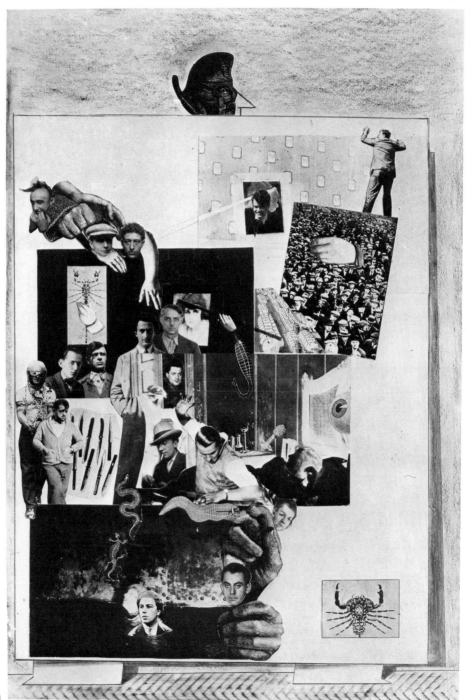

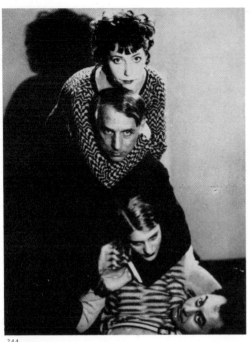

From 1930 onwards, Max Ernst illustrated numerous books, including texts by Arp (1930), Crevel (1931), Breton (1936), Péret (1936, 1949), Eluard (1939), Lewis Carroll (1950, 1968; 1970), Schwitters (1951, 1967), Artaud (1955), Hölderlin (1961), Prévert (1964), Beckett (1967) and Char (1969). In each case Max Ernst has treated the illustrations as an autonomous complement to the text, not as an attempt to interpret the text.

In 1930, the year after the appearance of *La Femme 100 têtes*, Max Ernst published a further collage novel under the title *Rêve d'une petite fille qui voulut entrer au Carmel*.

244 Marie-Berthe Aurenche, Max Ernst, Lee Miller, Man Ray 1931
245 The Parisian Surrealists, 1929. Left to right: Tzara, Eluard, Breton, Arp, Dalí, Tanguy, Max Ernst, Crevel, Man Ray. Photograph by Man Ray
246–49 Illustrations for René Crevel's *Mr Knife and Miss Fork* 1931

244

245

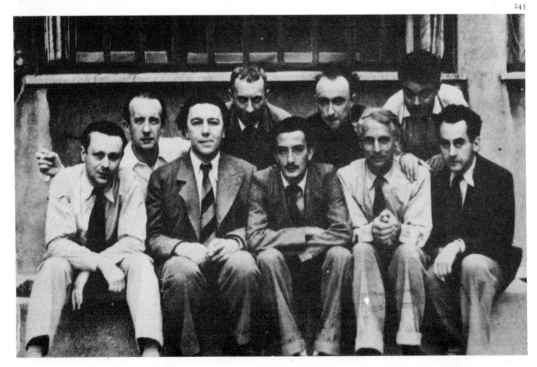

246

247

248

249

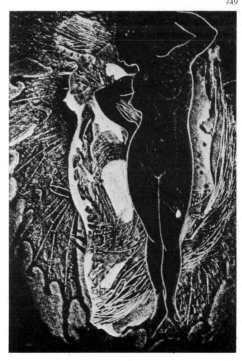

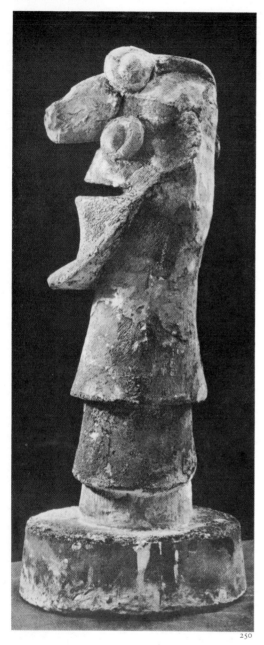

At the beginning of the 1930s sculpture drawing on the ideas of Surrealism was a rarity, the exceptions being Arp, Giacometti and Picasso. The emphasis lay on Surrealist 'objects'.

In 1934 Max Ernst stayed for a while with Giacometti at Maloja. The two of them found in a nearby riverbed large granite stones which had been worn smooth by the water. Max Ernst worked on these found materials: birds, flowers and figures decorate the egg-shaped stones like reliefs, and they are related to the series of pictures *The Interior of Sight* (ills 197, 199, 200). These objects provide the impetus for the further sculptural activities initiated by *Human Head* and whose new vocabulary is drawn together in *Chimeras*. The technique has changed from that of the stones: found objects from the most varied sources are moulded, juxtaposed, worked over and cast in plaster. Again the collage principle forms the basis.

251

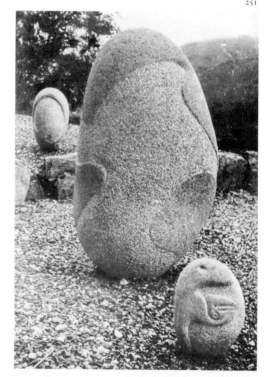

250

250 *Human Head* 1934
251 *Stones from Maloja* 1934
252 *Chimeras* 1935

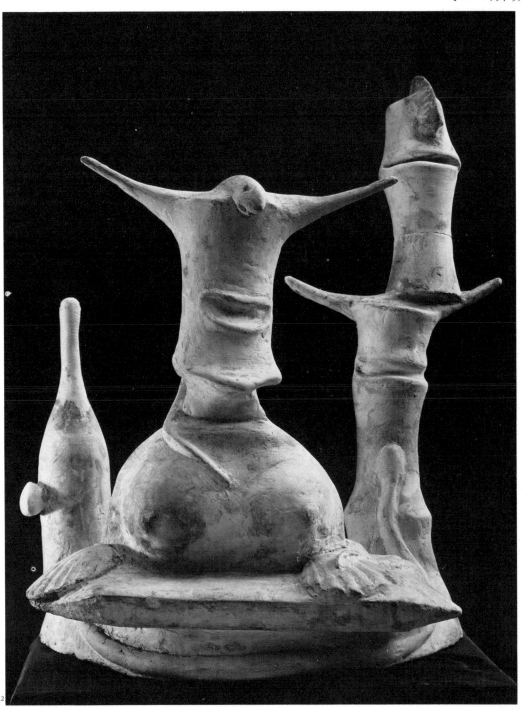

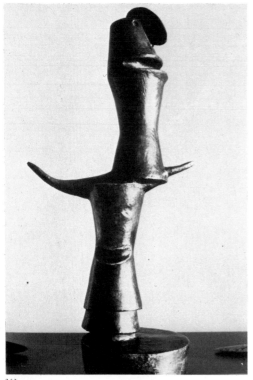

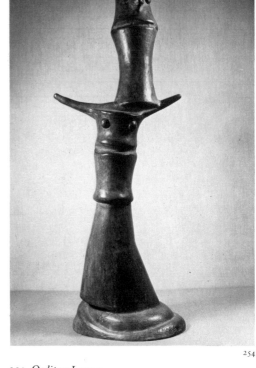

253 255 254

253 *Oedipus I* 1934
254 *Oedipus II* 1934
255 *Gay* 1935

Max Ernst's sculptures have a place of their own in his work, although they are not essentially different in construction from the pictures or collages. In the same way that the frottages are not just drawn, and the paintings not just painted, the sculptures do not owe their entire being to freehand sculptural procedures. Found objects in each case are the starting material, and are mostly changed beyond recognition. (Flowerpots served as the basis for *Oedipus* and *Habakkuk*.) Ambiguous man-bird figures appear, which in the *Head-Bird* are closely related to the Loplop pictures.

256–57 *The German Beauty* 1934–35
258 *Habakkuk c.* 1934
259 *Head-Bird* 1934–35

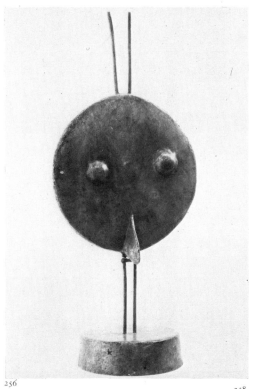

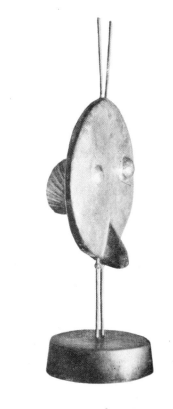

256

257

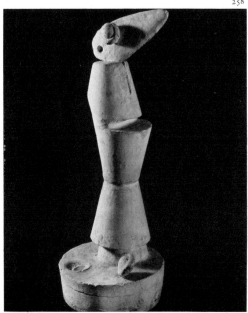

258

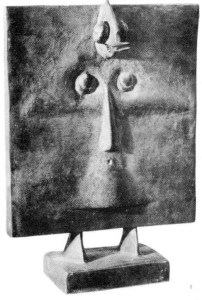

259

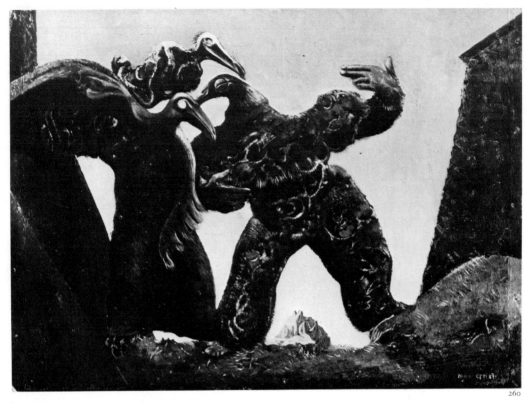

260

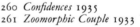

260 *Confidences* 1935
261 *Zoomorphic Couple* 1933

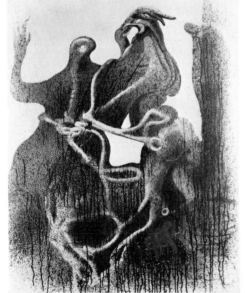

261

John Russell has drawn attention to the fact that the *Barbarians Marching Westwards* (ills 286, 288) call to mind 'the fantasies of Desnos, in which idealized barbarians from the East would come marching in to save the western world from itself' (bib. 39). There is no denying that an element of discontent with civilization, inspired by Surrealism, does have a part to play in these pictures, especially as the dogmatic Parisian leading lights of the movement did occasionally incline towards the idealization of anti-cultural impulses. Equally not to be denied is the fact that the *Barbarians* are conclusions drawn from political events, and thus point forward to the Nazi invasion of France.

Once again it is monsters, half man and half bird, that populate the world of Max Ernst's imagination at this period. But it does appear that the Loplop series really marked a genuine dividing line. It afforded a distancing, a reflection of his own motifs and techniques which was only possible because personal development and its pictorial expression brought with it a gradual liberation from the oppressive weight of his childhood and his relationship with his father.

Up until about 1930, creative work was for Max Ernst a personal process of elucidation. After the Loplop series the process became supra-personal. For it was no longer his own psychic doubts and uncertainties that predominated but the problems that faced his contemporaries, the process of coming to grips with the state of the world.

The works bear witness to these concerns. They are filled with repulsive monsters, symbols of mindless power, unchecked brutality and sheer unreason. With vicious irony, Max Ernst mocked the euphemisms used by the totalitarian rulers (as when they were pleased to refer to their seizure of power as a 'revolution'). *Confidences* and *Triumph of Love* are the sarcastic titles of pictures which document the rising tide of inhumanity. A little later, his titles give the illusion of an idyll, whereas their real concern is concrete political events: *The Angel of Hearth and Home* (ills 306–08), *The Nymph Echo* (ills 311, 312), *Nature at Dawn* (ill. 316). All these are themes which, presented in positive terms, would have gone down well in the Third Reich.

262 *Triumph of Love* 1937

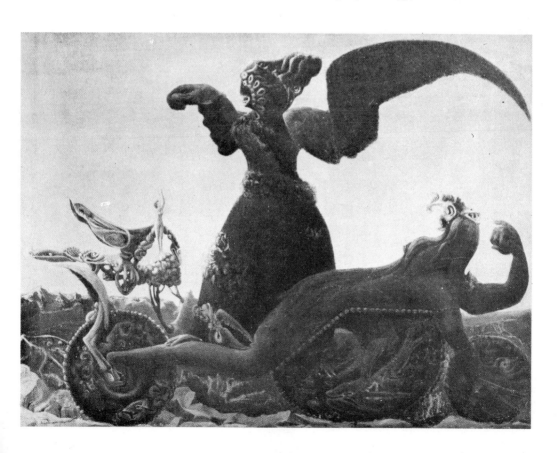

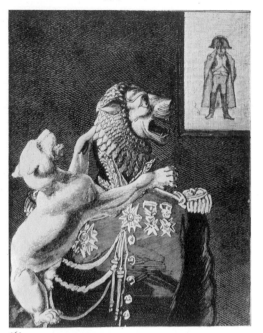

263

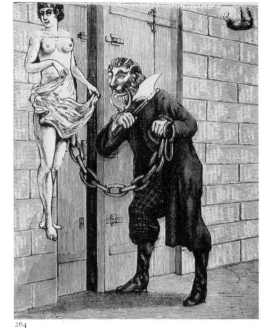

264

265

266

In 1933 Max Ernst, taking as one of his sources a volume with illustrations by Gustave Doré (in which Ernst's man-bird combinations are anticipated, as they are by Grandville), produced his most important collage novel, *Une semaine de bonté*, in five volumes. It appeared in Paris in 1934.

The material he worked from was the printed platitude. Illustrations from the popular literature of the end of the nineteenth century are taken as instances of the narrow-minded middle-class world of the Victorians and hotted-up, re-interpreted and distorted by means of slight alterations. For the first time trivial picture material is systematically employed as a source of art; one is reminded here of Roy Lichtenstein's later exploitation of the comic strip. The documentary illustration becomes intensified, psychologically

263–68 Collages from *Une semaine de bonté* 1934

interpreted through the intervention of the artist.

An interpretation in terms of depth psychology has been attempted by Dieter Wyss: 'A lion-headed general, with a lioness jumping up at him – symbolizing as it were the psyche lowered to the level of a wild beast – stares admiringly, with rigid bronze features, at a blurred portrait of Napoleon, the representative of power, of the state, of authority. There is a striking contrast between the head, which clearly betrays its metallic origins, and the soft contours of the powerful torso formed by another technique. Perhaps in this way the artist is pointing to the contrast between the fanatical, rigid will of the dictator and the fact that he belongs to a broader humanity, as his bodily shape demonstrates. Thus the very first picture in the series documents in a few expressive forms the problem of the will to power' (bib. 27).

267

268

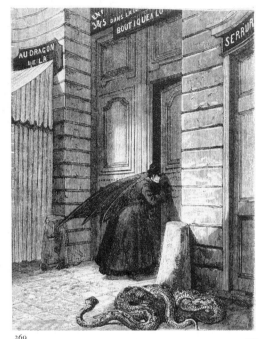

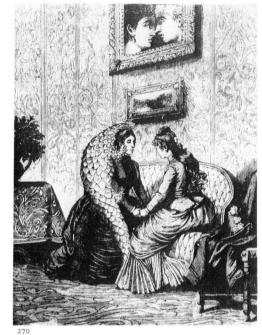

269

270

271

272

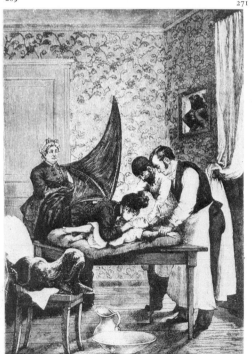

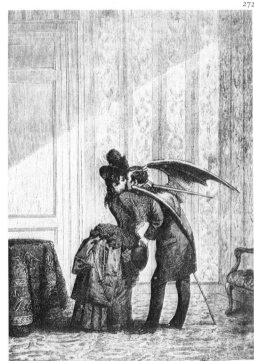

Max Ernst once said of the collage that its hallucinatory power transforms 'the banal advertisement page into a drama which reveals my most private desires' (bib. 64). In this work, the secret impulses are no longer his own but those of a society in which he has grown up, and which was documented by the very images which serve as the raw material for the collages. Max Ernst has himself made it clear that such impulses can be detected in the illustrations themselves. He handles his material with great mastery, like a scientific observer analysing his father's generation, and setting out, like Freud, to demonstrate the effects of sexual repression in human life.

It is for this very reason that these collages have such extreme suggestive power: they derive their impact not from the formal interplay of pictorial elements, but from the analysis of social realities.

269–75 Collages from *Une semaine de bonté* 1934

274

273

275

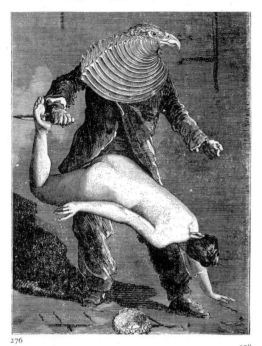

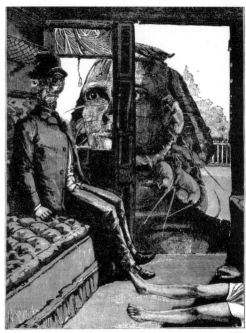

276

278

277

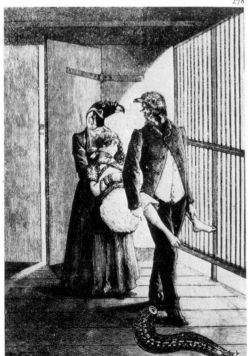

Some of the sources for these collages have been traced by Werner Spies, one example being the illustrations in *Les Damnés de Paris*, by Jules Mary (1883). These sources are dramatic enough in themselves; indeed, for all their banality they are melodramatic, mysterious, unreal. Sometimes Max Ernst's modifications and additions are minor and scarcely perceptible. The least intervention inverts or clarifies the banal pictorial situation, makes it speak, reveals it. The illusionism of the additions makes the altered scenes appear to be, like the originals, dramatic pieces of sensationalism from a possible reality expressed in terms of a pictorial convention.

For the first edition in the German language (1963), Max Ernst gave *Une semaine de bonté* a title which again makes ironic use of euphemisms: *Die weisse Woche. Ein Bilderbuch von Güte, Liebe und Menschlichkeit*. Translated, it runs: 'The White Sale Week. A Picture Book of Goodness, Love and Humanity'.

276–82 Collages from *Une semaine de bonté* 1934

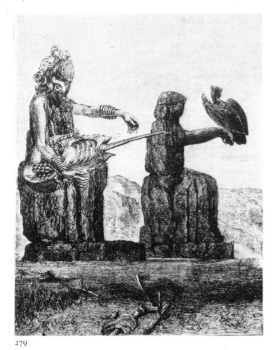

279

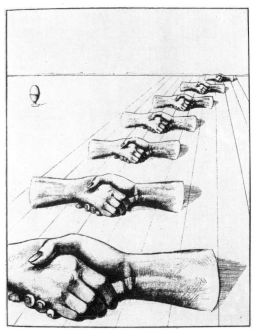

280

281

282

283 *Blind Swimmer (Effect of Touch)* 1934

284 *Landscape with Wheatgerm* 1934–35

285

This image of a distorted Europe dates from 1933. At the beginning of that year Hitler conducted negotiations to win the great capital interests over to supporting the advance of Fascism; on 30 January he became Reich Chancellor. The burning of the Reichstag on 27 February offered a pretext for the persecution of Communists and others. One day later, important basic civil rights in the constitution were set aside. In the Reichstag elections on 5 March the Nazis scraped home with a bare majority (52 per cent). On 24 March came the enabling act, and a little later the hue and cry against 'non-Aryans' began. The Nazi party had a monopoly of power. The laws establishing the Reich Chamber of Culture and controlling editorial activities extended the process of intellectual 'normalization'. The Reichstag election of 12 November consolidated the totalitarian state under the Führer. A large number of intellectuals and artists left Germany.

Since 1919–20 – when proto-Fascist tendencies began to make themselves felt – there had been individual works by Max Ernst which pointed a prophetic finger at the coming horrors. *The Preparation of Glue from Bones* (ill. 80) seems to prophesy the liquidation of the Jews and the sick; the *Massacre of the Innocents* (ill. 76) points to the mass slaughter of war, and the *Horde* pictures tackle the rise to power of the new masters.

In the year of Hitler's takeover of power came the first version of *Europe after the Rain* (ill. 285). The continent is deformed, laid waste, all traces of civilization are wiped out. What remains after the destruction is scarcely identifiable. When Joyce saw the picture, he found a play on words which acts as a verbal equivalent: 'Europe – Purée – Pyorrhée.'

The resources of *belle peinture* were no match for the task of portraying what was coming in Europe. Like Dubuffet later, Max Ernst is working here with crude implements.

286

287

285 *Europe After the Rain I* 1933
286 *Barbarians Marching Westwards* 1935
287 *Barbarians Leaving the City* 1935
288 *Barbarians Marching Westwards* 1935

288

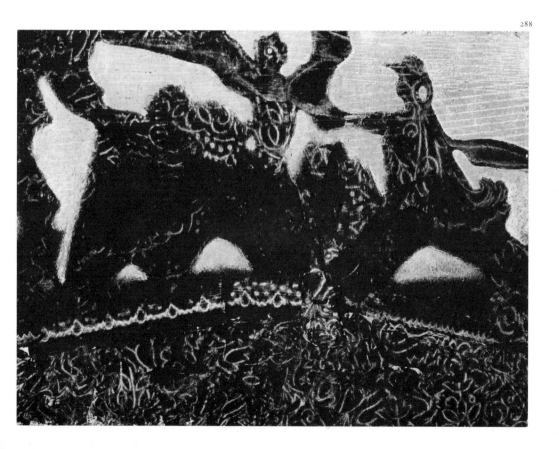

289

290

289 *The Entire City* 1933
290 *Petrified City* 1933
291 *The Entire City* 1934

291

292 *The Entire City* 1935

The *Entire Cities* are not entire at all, but ruined citadels. In one version (not reproduced here), the city on the mountain gives the impression of being the ruins of some urban utopia by a nineteenth-century architect – the remains, after some disaster, of Schinkel's projected palace on the Acropolis.

Werner Hofmann has pointed to a related iconographic pattern: 'The Romantic metaphors of transience prophesy the destruction of human creations: they are *vanitas* landscapes. Friedrich's "inner eye" transforms the perfectly preserved cathedral at Meissen into a ruin, as Hubert Robert had painted the ruins of the Grande Galerie of the Louvre; Sir John Soane portrays the ruins of the Bank of England; Flaubert visualizes Paris after an earthquake' (bib. 63).

But Max Ernst does not intend a metaphor for transience in general; these are not topographically identifiable cities and mountains. His pictures, on whose form the techniques of frottage and decalcomania (patterns pressed on to wet paint) are crucial influences and sources of inspiration, are variations on the older sun and forest motif which becomes released from the exclusively personal level of experience and transformed into general visions of the pattern of natural history. They now appear to us, in retrospect, as prophetic of the destruction visited on European cities by the Second World War.

The 1935 version of *The Entire City* sets against the structured framework of rubbed or imprinted forms a rampant fleshy plant world in harsh colours.

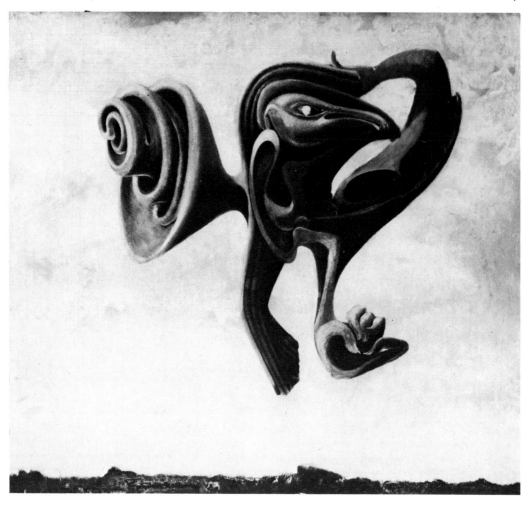

In 1931 Max Ernst had his first one-man exhibition in the USA (Julien Levy Gallery, New York). In 1933 he took part in a Parisian Surrealist exhibition, a year later in one in Zurich. In the Zurich catalogue he writes: 'By virtue of the fact that it [the Surrealist movement] threw relationships between "realities" into great confusion, it was able to contribute to the accelerating general crisis of conscience and of awareness in our day.' In 1934 he showed his recent works in the offices of the magazine *Cahiers d' Art*, which in 1936 devoted a whole issue to Max Ernst (bib. 34).

293 *An Ear Lent* 1935

This series of pictures is linked, along with *An Ear Lent*, to the group of bird memorials; but it introduces an entirely new element, the organic development of fictitious forms. Notable features are non-use of the collage principle, recognition of pure painting, replacement of the complete picture by a blown-up extract from a picture. Picasso's works from the 1931–32 period are related in their approach.

294

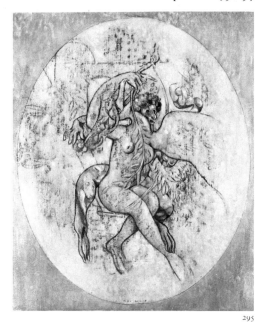

295

294 *The Grasshopper* 1934
295 *The Garden of the Hesperides* 1934
296 *Human Head* 1934
297 *The Birds* 1932

296

297

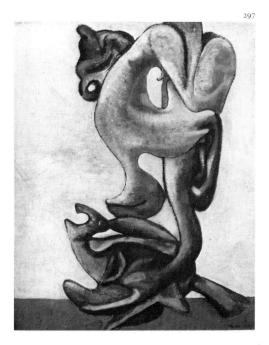

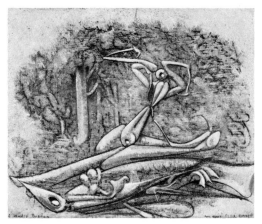

298 *Hunger Feast* 1935

300 *Henry IV, the Lioness of Belfort, a Veteran* 1935

299 *Berenice* 1935

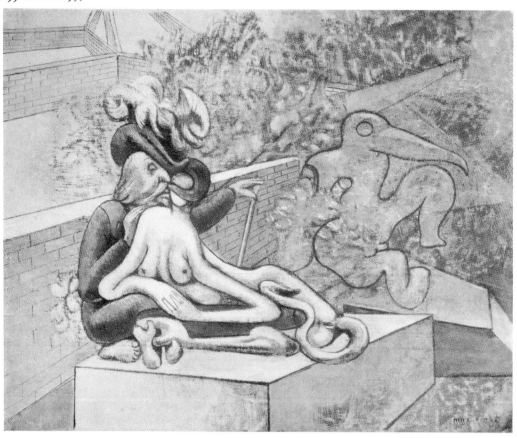

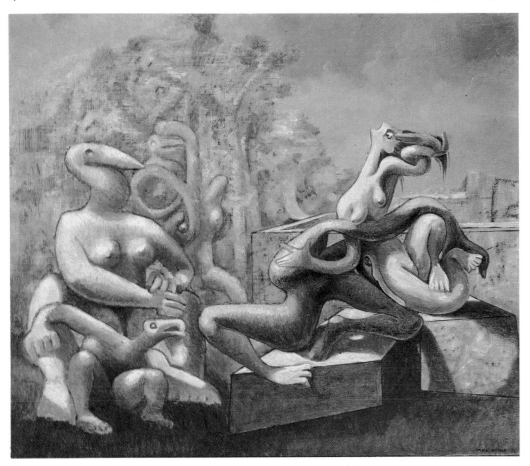

301 *The Breakfast on the Grass* 1935–36

There is a close formal relationship between *The Breakfast on the Grass* and Picasso's *Figures on the Shore* (1931). He is also paraphrasing a theme by Raphael which had been taken up by Manet. The title and layout lead one to expect an idyll; the picture itself turns a gay picnic scene into a grisly orgy. *Henry IV, the Lioness of Belfort, a Veteran* is also a counter-piece. The wedding of Henry IV was the occasion for the St Bartholomew's Night massacre; the 'Lion of Belfort', Colonel Denfert-Rochereau, defended Belfort in 1870–71. The picture is a grotesque drama in which the glorious defender is at one and the same time the bloodstained loser.

The title of *The Breakfast on the Grass* is a borrowing from Manet; and *Hunger Feast* is taken from Rimbaud. Max Ernst likes to play around with more or less current concepts. On his own admission the titles only come in the final stages. As plays on words and ideas, that is, as independent entities, they exist alongside, or even run counter to, the visual work. There are direct references to Rembrandt (*Polish Horseman*, ill. 373), Géricault (*Raft of the Medusa*, ill. 375), and the German novelist Theodor Storm (*Aquis Submersus*, ill. 29); and paraphrases of Nietzsche (*The Birth of Comedy*, ill. 366), Baudelaire (*The Elect of Evil*, ill. 160), and Matisse (*Lust for Life*, ills 314, 315). So in the world of language, too, Max Ernst modifies found objects.

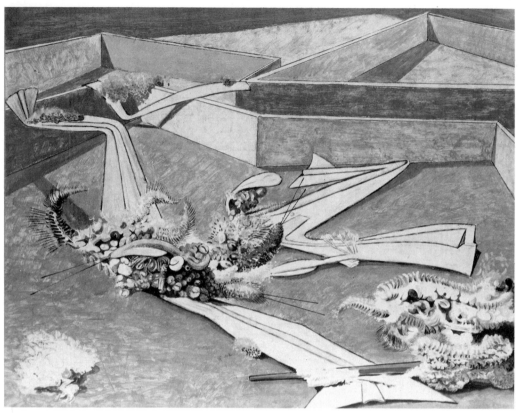

302

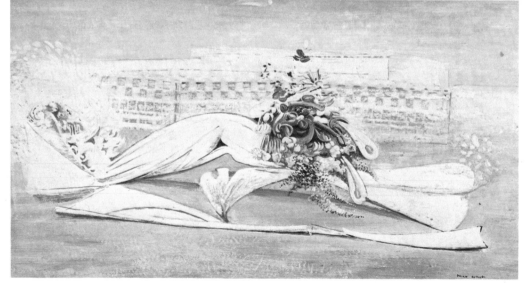

303

'Gluttonous gardens devoured by their own vegetation' (Max Ernst). Labyrinthine, snare-like garden architecture: Max Ernst owns an elaborate treatise by C. J. Kresz, dating from 1820, on the ways of trapping birds. Rampant plant growth with poisonous blooms: Max Ernst had long been interested in carnivorous plants. Aeroplanes: dogfights are the theme of an early collage; birds are their organic counterpart. One thing threatens another. It is left unclear who is setting the trap and who is falling victim. Pursuer and pursued are interchangeable.

304

302 *Garden Aeroplane-Trap* 1935

303 *Garden Aeroplane-Trap* 1935

304 *Study for Garden Aeroplane-Trap* 1935

305 *Garden Aeroplane-Trap* 1935

305

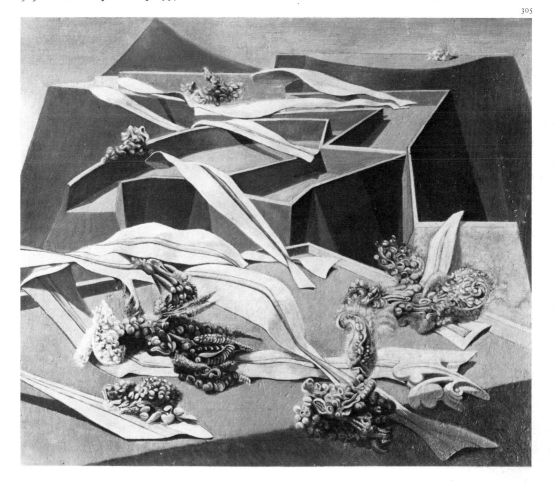

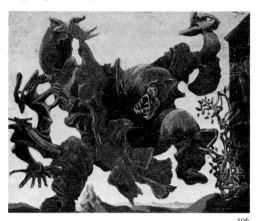

306

306 *The Angel of Hearth and Home* 1937
307 *The Angel of Hearth and Home* 1937
308 *The Angel of Hearth and Home* 1937

The *Angels of Hearth and Home* of 1937 are angels of death, biblically vengeful figures. Max Ernst himself said in this connection: 'One picture that I painted after the defeat of the Republicans in Spain, is *The Angel of Hearth and Home*. This is of course an ironic title for a kind of juggernaut which crushes and destroys all that comes in its path. That was my impression at the time of what would probably happen in the world, and I was right' (quoted in H. Reinhardt, *Das Selbstporträt*, Hamburg 1967).

This was one of the rare cases in which Max Ernst made a specific reference to political events. In 1938 he gave the picture for a time the title *The Triumph of Surrealism*, a despairing reference to the fact that the Surrealists with their Communist ideas had been unable to do anything to resist Fascism.

307

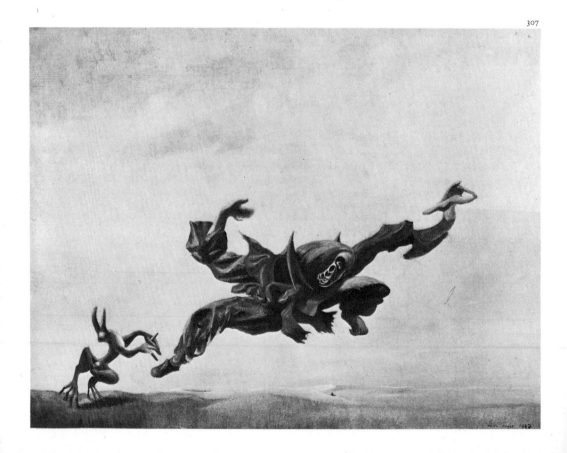

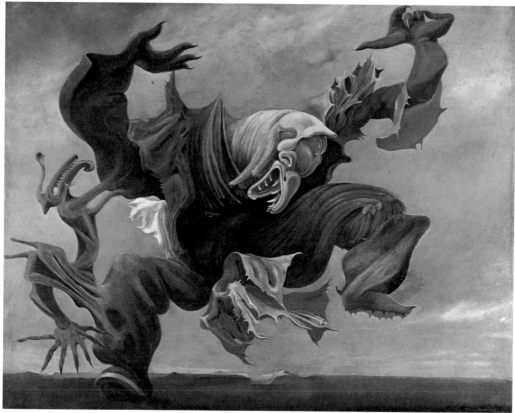

308

At the beginning of 1936 the parties of the Left in Spain, which had come together to form a popular front, won the elections. A military revolt under General Franco, which started in Spanish Morocco and soon spread out over all Spain, led to a civil war against the Republicans, Socialists and Communists. Forces sent by Mussolini and Hitler (Condor Legion) fought on the side of Franco for the establishment of a military dictatorship. A terrible war devastated Spain. With the help of German and Italian volunteers victory was finally achieved in 1939 against the Republican popular front government (which had been supported by an International Brigade). Under Franco's leadership Spain became a dictatorship with only one legal party, the Falange. Germany, Italy, England, France and the United States recognized the Franco régime.

In face of the civil war in Spain, progressive forces parted company with international Reaction. Very many artists and writers naturally came out in support of the Republic. In 1936 André Masson drew his sharp attacks on the clerics and the army, and John Heartfield encouraged the persecuted with the photomontage *¡No Pasarán! ¡Pasaremos!* in the Swiss magazine *Volks-Illustrierte*. In 1937 Julio González symbolized the resistance with his iron sculpture *La Montserrat*; Picasso declared his support for the oppressed with *Dream and Falsehood of Franco* and lamented the sufferings of the population of Guernica in a great easel painting; and Miró and Kokoschka produced posters demanding aid for the Spanish people. This was the context in which Max Ernst painted *The Angel of Hearth and Home*.

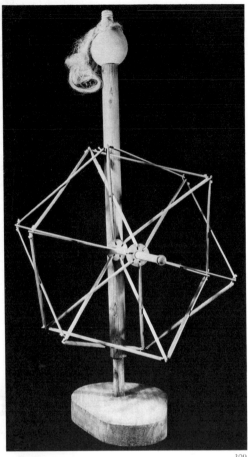

309

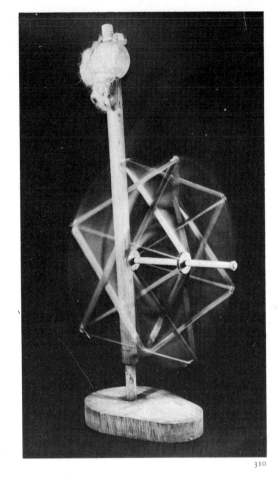

310

The *Mobile Object Recommended for Family Use*, first illustrated in 1937 in the special Ernst issue of *Cahiers d' Art*, bears testimony to Max Ernst's one excursion into kinetic sculpture.

Its forebears are Naum Gabo's *Virtual Volume* (1920), Alexander Rodchenko's *Hanging Construction* (1920) and Vladimir Tatlin's projected Monument to the Third International (1920). László Moholy-Nagy's *Light Set* (1926–29) became the model for the motorized kinetic sculptures of the 1960s (Harry Kramer, Nicolas Schöffer, Jean Tinguely). As early as 1913 Duchamp had brought into the art gallery a mobile readymade in the shape of his *Bicycle Wheel* (which depends, however, on the spectator to provide the motive power).

Long believed destroyed, this work was shown for the first time in Stuttgart in 1970.

In contrast to its predecessors, this sculpture is not an abstract kinetic object. Form and motion are directly derived from the spinning-wheel. Thus it is more a paraphrase of a utilitarian object than an artificial contribution to the history of kinetic sculpture. The wheel can be compressed or expanded on its horizontal axis, and also revolves about this axis. Like Giacometti's *Man, Woman and Child* (1931) and *Imprisoned Hand* (1932), it asks to be used, without the observer's handling and involvement with the object having any impact on its essential nature. It was sold as a multiple, in a small edition, in 1971.

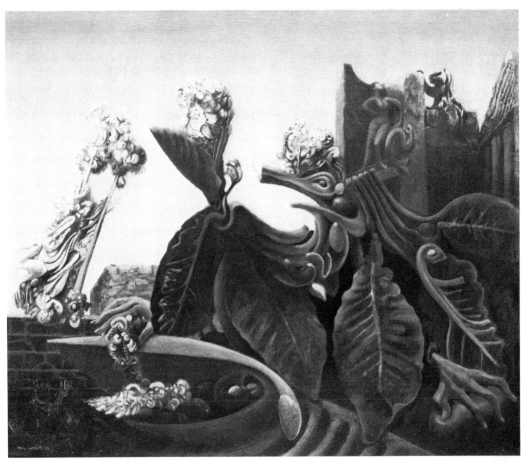

311

312

In a series of pictures dating from the late 1920s, the forest theme had been flattened into an abstract pattern; but this series from about 1936 has an entirely new significance: the forest now takes the form of a jungle of rampant, manifold growth which conceals human hands and creatures with beaked heads. The nymph Echo hovers in the background; Narcissus is a beast with bony hands, garlanded with fantastic vegetable regalia.

309–10 *Mobile Object Recommended for Family Use* 1936
311 *The Nymph Echo* 1936
312 *The Nymph Echo* 1936

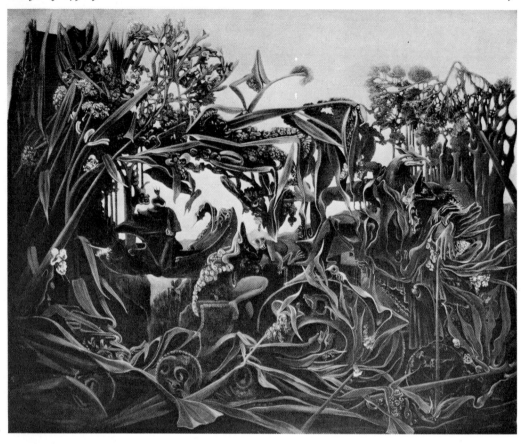

313 *Evening Song* 1938

314 *Lust for Life* 1936

The *Jungle Landscape with Setting Sun* by Henri Rousseau (1910) might well have served as a model for Max Ernst's rampant jungles, in which living creatures seem to be engulfed.

In an article in *Cahiers d'art*, Max Ernst himself designated the two animals in the lower part of the picture *Lust for Life* (*Joie de vivre*) as female dragonflies devouring their partners after the sexual act. In another picture of the same title, the motif of the identity between copulation and devouring returns. A 'lust for life' – in the sense of Matisse's *Joie de vivre* of 1906 – is not exactly what these pictures convey. Scorn is poured on the notion of an all-embracing unity fusing man, beast and plant.

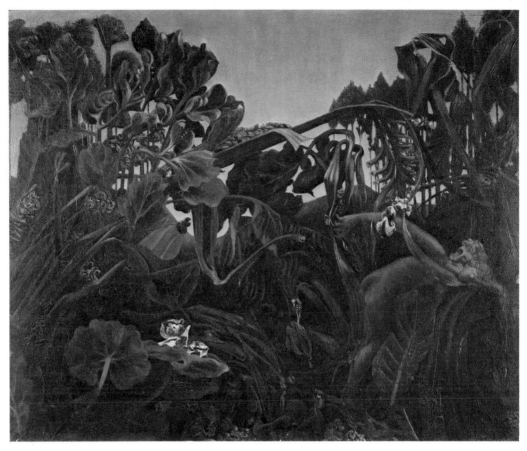

315 *Lust for Life* 1936–37

316 *Nature at Dawn* 1936

'My wanderings, my unrest, my impatience, my doubts, my beliefs, my hallucinations, my loves, my outbursts of anger, my revolts, my contradictions, my refusals to submit to any discipline . . . have not created a climate favourable to the creation of a peaceful, serene work. My work is like my conduct: not harmonious in the sense of the classical composers, or even in the sense of the classical revolutionaries. Rebellious, heterogeneous, full of contradictions, it is unacceptable to the specialists – in art, in culture, in conduct, in logic, in morality. But it does have the ability to enchant my accomplices: the poets, the 'pataphysicians and a few illiterates' (bib. 46).

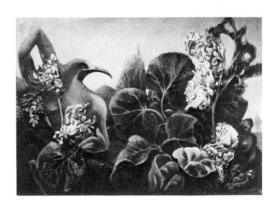

317

317-19 Stage sets for Alfred Jarry's *Ubu enchaîné* 1937

Diaghilev's Ballets Russes, for which Max Ernst had worked in 1926, are of supreme importance in the history of the work done for the stage by visual artists in this century. Around 1910, picturesque décor serving only to illustrate the action was dominant, but shortly before 1920 progressive experiments with an artistic approach valid in its own terms came to the fore: in 1917 *Parade* by Cocteau and Satie was designed by Picasso, and Stravinsky's *Firebird* was designed by the Futurist Giacomo Balla. In the 1920s Léger, Matisse (both 1927), Braque and Gris (both 1924), André Derain (1919, 1926), Naum Gabo and Antoine Pevsner (1927) and De Chirico (1929) all worked for the Ballets Russes. The 'painter's theatre' was born; but now it provided no fundamentally new impulses for the action on stage. Within the content of the production as a whole the visual arts again had a subordinate role.

318

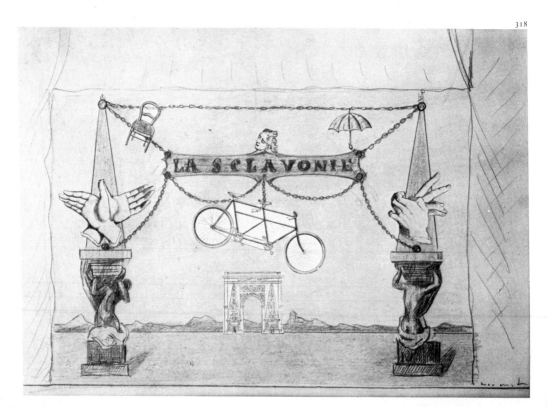

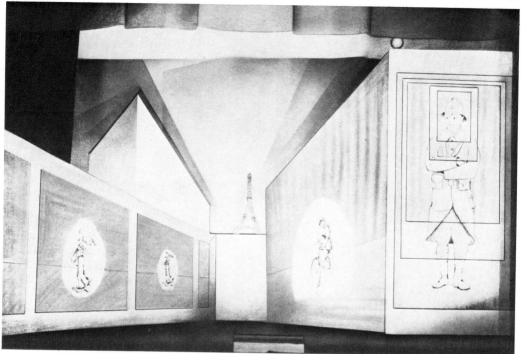

319

In 1926 Max Ernst provided the set for the second act of *Roméo et Juliette* for the Ballets Russes. (Miró did the first act; music was by Constant Lambert; choreography was by B. Nijinska and Georges Balanchine; Serge Lifar danced the role of Romeo.) In so doing Max Ernst incurred the disfavour of Aragon and Breton for having collaborated with a counter-revolutionary bourgeois organization.

His next stage designs were produced in 1937 for the world première of Alfred Jarry's *Ubu enchaîné* (written in 1899), under the direction of Sylvain Itkine, at the Comédie des Champs-Elysées. As is well known, Jarry was regarded by the Surrealists as one of their ancestors (the première of *Ubu roi* was in 1896, of *Ubu cocu* in 1946).

Not until the 1960s did Max Ernst design any further stage sets. He produced a setting for Jean-Louis Barrault's production of Giraudoux's *Judith* at the Odéon in Paris in 1961; costumes were by Dorothea Tanning. In 1968 there were designs for *Turangalîla* by Messiaen at the Paris Opéra (choreography by Roland Petit).

Max Ernst's stage designs bear the same relation to the drama as his illustrations to the text. This holds good particularly in the case of Jarry's *Ubu enchaîné*. Without seeking to interpret the play, he offers an acting area with only a few indications of content. In the manner of the collage he brings together on the stage the 'attributes of French mythology' (Werner Spies): the Eiffel Tower, cyclists competing in the Tour de France, French soldiers, the allegorical figure of fertility.

The programme for the première in 1937 contained a homage to Jarry with contributions by Picasso, Man Ray, Miró, Magritte, Tanguy and others.

320

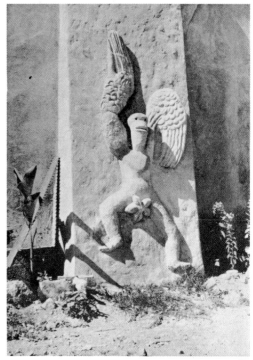

321

322

In 1938 Max Ernst moved to Saint-Martin d'Ardèche, north of Avignon, where he renovated a tumbledown seventeenth-century farmhouse and decorated it with cement sculptures of creatures part man, part bird, and part beast.

In defiance of Breton's veto, Max Ernst had contributed 48 works to the exhibition 'Fantastic Art, Dada, Surrealism' in 1936 in the Museum of Modern Art in New York. Now, in 1938, Breton ordered him to boycott Eluard; Max Ernst left the Surrealist group out of loyalty to his friend. At the beginning of the year the group had once more come together in a large exhibition in Paris organized by André Breton; but in 1939 the group began to disperse. Breton, Masson, Matta and Tanguy emigrated to the United States, Péret to Mexico.

323

320–23 Reliefs on Max Ernst's house at Saint-Martin d'Ardèche 1938

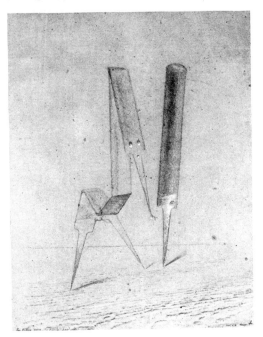

324 *Les Milles (Stateless Persons)* 1939

325 *Les Milles (Stateless Persons)* 1939

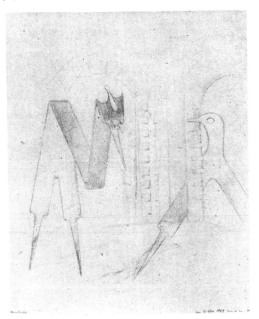

In 1939 Max Ernst was interned as an enemy alien, first at Largentière, then at Les Milles near Aix-en-Provence, where he met the German-born Surrealist Hans Bellmer. When Eluard intervened on Max Ernst's behalf with the authorities, he was freed, but when the Germans came in May 1940 he was arrested again. He managed to escape, was caught again, fled with the Gestapo on his track, and emigrated, with the help of Peggy Guggenheim, via Spain to New York; many Surrealists were on the same route.

Three of the frottages done in the camp at Les Milles, some coloured, some highlighted in white, are shown here. Anthropomorphic figures were formed by rubbings of files; these occasionally refer back to the Loplop motif.

In 1939 Max Ernst had painted *The Robing of the Bride* (ill. 328), a veristic picture of great imaginative power. Here, it seems, the potential of *Une semaine de bonté* is translated into colour. Creatures that are half bird, half human, fill the picture out to the frame, whose interior refers back to Renaissance paintings. Whereas in the 1920s Max Ernst's work, for all its representational quality, possessed a puzzling ambivalence by virtue of its psychic implications, now the fantastic figures become less and less equivocal. The use of surreal precision in the evocation of nightmare scenes goes one step further here than in *The Gardens of the Hesperides* of 1934 and 1935 (ills 295, 327).

These tangible figures of 1939 are also only a passing phenomenon; soon Max Ernst once more became fascinated by a new technique, that of decalcomania (squashing wet paint on the canvas; see p. 168), which gave him a new impetus for materializing his visions, externalizing the realism of the spirit and evolving 'beyond painting'. In these works the figures of 1939, whose antecedents are to be found lurking throughout his previous work, and which come out into the open in *Une semaine de bonté*, appear in a changed form; and their metamorphosis becomes the theme of the picture.

326 *Human Figure* 1939

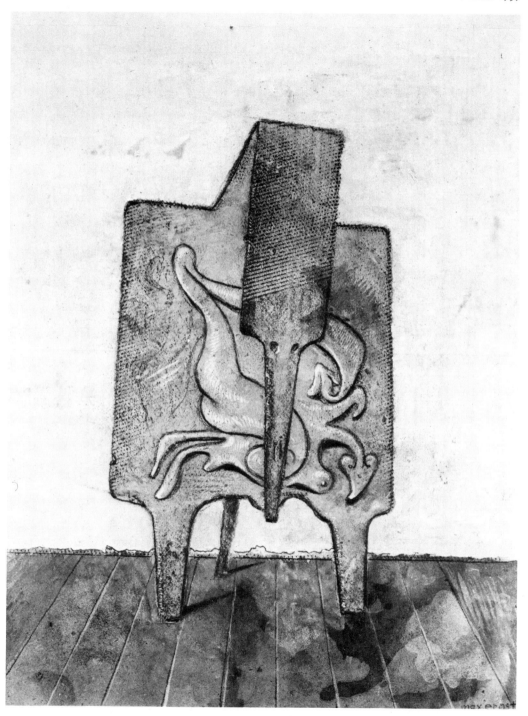

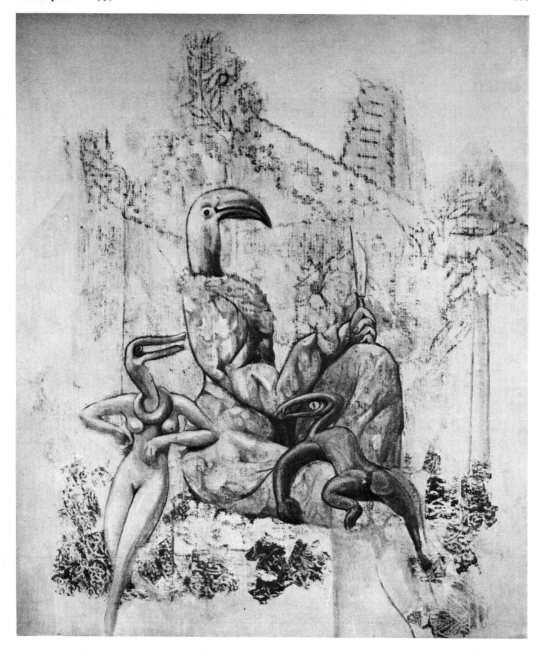

327 *The Garden of the Hesperides* 1935

328 *The Robing of the Bride* 1939

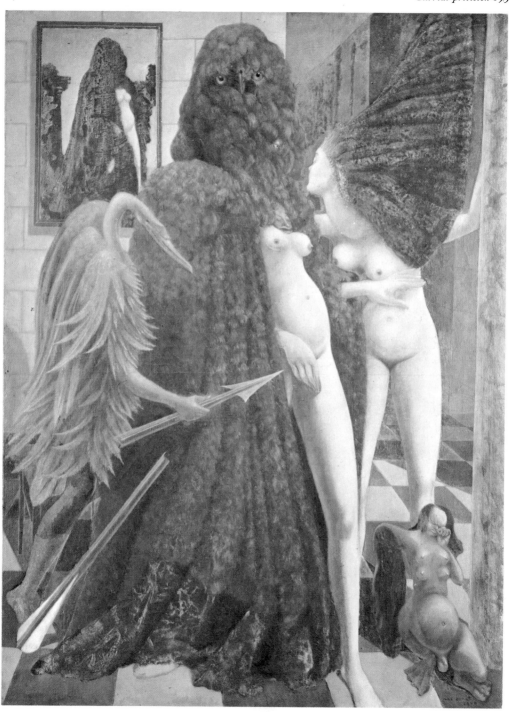

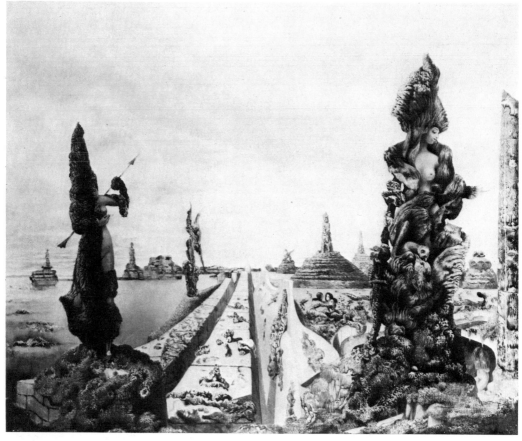

329 *The Stolen Mirror* 1941

When Max Ernst and Hans Bellmer met in a French internment camp, they both tried their hand at the technique of decalcomania developed by Oscar Domínguez in 1935. In decalcomania, thinned paint is pressed on to the canvas with a smooth-surfaced object (a pane of glass); this spreads it unevenly over the slightly irregular surface of the canvas, producing areas of colour of varying intensity which inspire the painter to interpret them as forms.

The Stolen Mirror and *Marlene* were executed shortly before he emigrated; he painted further works in 1941 on a journey to San Francisco. The principle underlying these works is that of metamorphosis.

Max Ernst fills out, expands or limits the basic structure formed by decalcomania by means of painstaking brushwork. Plants turn into living animals, architectural shapes turn into statues which are at once plant, human shape and *tropaion*. The metamorphosis takes place so smoothly that it is impossible to make out whether a living substance has been petrified or an inanimate one brought to life, whether these are plants revealing human forms or humans revealing plant forms.

These transformations do not owe their origin to psychoanalytical insights; Max Ernst is spurred on by the diffuseness of the original forms, which can be played with to produce the unexpected.

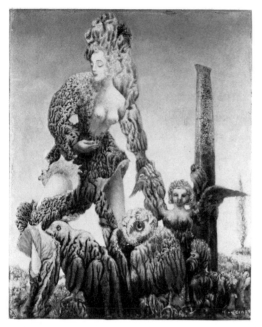

330 *Marlene (Mother and Child)* 1940–41

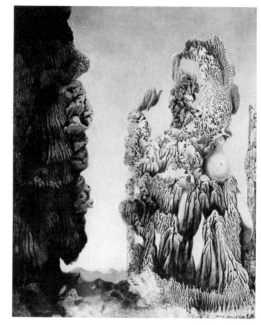

331 *Mythological Figure – Woman* 1940

332 *The Harmonious Breakfast* 1941

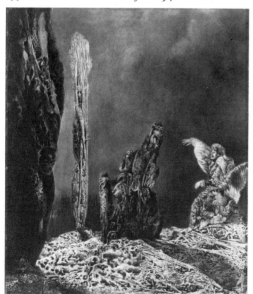

333 *Napoleon in the Wilderness* 1941

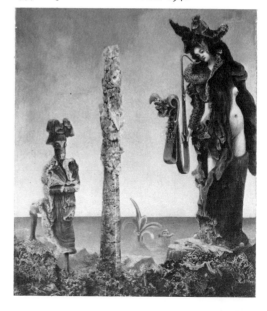

334 The Art of This Century Gallery, New York
1942

Max Ernst arrived in New York in 1941. His position, like that of the other European émigrés there, was not an easy one. American art, only occasionally coming under the influence of European painters, had pursued its own tradition of realism; but for all that a small circle was familiar with Surrealism. In 1931 Max Ernst had had his first one-man exhibition in New York; in the same year the first significant Surrealism exhibition outside France had been staged at Hartford, Connecticut. In 1936 Julien Levy, who had presented Arp, Dalí, Masson, Miró, Man Ray and others in his New York gallery, had published a book on Surrealism.

In October 1942 Peggy Guggenheim, whom Max Ernst had married the year before (she was his third wife), opened the Art of This Century Gallery in New York, designed by Frederick Kiesler and devoted especially to the European avant-garde; it was soon to be staging the fifth international exhibition of Surrealism. Peggy Guggenheim acquired a whole series of important pictures by Max Ernst, among them *The Antipope* and *Postman Cheval* (ill. 240). These works later entered her collection in Venice.

In the photograph of the New York gallery can be seen sculptures by Alberto Giacometti (*Strangled Woman*, 1932; *Woman Walking*, 1933–34) and pictures by Max Ernst (*The Kiss, The Robing of the Bride, Forest, The Antipope*).

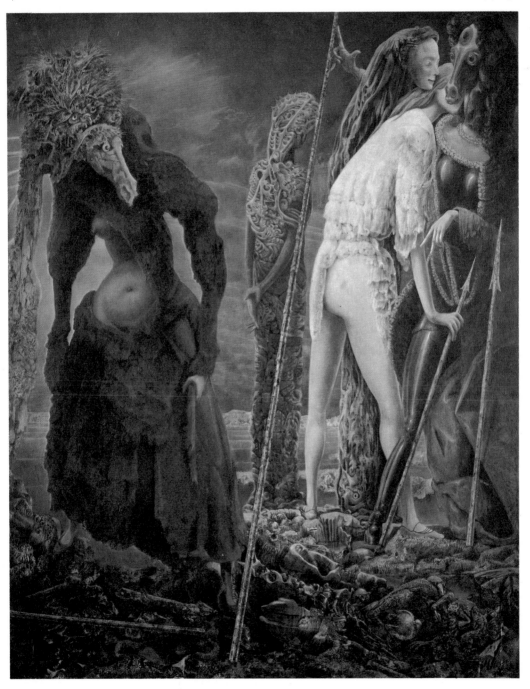

335 *The Antipope* 1941–42

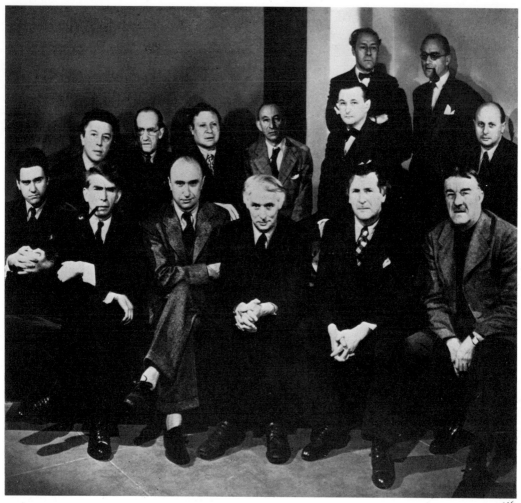

336

The Museum of Modern Art in New York, which had mounted the exhibition 'Fantastic Art, Dada, Surrealism' in 1936, showed works by Dalí and Miró in 1941. Shortly afterwards the Pierre Matisse Gallery put on an exhibition of 'Artists in Exile' – the photograph above was taken on the occasion of this exhibition. The émigrés had shifted the focal point of world art from Paris to New York. Josef Albers, Lyonel Feininger, Lászlo Moholy-Nagy, Hans Hofmann, Naum Gabo, Walter Gropius, Marcel Breuer and Ludwig Mies van de Rohe were among others in the USA.

The European avant-garde had made its initial impact on American art at the Armory Show in New York in 1913. The second big wave came with the émigrés. The teaching of Albers and Hofmann laid the foundations for a whole generation of American artists; and the Surrealists with their theory of automatism influenced the artists who later created Action Painting. Taking over the formal elements (Arshile Gorky) and techniques (Jackson Pollock, Robert Motherwell) of Surrealism helped American art to find a way out of its crisis of identity.

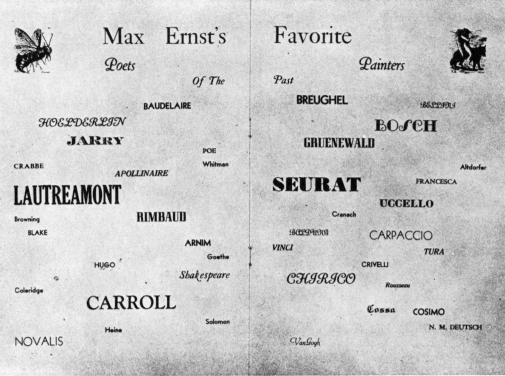

Max Ernst's Favorite

Poets Of The Past *Painters*

BAUDELAIRE BREUGHEL *BELLINI*

HOELDERLIN BOSCH

JARRY GRUENEWALD

POE

CRABBE Whitman Altdorfer

APOLLINAIRE FRANCESCA

LAUTREAMONT SEURAT

UCCELLO

Browning RIMBAUD Cranach

BLAKE *BALDUNG* CARPACCIO

ARNIM VINCI TURA

Goethe CRIVELLI

HUGO *Shakespeare* CHIRICO Rousseau

Coleridge

CARROLL *Cossa* COSIMO

Solomon N. M. DEUTSCH

NOVALIS Heine *VanGogh*

337

338

In 1940 the writer Charles H. Ford founded in New York a bulletin for modern art and poetry under the title *View*. In 1941 a double issue (no. 7/8) was devoted to Surrealism (ill. 337), and in 1942 another to Max Ernst.

From 1942 onwards, David Hare, Breton, Duchamp and Ernst produced the periodical *VVV*, which also aimed at an exchange of views between European emigrants and the American avant-garde. Also in 1942, a very important exhibition was arranged by Duchamp and Sidney Janis under the title 'First Papers of Surrealism'.

336 Artists in exile, New York 1942. Left to right: Matta, Breton, Zadkine, Mondrian, Tanguy, Masson, Max Ernst, Ozenfant, Tchelitchew, Lipchitz, Chagall, Seligmann, Léger, Berman
337 Page opening in *View*, designed by Max Ernst, 1941
338 Cover of the journal *VVV*, no. 1 1942

1942 NUMBER ONE

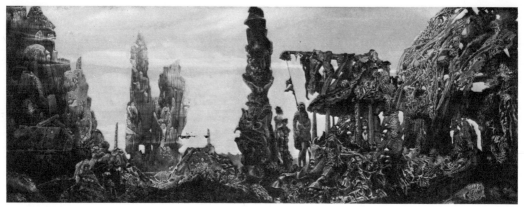

339

339 *Europe After the Rain II* 1940–42
340 *The Eye of Silence* 1943–44
341 *Temptation of St Antony* 1945

340

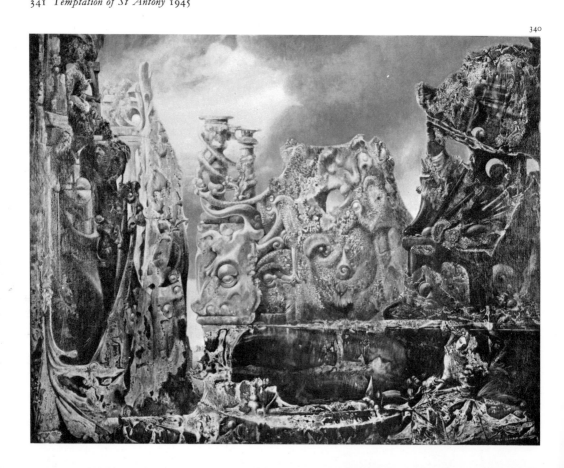

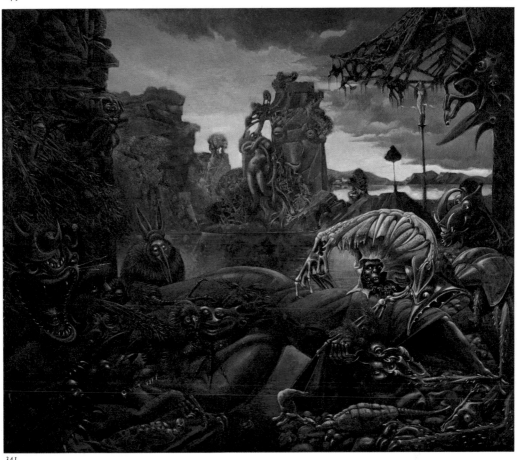

341

In *The Eye of Silence* Max Ernst takes up an old
theme using the technique of decalcomania.
The theme is that of the relationship between
blindness, visions and sight. It is based upon
a Romantic landscape, an inheritance from
Böcklin. Mountains and plant growth under-
go a metamorphosis, during which eyes and
facial features are introduced.

Europe after the Rain II is to some degree a
ground-level view of the first rainscape of that
title (ill. 285), which had been shown viewed
from above.

The *Temptation of St Antony* (ill. 341), mostly
painted with the brush, can be regarded as a
reflection of the *Temptation* by Grünewald
(Mathis Gothart Neithart) on the Isenheim
altarpiece. The metamorphosis of plants into
human forms and vice versa is anticipated
by Grünewald; Max Ernst repeated these
aggressive monsters without actually copying
them. In 1970 he said in an interview: 'Of
course there have been men of genius in
German painting: Grünewald and Altdorfer'
(bib. 42).

The work owes its origin to a competition
in which a picture for a film based on Mau-
passant's short story *Bel Ami* was sought. The
subject was set; among others Dalí competed.
The jury (Alfred H. Barr, Marcel Duchamp,
Sidney Janis) made Max Ernst the winner.

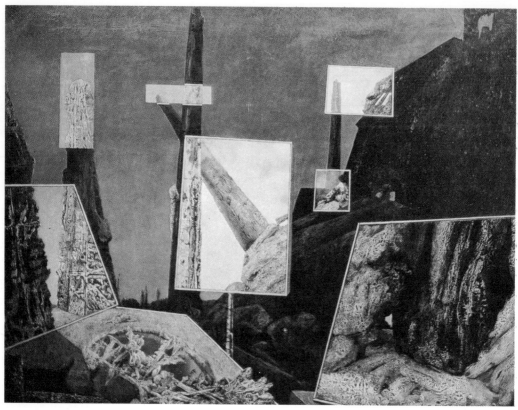

342 *Day and Night* 1941–42

Day and Night, a picture begun at Saint-Martin d'Ardèche and completed in New York, introduces a new series of works, which from the point of view of form derive from the collage, in that they do not present a unified pictorial entity. In the ideas underlying them, they go one step beyond the earlier collages.

The quotation technique practised in the Loplop series here brings together the daytime and night-time appearance of a single landscape. Each of the Loplop figures presented a single motif; but here each landscape is an exhibition in itself: the identity of the landscape and the picture in the landscape with the motif from that landscape calls to mind Magritte's use of easel pictures within pictures.

This principle is reinforced and clarified in the following works bearing the didactic title *Paintings for Young People*. Within a strictly rectangular framework Max Ernst presents motifs from his own pictorial world. What emerges is something like a representation of a wall in a collector's gallery or an artist's studio. The quotations cover *Forest and Sun*, *Lust for Life*, *Caged Bird*, *Earth Beams*, the positive-negative technique, decalcomania, frottage, the knife technique, drip painting (see p. 178). Max Ernst is very skilful at handling his own material, as he was in 1920 in the *Design for a Manifesto* (ill. 59) and again ten years later in the Loplop series. As résumés the *Paintings for Young People*, and above all *Vox Angelica*, are of central importance in Max Ernst's work.

343

343 *Vox Angelica* 1943

344 *Painting for Young People* 1943

345 *Painting for Young People c.* 1943

344

345

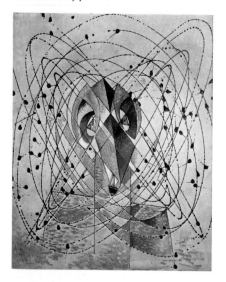

'Tie an empty tin can to the end of a piece of string one or two yards long, drill a small hole in its bottom, fill the can with paint. Allow the can to swing to and fro on the end of the string over a canvas lying flat on the ground, guide the can by movements of the arms, the shoulders and the whole body. In this way amazing lines trickle on to the canvas. And then the game of free association can begin' (bib. 64).

Max Ernst records in his autobiography that this was how he explained his new technique for the production of paintings to the young American painters.

346 *Young Man Intrigued by the Flight of a Non-Euclidean Fly* 1942–47
347 *The Bewildered Planet* 1942

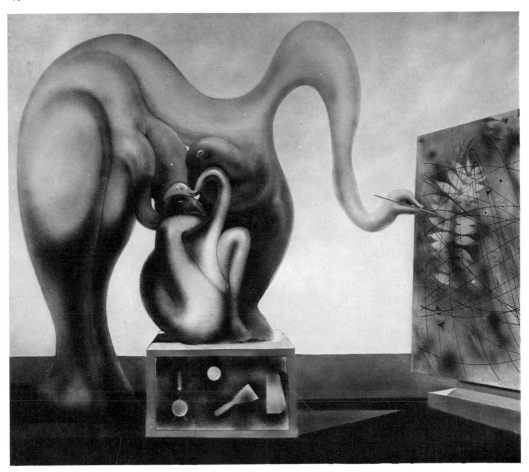

348 *Surrealism and Painting* 1942

The technique of drip painting was admired above all by Jackson Pollock, who saw the *Young Man . . .* as early as 1942; from a historical point of view, it marks the link between the Surrealist automatism theory and the Action Painting of the young Americans. True, the history of postwar painting would not have taken a different course if this picture had not been painted; the New York painters were simply ready to see in the drip technique the very best prospects for the pursuit of their own expressive concerns.

Surrealism and Painting brings together a monster-figure, related to those in the paintings of 1935–36 (ills 300, 301), and a drip painting (which it is paradoxically doing with a brush). The work thus combines a mysterious 'paroxysm of horror' (Waldberg) with an unmysterious new painting technique.

This painting, which was executed in the year in which he met the painter Dorothea Tanning (whom he married in 1946 and remained with ever after), marks the end of paintings expressing horror and disquiet in Max Ernst's work. *Surrealism and Painting* (which owes its title to a book by Breton) paves the way for the poetic, harmonious works of his later-period.

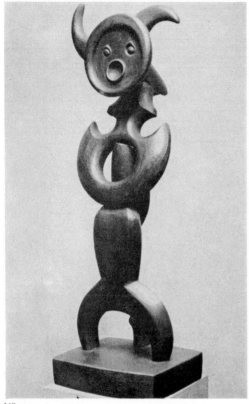

349

350

In 1944 Max Ernst spent the summer at Great River on Long Island. There, for the first time for ten years, he produced mainly sculptures. Some, including the *Young Man with Pounding Heart* and *Moonmad*, were carved in mahogany; others, such as *The Table is Set*, were made up of modified found objects cast in plaster. Not until the 1950s was any of them cast in bronze.

At about the same time, and independently of Max Ernst, Picasso was exploiting the principle of making a sculptural collage from modified found objects. In both cases the sculpture is neither the product of pure imagination, nor a single unified form, but a disconcerting combination of individual structures. Direct access to these works is obstructed by the fact that Max Ernst neutralizes the content of his found objects by modifying them; and as a result they are concrete and abstract at the same time.

The Table is Set is both a vision of a fantastic landscape and a frozen still-life of Surrealist objects on a platform or table. As early as 1933 Giacometti, with whom Max Ernst had stayed in the following year, had done a sculpture with the title *Surrealist Table*. The table motif was to be subsequently taken up by Eduardo Paolozzi (1948–49), Jean Ipoustéguy (1959–62) and Daniel Spoerri (after 1960).

Also in 1944, Max Ernst developed chessmen in wood. Some of them recur in *The King Playing with the Queen* (ill. 355). In the spatial support given by the bent arms and in the characterization of the patriarchal relationship between the king (with the bull's head) and the queen, who is under his protection and in his power at the same time, Max Ernst reveals himself as a sculptor of unusual power.

'Max Ernst's achievement lies not least in the fact that he has found his way to rounded sculptural forms, ostensibly modelled, but which in reality owe their existence and morphology to a complex technique of casting and assemblage' (Werner Spies, bib. 63).

349 *Moonmad* 1944
350 *Young Woman in the Shape of a Flower* 1944

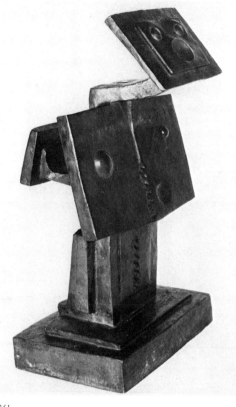

351

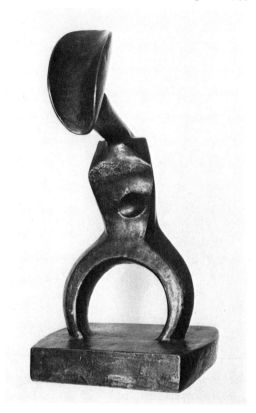

352

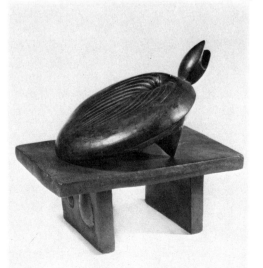

353

351 *A Solicitous Friend* 1944

352 *Young Man with Pounding Heart* 1944

353 *Tortoise* 1944

354 *The Table is Set* 1944

354

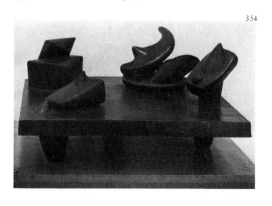

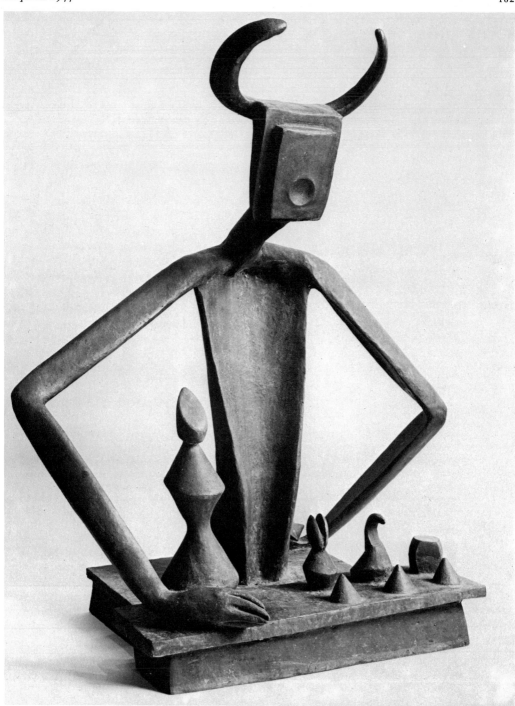

356

357

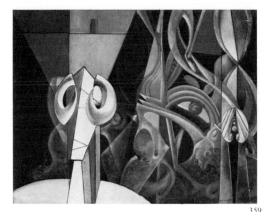

358 *Chymical Nuptials* 1947–48
359 *Design in Nature* 1947
360 *Euclid* 1945
361 *The Feast of the Gods* 1948

359

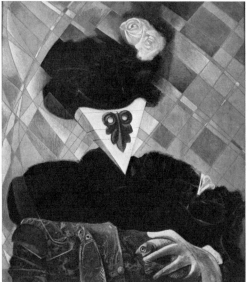

358

360

The first pictures incorporating a literal three-dimensional treatment of Cubist elements came when he was still in New York. The interlocking box-like forms (cf. ill. 366) call to mind the Merz constructions of Schwitters.

In 1946 Max Ernst moved with Dorothea Tanning to Sedona, Arizona. 'There I found once more the landscape which had always been in my mind and which is to be found time and again in my early pictures' (in Reinhardt, *Das Selbstporträt*, Hamburg 1967). He lived in Arizona, apart from a European trip in 1949–50, until he moved back to Paris in 1953.

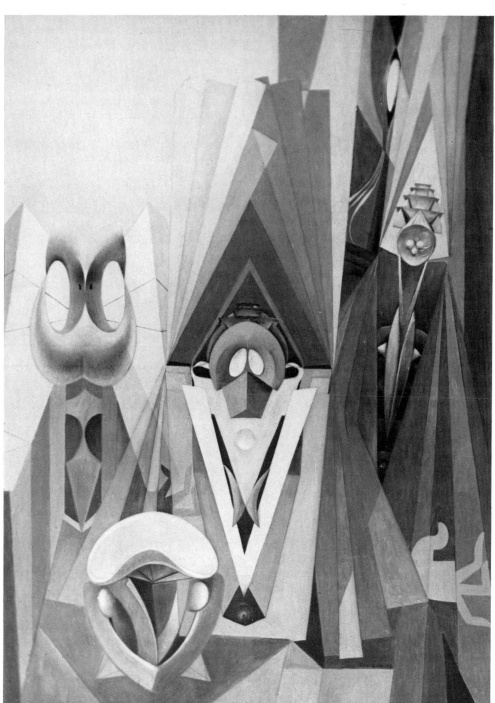

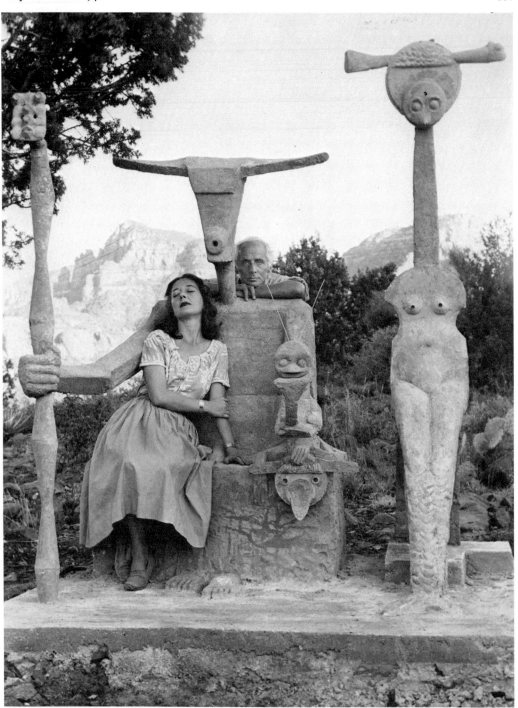

The main sculptural work of this period – and the greatest of all his sculptures – is the cement sculpture *Capricorn*, which was cast in 1964 in a slightly modified form.

This monumental group is a kind of family portrait with the character of a charm, and at the same time a summing-up of his sculptural activity. Max Ernst fuses medieval astrological conceptions with the psychological ideas current in his day.

'The male figure is not only the "king" of the chess game but also the symbolic bull and goat of the zodiac. Metamorphosis and rebirth are associated with Capricorn, as are fertility, Bacchus and rock (including cement). . . . Consciously or subconsciously, Ernst used the astrological fish motif in the fishtailed "dog" on the king's arm and in the mermaid form of the queen, whose "bone" head ornament is equally a fish' (bib. 51).

From the point of view of the form there are links with the destroyed sculpture *Standing Woman* from 1944 and the reliefs that Max Ernst made at his house at Saint-Martin d'Ardèche (ills 320–23).

In 1948 Max Ernst became an American citizen; and in the same year a comprehensive volume edited by Robert Motherwell appeared under the title *Beyond Painting and Other Writings by the Artist and his Friends* (bib. 35); it was the first substantial Ernst publication since *Cahiers d'Art* in 1937 (bib. 34).

The previous year there had been a big Surrealist exhibition in Paris, staged by Breton (and there works by Max Ernst were given their first postwar showing by Eluard), and in 1949 Max Ernst had a retrospective exhibition at the Copley Galleries, Beverly Hills, with sixty-six works covering the whole period between 1919 and 1948.

In 1949 Max Ernst visited Europe for the first time after an absence of nine years, and after a terrible war had devastated wide areas of the continent and slaughtered its population. He kept out of Germany. He never really felt happy when living in his homeland; he did go back several times afterwards, but never to live. In 1958 he was to take out French citizenship.

363

Max Ernst decorated his house in Sedona, especially with reduced metaphorical reliefs which in part probably owe their origin to impressions gained on a journey to Mexico in 1941: the heads resemble those of the skull rack of the rain god Tlaloc at Calixtlahuaca.

362 Dorothea Tanning and Max Ernst with the sculpture *Capricorn*, Sedona 1948
363 Frieze on Max Ernst's house, Sedona 1948
364 Dorothea Tanning and Max Ernst, Sedona 1948

364

In the second half of the 1940s Max Ernst
continued the series of pictures with angular,
geometrical heads which had begun with
Euclid (ill. 360); here and there are to be found
in these works echoes of earlier periods, not
least in the case of the Tanguy portrait with
its use of letters. In *The Birth of Comedy*, the
title of which is an allusion to Nietzsche, he
employs the motif of the ancient Greek
dramatic mask.

In 1949, Max Ernst published in Beverly
Hills a set of poems and collages under the
title *At Eye Level: Paramyths*, and in Paris
illustrations to Péret's *La Brebis galante*. In
1952 he gave a series of lectures at the Univer-
sity of Honolulu on the influence of so-called
primitive art on contemporary art.

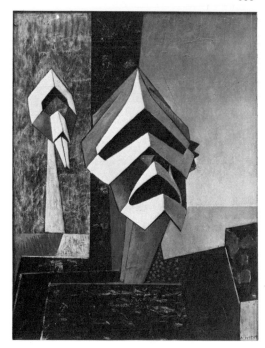

365 *The Cocktail Drinker* 1945

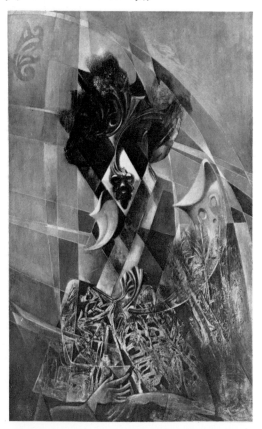

366 *The Birth of Comedy* 1947
367 *Portrait of Yves Tanguy* 1948

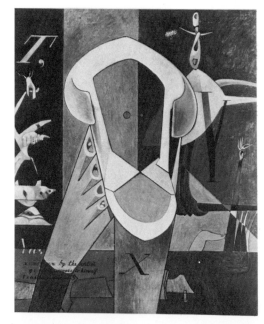

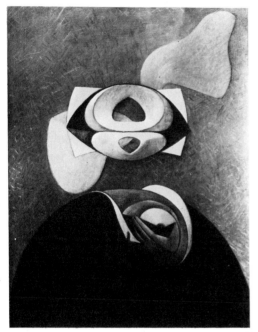

368

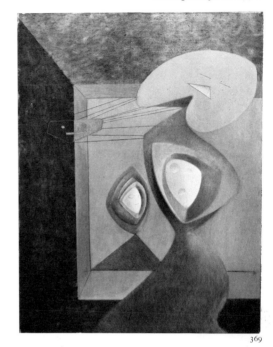

369

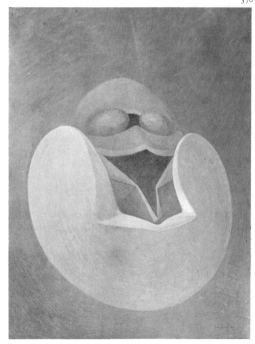

370

At this time he also produced paintings – painted exclusively with the brush, and thus 'conventional' in technique – which incorporate amorphous figures which should be regarded in the context of the figurations of the early 1930s (ills 293, 294). Max Ernst's creative powers were not on the wane. The great picture *Spring in Paris* seems to be a reaction to certain tendencies towards abstraction and distortion which can be found in individual works of Max Ernst's great opposite, Picasso, in the late 1920s, mid-1930s and late 1940s. Despite all their differences, the two artists have this in common, that they remain within the sphere of the concrete. Max Ernst devoted himself more and more to illustrating: between 1949 and 1971 around sixty print portfolios and books appeared.

368 *The Portuguese Nun* 1950
369 *Spring in Paris* 1950
370 *Backfire* 1950

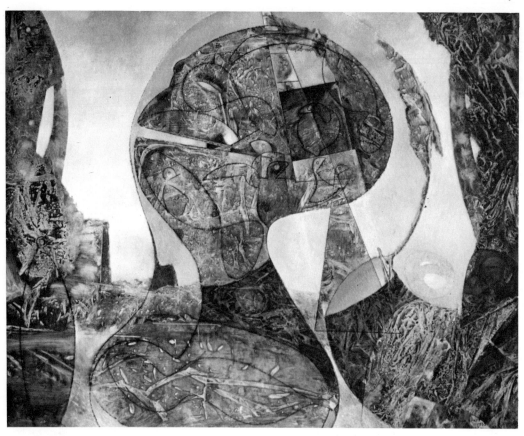

371 *Old Man River (Vater Rhein)* 1953
372 Marcel Duchamp, Max Ernst and Hans Richter, New York 1953

Max Ernst's first big retrospective exhibition was held in the Schloss Augustusburg in his home town, Brühl, in 1951. As if in memory of his homeland he painted two years later the picture *Old Man River (Vater Rhein)*, with strongly glazed colours and employing all the virtuosity at his command. The picture is as hermetic as *Polish Horseman* – the title of which is a reference to a picture by Rembrandt – in which figures and landscape are superimposed in similar transparent forms.

Both pictures were painted in Europe; in 1953 Max Ernst returned to Paris for good. In the same year he had a retrospective exhibition at Knokke-le-Zoute. But it could not yet be said of Belgium, of France, or yet of Germany – where the Brühl exhibition caused those involved a great deal of trouble – that he had gained recognition there.

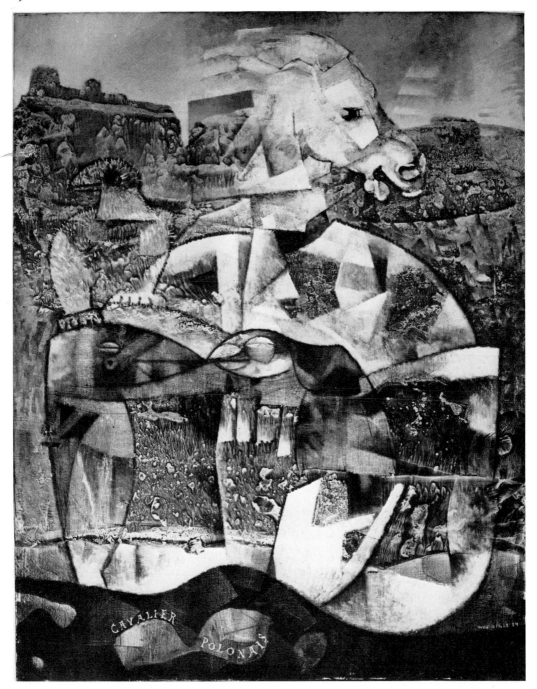

373 *The Polish Horseman* 1954

374

In 1954 'M.E. to his great surprise captured the top prize for painting (with Arp getting the sculpture and Miró the drawing prize)' (bib. 64) at the Venice Biennale; and this resulted in his final expulsion from the circle of the Surrealists.

'1956. Finds in a shop at Chinon rolls of old-fashioned wallpaper of the kind he had used over thirty-five years before, and much enjoys making a series of collages: *Dada-Forest*, *Dada-Sun*' (bib. 64). Forest and sun, collage and Dada: all reappear in these works. But Max Ernst is not here trying to recapture his own youth; he is delighting in renewing acquaintance with what has long since become history. The sun becomes a gleaming, working cogwheel, the forest a reproduction of wood graining, which at the same time might be a frottage. What he takes over is disrupted in a spirit of irony. In the same way that Max Ernst at other times metamorphosed found objects from outside sources, he here applies the process of metamorphosis to his own past work, and does so in such a way that he seems to be deliberately inviting the accusation of self-plagiarism which is frequently levelled at an artist's late work.

374 *Dada-Sun, Dada-Forest* 1956

375 *The Colorado of Medusa (Coloradeau de la Méduse)* 1953

376 *Sign for a School of Herring* 1958

376

375

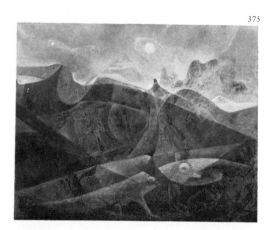

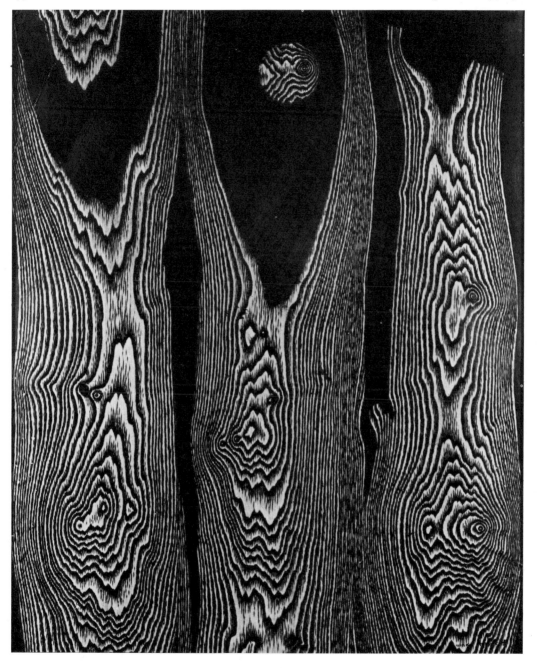

377 *Forest, Sun, Snow* 1956

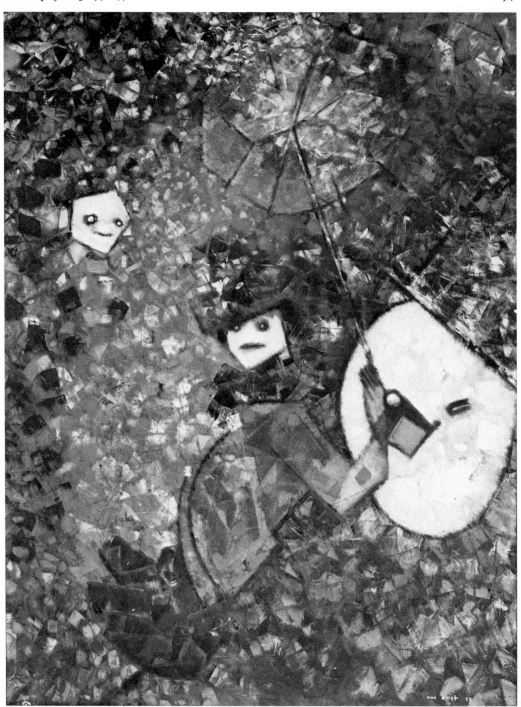

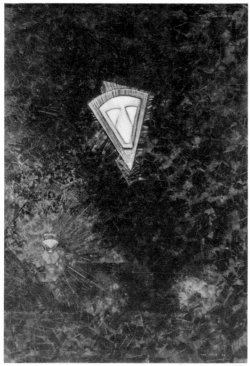

379

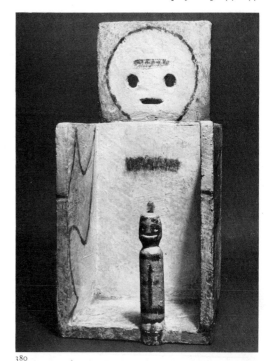

380

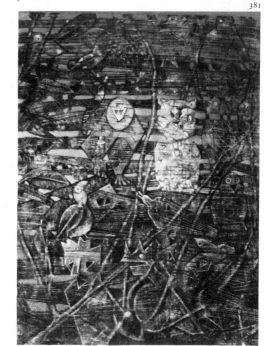

381

In 1955 Max Ernst settled at Huismes near Chinon. There he painted pictures filled with a fairytale atmosphere, witty, ironic and hinting at deeper implications.

The comedian W. C. Fields played one of his greatest roles in a film of *Alice in Wonderland*. This dream narrative with its incessant puns inspired another work, which again reshuffles the elements of Carroll's book. *Albert the Great* alludes to a medieval Bishop of Regensburg, who, although a saint and a Doctor of the Church, also had an evil reputation as a magician and warlock. *Two and Two Make One* is a modification of an implement for cutting asparagus.

378 *Homage to W. C. Fields and his Little Chickadee* 1957

379 *Albert the Great* 1957

380 *Two and Two Make One* 1956

381 *For Alice's Friends* 1957

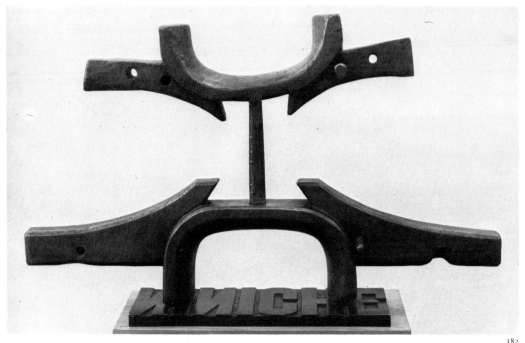

382

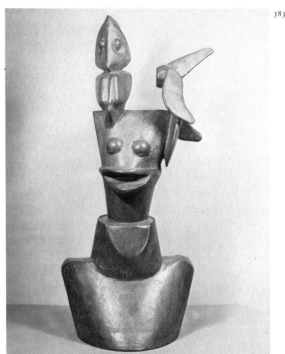

383

384

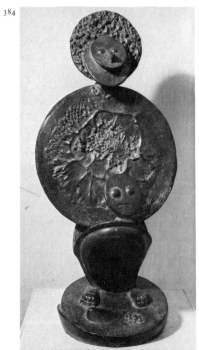

'Whenever I get into an impasse with painting, which happens to me all the time, sculpture is always there as a way out; for sculpture is even more a game than painting' (Max Ernst in Peter Schamoni's film *Die widerrechtliche Ausübung der Astronomie*). But this does not prevent the sculptures of the late 1950s and early 1960s – the works of a man in his seventies – from taking their deserved position as major contributions to the history of sculpture.

Are You Niniche?, like his other sculptures, is based on the additive technique. It is made up from casts of two ox yokes and a block of type. Its symmetrical arrangement has been achieved by a playful exploitation of the allure of the found object.

382 *Are You Niniche?* 1955–56
383 *The Imbecile* 1961
384 *Reassurance* 1961
385 *Sister Souls* 1961
386 *The Genie of the Bastille* 1960

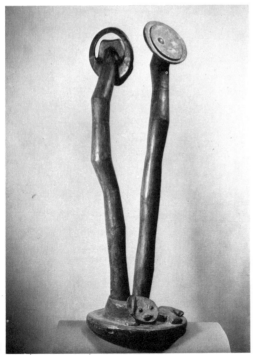

385

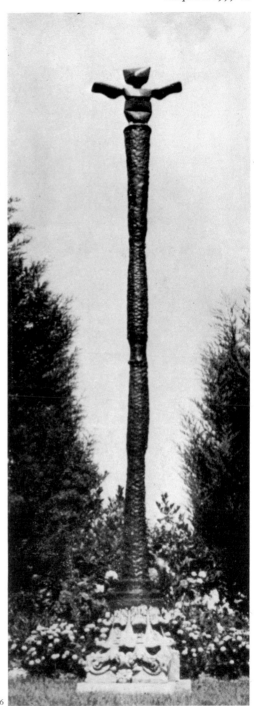

386

387

388

At Huismes, Max Ernst incorporated into the garden wall a series of massive late nineteenth-century reliefs which he rescued from a house which was being demolished in the Champs-Elysées, reminiscences of the past generation – that of his father – which had found expression in the collage novels.

In 1963 Max Ernst and Dorothea Tanning moved to Seillans in southern France. There he produced a new book, *Maximiliana ou l'exercice illégal de l'astronomie*, in conjunction with which Peter Schamoni made a film. In Buñuel's *L'Age d'or* (1930) and Hans Richter's *Dreams that Money Can Buy* (1947) and *8×8* (1957), he had appeared as a performer alone; in this film he also drew direct on the film.

387 Garden wall of Max Ernst's house, Huismes 1963
388 Max Ernst, Seillans 1966
389 Still from Peter Schamoni's film *Die widerrechtliche Ausübung der Astronomie* 1964

390

391

Maximiliana ou l'exercice illégal de l'astronomie, which appeared in 1964, dedicated to the life and work of the astronomer and lithographer Wilhelm Leberecht Tempel (1821–89), is regarded by Max Ernst as his finest book publication. Produced in collaboration with the typographer Iliazd, it is a paraphrase of Max Ernst's own life.

The facts about Tempel had been brought to light by Iliazd and were recounted by Max Ernst in Schamoni's film. Despite his outstanding knowledge in the field of astronomy, Tempel was rejected everywhere by experts because he was self-taught. In 1861 he discovered Asteroid 65, to which he gave the name Maximiliana. In 1858 he married a daughter of the gatekeeper to the Doge's palace in Venice, in order to be able to make his astronomical observations from the Scala del Bovolo. After a life of exile, recognition came very late.

'That was what particularly moved me about him,' said Max Ernst in the Schamoni film, 'because in Wilhelminian Germany, where I spent my youth, things had not been so very different.' The subtitle of *Maximiliana*, 'The Art of Seeing of Ernst Wilhelm Leberecht Tempel', points to Max Ernst's interest in making visible the invisible, in seeing what is hidden.

The pages of the book are pictorial entities formed from writing, drawing, collage, etching and aquatint. Only the writing, if such it may be called, varies in character. Some of it is Max Ernst's secret script, pictographic writing with no linguistic content; it also includes simple rhymes which could have come from Tempel, and extracts from a scientific text in Italian which really is by Tempel. Drawings and collages break up or highlight the text, which is arranged in a variety of forms. Particular emphasis is placed upon the etchings and aquatints which, placed centrally, give the impression of spiral nebulae, comets or constellations.

390–97 Illustrations from *Maximiliana ou l'Exercice illégal de l'astronomie 1964*

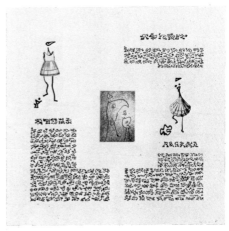

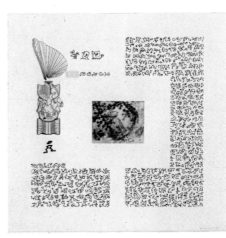

398

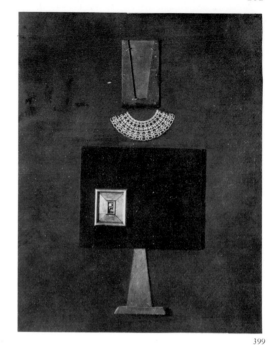

399

398　*Peace, War and Rose* 1965
399　*Ancestral Portrait* 1965
400　*The Impeccable One* 1967
401　*Soliloquy* 1965

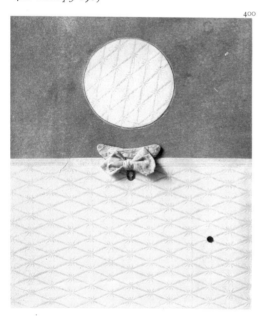

400

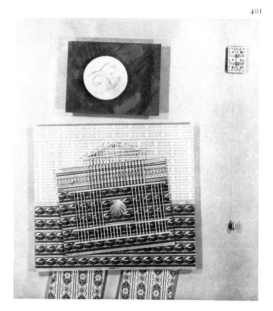

401

The assemblages of 1965 are poetic and ironic plays on the motifs and techniques which he applied with such virtuosity in his early days. The relationship between picture and title is deceptive; the relationship between creator and work is distant.

For all the accessibility of these works, they retain the notable characteristic that they are part of a development along consistently self-willed lines which has never accepted compromise. Max Ernst continues to operate 'beyond painting'; only he exploits his potential more ironically, with greater virtuosity. It is the last phase of a complex career that has been marked by forward-thrusting innovations in technique (in 1919 collage and rubbing, in 1925 frottage and grattage, in 1940 decalcomania, in 1942 drip painting), thematic inventiveness (above all between 1925 and 1940), introspective interludes (*Design for a Manifesto* in 1920, *Loplop* in 1930, *Paintings for Young People* in 1943), and astonishing climactic points.

All these phases in Max Ernst's *œuvre* inevitably lead from an attempt at interpreting the pictures to the central problem of the artist and of artistic creation itself. In the theoretical sector the methods call for as much interest as the results.

Since the mid-1950s there has been a revival of interest in art before the Second World War, above all in Dada and Surrealism, which are now regarded as a living heritage. Several comprehensive retrospective exhibitions have included Max Ernst's work: in 1956 in the Kunsthalle, Berne, in 1959 in the Musée National d'Art Moderne, Paris, in 1961 in the Museum of Modern Art, New York, and in the Tate Gallery in London, and in 1962–63 in the Wallraf-Richartz-Museum in Cologne and in the Kunsthaus in Zurich.

In 1971 Max Ernst celebrated his eightieth birthday. In the previous year large exhibitions in Stockholm (Moderna Museet), Amsterdam (Stedelijk Museum) and a comprehensive retrospective exhibition in Stuttgart (Württembergischer Kunstverein) had all taken place. In the same year an edition of Max Ernst's writings appeared in Paris (bib. 47), and a *Hommage à Max Ernst* (bib. 41).

402 Illustration for Lewis Carroll's *The Hunting of the Snark* 1968
403 Illustration for Lewis Carroll's *Alice in Wonderland* 1970

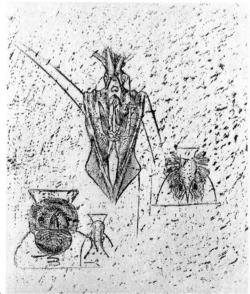

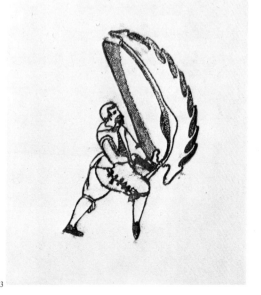

402

403

Select bibliography

DADA AND SURREALISM: GENERAL

1 Adorno, Theodor W. 'Rückblickend auf den Surrealismus'. *Noten zur Literatur I*. Frankfurt am Main 1958.

2 Alquié, Fernand. *La Philosophie du surréalisme*. Paris 1956.

3 'Fantastic Art, Dada, Surrealism'. Exhibition catalogue edited by Alfred H. Barr, Jr, New York, The Museum of Modern Art, 1936–37 (reprinted New York 1968).

4 Breton, André. *Le Surréalisme et la peinture*. Paris 1965.

5 Breton, André. *Manifestes du surréalisme*. Paris 1962 (translated as *Manifestoes of Surrealism*, Ann Arbor 1969).

6 Crispolti, Enrico. *Il Surrealismo*. Milan 1967.

7 'Dada – Dokumente einer Bewegung'. Exhibition catalogue including English translations. Düsseldorf, Kunsthalle, 1958.

8 'Dada – Ausstellung zum 50jährigen Jubiläum'. Exhibition catalogue. Zurich, Kunsthaus, and Paris, Musée National d'Art Moderne, 1966–67.

9 'Dada, Surrealism, and Their Heritage'. Exhibition catalogue with text by William S. Rubin. New York, The Museum of Modern Art, 1968.

10 Duplessis, Yves. *Surrealism*. New York 1962.

11 Gershman, Herbert S. *A Bibliography of the Surrealist Revolution in France*. Ann Arbor 1969.

12 Holländer, Hans. 'Ars inveniendi et investigandi: Zur surrealistischen Methode'. *Wallraf-Richartz-Jahrbuch XXXII*. Cologne 1970.

13 Huelsenbeck, Richard (ed.). *Dada Almanach*. Berlin 1920.

14 Huelsenbeck, Richard (ed.). *Dada. Eine literarische Dokumentation*. Hamburg 1964.

15 Hugnet, Georges. *L'Aventure Dada 1916–1922*. Paris 1957.

Janco, Marcel. See bib. 24.

16 Jean, Marcel (with Arpad Mezei). *Histoire de la peinture surréaliste*. Paris 1959 (translated as *The History of Surrealist Painting*, London and New York 1960, 1967).

17 Motherwell, Robert (ed.). *The Dada Painters and Poets. An Anthology*. New York 1951.

18 Nadeau, Maurice. *Histoire du surréalisme*. Paris 1945, revised edn 1958 (translated as *History of Surrealism*, New York 1965).

19 Pierre, José. *Le Surréalisme*. Paris 1967.

20 Prosenc, Miklavz. *Die Dadaisten in Zürich*. Bonn 1967.

20a Read, Herbert (ed.). *Surrealism*. London 1936.

21 Richter, Hans. *Dada. Kunst und Antikunst*. Cologne 1964 (translated as *Dada, Art and Anti-Art*, London and New York 1966).

22 Rubin, William S. *Dada and Surrealist Art*. New York and London 1969.

23 Sanouillet, Michel. *Dada à Paris*. Paris 1965.

24 Verkauf, Willy, Marcel Janco and Hans Bolliger (eds). *Dada. Monographie einer Bewegung*. Teufen 1958.

25 Waldberg, Patrick. *Surrealism*. London and New York 1966.

26 'Was ist Surrealismus?' Exhibition catalogue. Zurich, Kunsthaus, 1934.

27 Wyss, Dieter. *Der Surrealismus*. Heidelberg 1950.

28 'The Art of Assemblage'. Exhibition catalogue. New York, The Museum of Modern Art, 1961.

COLLAGE

Blesh, Rudi. See bib. 30.

29 'Die Fotomontage. Geschichte und Wesen einer Kunstform'. Exhibition catalogue edited by Richard Hiepe. Ingolstadt, Stadttheater, 1969.

30 Janis, Harriet, and Rudi Blesh. *Collage. Personalities, Concepts, Techniques*. Philadelphia and New York 1962.

31 Mon, Franz. Chapter in *Prinzip Collage* (ed. Institut für moderne Kunst). Nuremberg 1968.

32 Wescher, Herta. *Die Collage*. Cologne 1968.

33 Wissmann, Jürgen. 'Collagen oder die Integration von Realität im Kunstwerk'. In W. Iser (ed.), *Poetik und Hermeneutik*, Munich 1966.

MAX ERNST: GENERAL

34 *Cahiers d'Art* (ed. Christian Zervos). Special number: 'Max Ernst. Œuvres de 1919 à 1936'. Paris 1937.
35 Ernst, Max. *Max Ernst: Beyond Painting and Other Writings by the Artist and his Friends*. 'The Documents of Modern Art' (ed. Robert Motherwell), New York 1948.
36 Fischer, Lothar. *Max Ernst*. Hamburg 1969.
37 Gatt, Giuseppe. *Max Ernst*. Florence 1969.
38 Lebel, Robert. 'Max Ernst parle avec Robert Lebel'. In *L'Œil*, no. 176–77, Paris, August–September 1969, pp. 28–37, 44.
39 Russell, John. *Max Ernst. Life and Work*. London and New York 1967.
40 Seghers, Pierre (ed.). *Max Ernst*. Paris 1960.
41 *XXe Siècle*. Special number: 'Hommage à Max Ernst'. Paris 1970.
42 *Der Spiegel*. 'Die Frommen riefen dreimal pfui'. Hamburg 24 September 1970.
43 Trier, Eduard. *Max Ernst*. Recklinghausen 1959.
44 *View*. Special number: 'Max Ernst'. New York, April 1942.
44a Waldberg, Patrick. *Max Ernst*. Paris 1958.

MAX ERNST: SPECIFIC ASPECTS

45 Breton, André. *Les Pas perdus*. Paris 1924.
46 Ernst, Max. *Die Nacktheit der Frau ist weiser als die Lehre des Philosophen*. Cologne 1962.
47 Ernst, Max. *Ecritures*. Paris 1970.
48 Ertel, K.F. 'Max Ernst als Kunstkritiker'. *Die Weltkunst*, XXXIV, 621f., Munich 1964.
49 Klapheck, Anna. *Mutter Ey – Eine Düsseldorfer Künstlerlegende*. Düsseldorf 1958.
50 Leppien, Helmut R. *Max Ernst. Der grosse Wald*. Stuttgart 1967.
51 Lippard, Lucy R. 'Max Ernst and a Sculpture of Fantasy'. *Art International*, XI, 37–44, Lugano 1967.

52 Sala, Carlo. *Max Ernst et la démarche onirique*. Paris 1970.
53 Spielmann, Heinz. 'Notizen über Max Ernst und Herkules Seghers'. *Das Kunstwerk*, XIII, no. 8, pp. 3–19, Baden-Baden 1960.
54 Spielmann, Heinz. 'Max Ernst, "Maximiliana"'. *Stiftung zur Förderung der Hamburgischen Kunstsammlungen*, pp. 49–56, Hamburg 1970.
55 Spies, Werner. *Max Ernst – Frottagen*. Stuttgart 1968 (translated as *Max Ernst: Frottages*, London and New York 1969).
56 Spies, Werner. 'Max Ernst und das Theater'. In Henning Rischbieter (ed.), *Bühne und bildende Kunst im XX. Jahrhundert*. Hanover 1968.
57 Spies, Werner. *Max Ernst 1950–70. Die Rückkehr der schönen Gärtnerin*. Cologne 1971.
58 Waldberg, Patrick. *Max Ernst: peintures pour Paul Eluard*. Paris 1969.

EXHIBITION CATALOGUES

59 Brühl, Schloss Augustusburg. 'Max Ernst. Gemälde und Graphik 1920–1950'. 1951.
60 Düsseldorf, Städtische Kunsthalle. 'Avant-garde gestern. Das Junge Rheinland und seine Freunde 1919–1929'. 1971.
61 Geneva, Musée d'Art et d'Histoire. 'Max Ernst. Œuvre gravé. Dessins. Frottages. Collages'. 1970.
62 Hamburg, Kunsthalle. 'Max Ernst. Das graphische Werk'. 1967.
63 Hamburg, Kunsthalle. 'Max Ernst. "Das innere Gesicht". Die Sammlung de Menil'. 1970.
64 Cologne, Wallraf-Richartz-Museum, and Zurich, Kunsthaus. 'Max Ernst'. 1962–63.
65 New York, Museum of Modern Art. 'Max Ernst'. 1961.
66 New York, Jewish Museum. 'Max Ernst: Sculpture and Recent Painting'. 1966.
67 Paris, Le Point Cardinal. 'Max Ernst. Œuvre sculpté 1913–1961'. 1961.
68 Stuttgart, Württembergischer Kunstverein. 'Max Ernst – Gemälde, Plastiken, Collagen, Frottagen, Bücher'. 1970.

A fuller bibliography of Dada and Surrealism is contained in bib. 22, and of Max Ernst in bib. 39 (see also 36, 37, 66, 68).

List of illustrations

Measurements are given in millimetres and inches, height before width.

Photo credits

Helene Adant 235; Attilio Bacci, Milan 30, 31, 33, 34, 66–68; Paul Bijtebier, Uccle (Brussels) 108, 140, 155, 186, 239; Eva Bollert, Karlsruhe 169; Cauvin, Paris 318; Celesia, Locarno 142, 376; Colton, New York 348, 357; Walter Dräyer, Zurich 346; Thomas Feis 184; Lothar Fischer, Berlin 3; Richard Franke, Murrhardt 17, 18, 94; A. Frequin, The Hague 103; Galleria Galatea, Turin 54, 167, 236, 297, 303, 306; Pietro Galletti, Rome 191; Hans-Georg Gessner, Bielefeld 92; Peter Grünert, Zurich 285; Michael Hertz, Bremen 386; Yves Hervochon, Paris 69, 298; Hickey & Robertson, Houston, Texas 353, 355; Jacqueline Hyde, Paris 6, 62, 225–27, 237, 255, 256, 295, 299, 308, 320, 321, 324, 325, 351, 352, 356, 380, 381, 384; Bernd Kirtz, Duisburg 341; Walter Klein, Düsseldorf 97, 152, 258, 365; Ralph Kleinhempel, Hamburg 93; Pierre Lebrun, Paris 199; Lessmann, Hanover 77; Wolfgang Maes, Düsseldorf 157; N. Mandel, Paris 135, 175, 198; Digne Meller Marcovicz, Munich 1; Claude Mercier, Geneva 177; A. Mewbourn, Houston, Texas 182; André Morain, Paris 400, 402; Heinz Müller, Stuttgart 390, 391; Musée d'Art et d'Histoire, Ville de Saint-Denis (P. Trovel) 83–85; Iris Papadopoulos, Berlin 8, 210; Piaget, St Louis 340; Rheinisches Bildarchiv, Cologne 13, 14, 123, 188, 369; Roger Roche, Paris 370; Maurice Routhier, Paris 148, 302; Sachsse, Bonn 9, 208; Peter Schamoni, Munich 196, 328, 335, 387, 389; Schmitz-Fabri, Rodenkirchen 181; Schmölz-Huth, Marienburg (Cologne) 366; Schnetzer, Munich 388; F. Wilbur Seiders 75, 359; Service T.I.P., D. Daniel, Liège 179; Staatliche Landesbildstelle Saarland, Saarbrücken 165; Stadtbildstelle, Mülheim a. d. Ruhr 197; Walter Steinkopf, Berlin 190; Taylor & Dull, New York 205, 330, 331, 344, 350, 379; Eileen Tweedy, London 91, 301; Marc Vaux, Paris 96, 252; John Webb, London 29, 314, 315; Etienne Bertrand Weill, Paris 50; Freiherr von Werthern, Obermenzing (Munich) 286; I. Zafrir, Tel Aviv 347

Index of names